Cyber Ireland

Cyber Ireland

Text, Image, Culture

Claire Lynch

Brunel University London, UK

First published 2014 by
PALGRAVE MACMILLAN

Palgrave Macmillan in the UK is an imprint of Macmillan Publishers Limited, registered in England, company number 785998, of Houndmills, Basingstoke, Hampshire RG21 6XS.

Palgrave Macmillan in the US is a division of St Martin's Press LLC, 175 Fifth Avenue, New York, NY 10010.

Palgrave Macmillan is the global academic imprint of the above companies and has companies and representatives throughout the world.

Palgrave® and Macmillan® are registered trademarks in the United States, the United Kingdom, Europe and other countries.

ISBN 978–0–230–35817–1

This book is printed on paper suitable for recycling and made from fully managed and sustained forest sources. Logging, pulping and manufacturing processes are expected to conform to the environmental regulations of the country of origin.

A catalogue record for this book is available from the British Library.

Library of Congress Cataloging-in-Publication Data
Lynch, Claire, 1981–
 Cyber Ireland : text, image, culture / Claire Lynch, Brunel University, UK.
 pages cm
 Includes bibliographical references and index.
 ISBN 978–0–230–35817–1
 1. Literature and technology—Ireland—History—21st century.
 2. Literature and the Internet—Ireland. 3. Irish fiction—21st century—History and criticism. 4. English fiction—Irish authors—History and criticism—21st century. 5. Social networks—Ireland.
 6. Mass media—Technological innovations—Ireland. I. Title.
 PR8803.2L96 2014
 820.9′941509051—dc23 2014022093

For Bethan

Contents

Figures

Acknowledgements

Many people have contributed to this book, by enthusiastically recommending websites or books, politely enduring my flights of fancy and, most importantly, challenging me on whether the book should be written at all. Too numerous to name in person, this community of friends and colleagues helped to frame the ideas discussed here and I am grateful to them. The opportunity to present the first iterations at the 2009 IASIL conference at the University of Glasgow and, shortly afterwards, at the 'Nations and Knowledges' event for the Ireland–Wales Network at Cardiff University was genuinely formative. Similarly important feedback grew out of discussions at the Conference of Irish Historians in Britain in 2012 at the University of York, with final 'beta testing' of the *Cyber Ireland* concept in 2013 at events at the Irish Cultural Centre in Hammersmith and University College Dublin. I am grateful to the organisers and fellow participants of all of these events for developing and supporting my thinking on these topics.

At Palgrave, my thanks go to Felicity Plester for getting the book started and to Chris Penfold for getting it finished.

Permission to reproduce the cover image 'The Táin' and 'The Journey Begins' from Kú © was kindly provided by artist Basil Lim of bitSmith Games. I am extremely grateful to the generous permission provided by the following: 'Dublin Goes Digital' © image reproduced by permission of Craig Robinson, 'I: Telemachus' *Ulysses* 'Seen' © by permission of Robert Berry, 'Trinity College at Sunset' and 'View from O'Connell Bridge' © by permission of John Mahon and the image and map from *Tír Na Nòg* © by permission of Greg Follis and Roy Carter of Gargoyle Games.

Introduction

On 30 August 2013, Nobel laureate Seamus Heaney sent a final message of comfort to his wife, Marie, urging her not to be afraid. A few days later, their son Michael shared these words with the congregation at Heaney's funeral, and thus, with the world's media. From the pulpit in Donnybrook, the two-word text message was beamed across the globe, re-emerging on the pages of newspapers and the cycling ticker-tape of 24-hour television news. But it was online, through social media, that the message really took flight. Concise and compelling, Heaney's last words appeared in the world as a ready-made tweet, forwarded and shared between the computers and mobile phones of millions of people. In the days and weeks afterwards, passing on the private message became a public tribute to the poet and to poetry – an act of communal condolence and vicarious stoicism. That Heaney's final words were characteristically mighty was no cause for surprise; even so, a gentle rumble of curiosity gathered around the fact that the 74-year-old poet's last words had been transmitted by text message. The apparent contrast between the new technology of the mobile phone and Heaney's 'beloved Latin' is, of course, the very point – paying homage to the past while retaining faith in the future. The words of Heaney's text message were analysed and admired on blogs, news websites and social networks, but they were also appropriated, taken up as an online battle cry against any and all obstacles. Sending and receiving the two words 'noli timere' allowed people to absorb Heaney's imperative into their own devices and lives, recycling the message in acts of memory, celebration and inspiration. These words are also the starting point here, because, in many ways, this is a book about fear and about not being afraid. In the chapters below, I explore the intersections between cyberculture and Irish literature, including the ways in which Irish writers have

started to engage with computer technology and the parallel impact that such technology has had on Irish writing. These are new areas of investigation and, as such, they provoke an understandable fear of the unknown. At the same time, this topic reveals numerous Irish writers, artists, programmers and developers who have shown themselves to be fearless in their engagement with new ideas and new opportunities.

Context

A few years ago, when I started to frame the ideas for this book, social networking, through platforms such as Facebook, Twitter and LinkedIn, seemed to be revolutionising the way we thought of ourselves. Apparently transforming the very notion of identity and the ways in which we are involved in the lives of others, these online platforms are now ubiquitous to the point of passé. Considered 'universal technologies', users are as likely to be grandparents as teenagers, and online rituals such as 'checking in' at a location or updating one's 'status' are now everyday activities for millions around the world. They are also, for many people, a matter of real concern. Marketed as an additional way to maintain friendships and professional contacts or to share news and entertainment, some critics are anxious that

> digital selves [have] become fractured, confused reflections of a person, never wholly unreal, but never wholly real either – a seeming half-truth.
>
> (Boon & Sinclair, 2009, p.103)

If social networks are sites of potential identity crisis, numerous other online technologies have become established aspects of daily life, used to check the weather forecast, buy the groceries or find directions on a map. Indeed, there are people for whom the internet has already become the default source for entertainment, education, shopping and sex. Whether one chooses to view this as a depressing dystopia or as exhilarating progress, it is impossible to deny technology's 'increasing embeddedness in everyday life' (Bell, 2007, p.12). Responses to these new technologies, both in the media and in scholarly debate, are inevitably couched either in fear (where will it all end?) or in awe (how far can we go?); both are inspired by the shared sense that the 'future' is already here. Rather than waiting to see where technology leads us, of course, we might well begin by examining our initial uses of and reactions to the various phenomena we now think of as comprising

cyberculture. The term 'cyberculture' resists any neat definition, and rightly so. Here, at least, it will be used to refer to the culture created by and in response to computer technology; that is, the behaviours, actions and outputs that arise from it and because of it. As Roy Foster points out, 'there is no "thirty-year rule" of the mind' to stop us 'from analysing things that have happened over the last generation' (2008, p.1). In the case of cyberculture in Ireland, such a timeframe is a prerequisite; we have neither the benefits nor the impediments of hindsight. Using contemporary Irish fiction, websites, blogs, videogames and other artefacts of the digital age, this book hopes to explore the concept of a 'Cyber Ireland' by directly 'engaging with and writing the history of the present' (Berlant, 1998, p.106).

In talking to people during the preparation of this book, by far the most common reaction was incredulity that such a relationship might exist, as if it were somehow unseemly to discuss Irish literature and cyberculture in the same breath. The scepticism speaks, perhaps, of a wider reluctance in some quarters to move beyond 'traditional' topics, including but not limited to 'childhood, isolation, religion and politics' (Donoghue, 1986, p.185), which have so dominated Irish literary, cultural and historical research in previous decades. Yet, while Irish studies has been shaped by certain thematic and historical imperatives, it is also characterised by an inherent pliancy. Recent research trends, including important work in the areas of queer theory, ecocriticism and the digital humanities, are testament to this (see, e.g., Mulhall, 2013; Wenzell, 2009; Clements, 2012). The area of digital humanities is particularly relevant in this context, promising a 'productive alliance' with Irish studies, which may prove intellectually and practically sustaining for both fields in the future (Kelleher, 2013, p.64). At present, however, the very concept of the digital humanities remains largely undefined; as Margaret Kelleher argues, it seems to be simultaneously 'a methodology, a theory, a set of tools, a mode of practice, or a newly emergent discipline' (2013, p.64). Any number of visionary projects could be highlighted here for bringing new technologies to bear on Irish texts, images and ideas, not least of which includes the app for James Joyce's 'The Dead' (Meaney, 2014), the Abbey Theatre Archives (Abbey, 2014) and the database of Irish Women's Writing 1800–2005 (Luddy & Meaney, 2007). At the same time, an increasing back catalogue of abortive digital humanities projects has built up with no wider an audience online than they ever had in print. Use of the 'digital' has seemed to be a funding talisman in recent years, giving an irresistibly contemporary sheen to otherwise unpromising projects. The corollary of this is a sort

of collective cringing apology on behalf of the humanities more generally as researchers attempt to legitimise important but unfashionable work by latching on the kind of digital element so favoured by funding bodies and government policy makers. At best then, the digital humanities offers Irish studies a range of new capacities; where collaborations are superficial, however, the outcome is inevitably limited. Important work is taking place in universities in Ireland and globally that aims to make use of the techniques and approaches valued by digital specialists, as well as making use of the capacity for historical, visual or textual analyses that are still best computed by brains rather than processors. It remains to be seen whether these projects will be considered long-term successes; nevertheless, it is apparent that overlapping interests from varied disciplines are increasingly brought together to achieve collective ambitions. All of this speaks of a clear imperative for new modes of working, although not, as some have feared, to the exclusion of established expertise. As Steven Poole points out, the development of a new medium does not lead to the necessary extinction of another: 'Film did not replace theatre. The internet did not replace the book' (2004, p.17). Similarly, the growth of the digital humanities – an indicator of the prevalence of cyberculture – while not a question of replacement, is most certainly a form of displacement. This book could not be described as digital humanities research in the typical sense, after all, there is no database, app or digital archive attached to it. Even so, it is animated by the relationship between the objects and activities which define the digital age and the cultural, historical and literary methodologies which power the humanities. As Bell explains:

> Thinking about cyberculture involves thinking about representations, meanings, images: about the ways in which we assemble particular narratives about how these technologies have changed, are changing, or will change lives.
>
> (2007, p.6)

In the context of Irish studies, we are only just beginning to observe these narratives and are some way off proposing their meanings. Yet these debates are well overdue, as Fergus Burns forewarned, 'a future Taoiseach or president of Ireland is now on *Bebo*' (Burns, 2006) In 2014, the most revealing aspect of this statement is the implied sustainability of the social networking platform Bebo. Extremely popular in Ireland, the now defunct Bebo, displaced by Facebook and Twitter, stands as a warning against futurology. Nevertheless, Burns' point that a 'future Taoiseach or president of Ireland' might be prevented from achieving

his or her potential by the whims and trends of their teenage-self being broadcast to the electorate remains pertinent. Perhaps, but this is an anxiety which grows out of pre-cyberculture ideas of privacy. We might equally argue, for instance, that such a 'future Taoiseach or president of Ireland' will have mercifully few opportunities to be secretive, coming into the role with a ready-made archive of personal source material and a lifetime's worth of draft memoir. Burns' note of caution provides a useful thought experiment because it reminds us of the extent of the changes that are as yet unimagined and are perhaps unimaginable. It also demonstrates that within Irish studies, the incursion of cyberculture must surely be experienced as an opening up of some of the implicit limits placed upon the core concerns of people and place. Historical narratives of Irish emigration, to take one example, must now make space for the contemporary scenario in which 'technology makes it possible for an immigrant to keep in touch with his or her original culture and, at the same time, encourages and allows access to other cultures' (Salerno-O'Shea, 2002, p.137). Since technologies such as Skype, email and Facebook have transformed experiences, so too will they transform the historical and fictional narratives which reflect them. The question of emigration is doubly useful here, as it links into one of the key difficulties; that is, pinning down not just *what* cyberculture is, but *where* it takes place. Dublin City Council's recent 'Free Wifi' campaign provides a useful metaphor for this (See Fig I.1). Artist Craig Robinson's 'iconic'

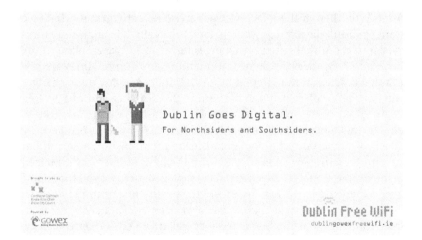

Figure I.1 'Dublin Goes Digital', artwork by Craig Robinson, on behalf of DDFH&B Advertising

Dubliners – part ancient mosaic, part pixelated videogame avatars – mark the capital's hotspots (Dublin City, 2013). In parallel with other monuments, not least the embedding of Joyce's *Ulysses* (1922) in bronze plaques in the pavement, the mosaics create a network of nodes across the capital. In this way, cyberculture makes it possible to walk through Dublin with literature beneath your feet, wifi above your head and both in your hand via your smartphone. At the same time, it is entirely possible to be surrounded by these images and ideas without noticing them at all. The wifi mosaics, just like the examples discussed in this book, simply highlight the fact that cyberculture is already all around us.

Cyber Ireland

Of course, all of this takes for granted the kind of individual and structural circumstances required to be able to engage with cyberculture. Access to an internet-enabled device, the necessary funds to support the connection and the political freedom to read and write online narratives are by no means guaranteed. Indeed, one of the greatest illusions of the internet is the idea that it is the same for any person in any place. Yet in Ireland and elsewhere, those who do have access to the internet soon discover that cyberculture's primary function is to disrupt the authority of place. The 'places' online where you share your photos, chat to friends or watch movies, for example, defy the limits of geographical location, creating an entirely different sense of global connectivity. Where you 'go' online, in other words, is more relevant than where you are coming from. Why then, if these technologies are so patently global, would we want to shrink the focus down to Ireland? To begin, it is surely uncontroversial to claim that extensive changes have already taken place to the ways in which ideas are shared and culture and commodities are distributed because of the internet in Ireland. Indeed, many more changes will have taken place between me writing this sentence and you reading it. As I'll go on to argue in this book, Ireland has a particular role to play in this global narrative, particularly in the way Irish people have taken on universal technologies and made them 'Irish'. These cultural encounters with new technologies form the basis of the ideas expressed here. Unquestionably, the increased overlap between cyberspace and lived experience in the first decades of the twenty-first century has made virtual reality more real than it has ever been and markedly so in an Irish context. From the boom years of Ireland's Celtic Tiger economy, during which the manufacture and development of computer hardware and software in Ireland thrived, through to various government policies

to increase domestic access to web technology, cyberculture has been at the core of Ireland's social and cultural identity. At the same time, the increasing overlap between online and literary narrative forms has led to an increased focus on the changing nature of Irish cultural expression in the digital age. A key priority in this book will be to historicise the emergence of Irish cyberculture by considering, for example, some of the first novels to include references to emails, search engines and online shopping. In fact, cyberculture is represented in contemporary Irish literature not only through characters' actions and behaviours, but also in the forms and styles which echo online narrative conventions. The focus here on Irish novels, videogames and websites, as well as on their intersections with other 'universal' technologies, helps us to make sense of the more broad-brush definitions which begin and end with the economic impact of computer technology. As Karlin Lillington observed in 2004:

> Although we might be the world's leading software exporter, the world's most globalized economy, and one of the best locations for ebusiness (at least according to past surveys), we also are, curiously, almost bereft of any cyberculture.
>
> (p.72)

In Lillington's account, the manufacture and distribution of computer technology bolstered Irish businesses without having a correlative impact on 'the daily lives of Irish citizens' (p.71). Can this really still be true a decade later? Certainly, in the intervening years since Lillington's observation of the absence of Irish cyberculture, the presumed significance of the internet has become a tedious truism, impacting on our lives in manifold ways. My concern here is not with how these technologies work (undoubtedly fascinating as that may be), but rather, what they might come to mean in a particular time and place. Focussing on the consequences rather than on the functions of cyberculture in this way acknowledges that it is capable not only of changing actions, how we work and play, but also of how we think about ourselves. In an Irish context, in Roy Foster's terms, from 'about 1990 the traditional mantra for self-sufficiency, "Ourselves Alone", had mutated into "Ourselves Online"' (2008, p.29) – a dramatic shift from political isolationism to cyber elitism. Meanwhile, the adoption of information technology in domestic as well as institutional settings led to what Gerry Smyth describes as an Irish 'revolution in home-computing' (2007, p.124). While these transitions can be quantified statistically and anecdotally

in terms of internet usage figures and computer ownership, the more compelling case comes in the form of cultural evidence. If, as Smyth claims, few countries had 'embraced the IT-sponsored information revolution with as much alacrity as Ireland' (Smyth, 2007, p.126), was it equally the case for poets as programmers?

The crossover between cyberculture and popular literature could hardly be better exemplified than in Roddy Doyle's *Two Pints* (2012). First published as a series of Facebook posts, then gathered together in print and e-book form, the text is a dialogue between two men who think of their local pub as 'a social network as well, really' (Doyle, 2012, p.975). Their topics of conversation are shaped by current affairs, creating a comic archive of news stories on digital enhancement and the price of Facebook shares. In the case of drama, Ciara O'Dowd's claim that the 'explosion of technology on stage' is indicative of 'a society steeped in digital expression and instant communication' (2010, p.151) directly links experimental Irish theatre to the presence of 'technogiants' such as Google in the Irish capital. O'Dowd's discussion of Pan Pan's *The Crumb Trail* (2009) provides a case in point, examining the use of YouTube footage and Skype calls on stage and observing that the 'trail of the title seems to allude to Internet "cookies" rather than mythic fairy tales' (p.148). Declan Hughes' play *Shiver* (2003) is also pertinent, featuring 'former Irish emigrants who have returned to Ireland in order to join the new technology industry with a dot.com start-up' (Buchanan, 2009, p.311). As Jason Buchanan's instructive essay on *Shiver* demonstrates, within the play, 'the Internet represents this new idea of a home without history' (2009, p.311). If novels and plays about the internet offer one way into Irish cyberculture, actual websites must be seen as at least equally revealing. Curated 'magazine' websites such as Ramp.ie, Culch.ie, Krank.ie and Journal.ie featuring illustrated lists and reviews are the essence of zeitgeist, reporting on popular culture, but also creating it. The witty contributors employ a form of smug undergraduate humour, in the best sense of that term, since they write to an audience of knowing peers. Online trends, new gadgets and games culture shape the material while links to social media allow for real-time communication with and between readers. While the comment sections of these curated websites provide space for readers to discuss (or, primarily to argue over) news and gossip, the group blog 'Come Here to Me!' develops the idea of reader contributions as mini-essays on the 'life and culture of Dublin city' (CHTM, 2013). The full range of Irish blogs and social networking initiatives are inevitably too numerous to outline here in any detail, but their cultural and political significance provides

an undercurrent to this book. That said, these forms of online writing which allow people to 'articulate their thoughts, feelings, experiences, and particularistic identities' (Keren, 2010, p.110), without the formalities of publishing, deserve further attention. As already discussed in relation to Seamus Heaney's last words, mainstream technologies such as news channel live blogs and social networking feeds are regularly used to translate public events into private experiences. When the Queen visited Ireland in 2011, for instance, people tweeted as police helicopters buzzed overhead and those watching the BBC and RTÉ live feeds converged online in their joint recognition that the British monarch had arrived wearing Aer Lingus green. Tens of thousands have since watched the YouTube video of President Mary McAleese's mimed 'wow' at the Queen's use of the Irish language. Through the use of new media then, would-be observers were able to write the event into their own life narratives through their virtual contributions. An extension of these ideas is the '@Ireland' Twitter account. Inspired by 'the idea that a single voice cannot represent a country', the account rotates to a new person each week, allowing a range of 'custodians' to lead discussions and share their opinions and experiences (@Ireland, 2014).

If blogs and online journalism formats facilitate observation and commentary, games and apps create a space for a performative Irish cyberculture. From Gaelic Athletic Association (GAA) football and hurling on the PlayStation to the Cúchulainn-inspired *Kú* discussed in detail in Chapter 6, Irish gaming is a vibrant growth area. For tablets and smartphones, as convention demands, there is an app for almost anything from Irish baby names, jokes and train times to the Irish statute book (eISB, 2011). Apps and online resources for the Irish language are particularly popular, including the dedicated social networking platform Abairleat (2014). Both commercially and state-funded apps provide a valuable insight into resources that are perceived to have cultural capital. The Arts Council Cultural Technology Grant Scheme is a case in point, leading to the creation of a 'Culture App (Dublin Culture Trail), along with a "satnav for the arts" (Culturefox)' (Slaby, 2011, p.86). Religious organisations have taken a similar path with apps for specific churches and the broader notion of 'cyberspirituality', perceiving the 'Internet as a locus not only for authentic spiritual experience but as a new theatre for social action on a global scale' (Tobin, 2004, p.596). Perhaps unsurprisingly, with this kind of potential impact, Irish politicians have similarly taken their rhetoric online. As early as 2007, the Green Party's Eamon Ryan suggested that 'most of this election is an e-campaign' and by 2011 'it seemed to be expected that candidates

would have a social media profile and engage with voters on-line' (Farrell et al., 2011, p.44). Indeed, as Farrell et al. have pointed out, the web presence for Irish politics was such that 'the National Library of Ireland decided to expand its ephemera collection in 2011 by taking screenshots of one hundred web sites' (p.45) in order to maintain a relevant political archive. The National Library's recognition of the importance of online archives is a reflection of a general faith in the longevity and economic value of cyberculture during this period. Also with a leap of faith, Media Lab Europe (MLE) – 'a government-supported industry initiative' set up to 'foster technological innovation through art/technology research' (Haahr, 2004, p.45) – famously failed to capitalise on such lofty ambitions. After five years, the lab went into voluntary solvent liquidation. Even with this misfire, the MLE, along with similar initiatives such as the Digital Hub, 'intended to be a home to special effects, content creation [...] and new digital platforms' (Lillington, 2004, p.72), underline the commitment to the creative and technological industries in Ireland during these years. These outputs and associated infrastructures provide the foundation for the more detailed case studies considered here.

Intentions and limitations

Primarily, this book offers a discussion of narratives in which Ireland and/or Irishness intersect with cyberculture. A central concern here, therefore, is to observe and describe the impact of exactly what it is that computers have done and will continue to do to the narratives produced by and about Irish people. As Sherry Turkle famously argued, computers are best understood as things which do things 'to us' and not just for us (1996, p.26). Nevertheless, if there is a symbiotic relationship between Irish literary culture and cyberculture, it begins with pragmatic rather than theoretical foundations – simply, computers have changed how books are written, sold and read. However, a focus on the threatened usurpation of books by computers is a distraction from the equally significant matter of computers infiltrating books both in content and form. In fact, the relationship between the two is not so much a matter of infringement as of a mutual merging, shared influence and reciprocal inspiration. In line with this focus on literary narratives, careful attention will be paid here to the unstable language used to describe these still new modes of expression and communication. The internet, for instance, is beset with a number of telling metaphors, made to shape our attitude towards it. Is the act of going online to

be considered a matter of 'navigating' or 'exploring' an overgrown terrain, for instance, or is it a case of 'surfing' on an ocean of possibility (albeit with deep and dangerous depths)? By problematising some of the language commonly used around cyberculture, I hope to suggest that these are pertinent topics for everyone with an interest in Irish cultural expressions. At least in part then, this book is an attempt to reconceptualise ways of thinking about Ireland and Irishness in light of cyberculture's ever-increasing influence. Although the examples drawn upon have a particular relevance in an Irish context, this is not an argument for Irish exceptionalism; these are simply Irish manifestations of global phenomena with equivalents and contradictions in other cultural contexts.

This book does not provide a chronology or critique of particular technologies, but rather moves towards something approaching a philosophy of cyberculture and its significance in Ireland at this particular time. In doing so, it echoes Thomas McCarthy's sense of the limitations of sociology when he argues that 'To know Ireland, you have to use the more precise sciences of fiction and poetry' (1997, p.116). The categories of text, image and culture are obscure and capacious, but necessarily so, since they encompass the incongruous, even apparently incompatible genres under scrutiny here. The online examples selected are also deliberately broad and varied. Each reader will, no doubt, be able to draw upon his or her own experiences of social networking, online games and virtual worlds to supplement those suggested. Indeed, it might even be an advisable reading strategy to look up the websites discussed as you read about them or to browse for new examples of your own. All of the blogs, chat rooms, web platforms, novels and images have been selected because they are pertinent to the argument. That said, they might equally be considered arbitrary in the way that the web demands. Researchers of online expressions of culture are often forced to acknowledge that the whole might be best understood by looking closely at the part, and this is the approach taken here.

It is clear that a book like this is highly time-sensitive. Indeed, it seems impossible to avoid becoming instantly out of date since the subjects change and multiply hourly, making several sins of omission inevitable. David Bell has pointed out that 'writing a book about cyberculture means writing about a present that will already be the past by the time you're reading this, or writing a future that might not happen' (2007, p.131). These temporal frustrations can only be endured by both author and reader, at least until such time when books, like websites, are subject to regular updates and revisions. Bell overcomes this problem by

suggesting his book be read as a 'time capsule' (p.131), capturing an accurate and diverse picture of a particular moment. I hope the same will be true here. Perhaps the principal danger, however, is the temptation towards futurology. When talking about the newest manifestations of technology, there is an understandable desire to see current developments through to their imagined conclusions. That is the job of science fiction, not critical analysis, and I will do my best not to romanticise the potential of cyberculture here. Nor is this book a manual for the use of online technologies in the sense that it does not focus on how technology works, but rather, on how it works on us. I am interested in the sociocultural impact of Irish cyberculture and the sense that the real and the virtual are becoming increasingly difficult to separate. A detailed reading of contemporary Irish novels is crucial in this endeavour since it helps to chart the adoption of cyber ideas into mainstream cultural references. This book, in other words, cannot only rely on what can be found online about the online realm but must also trace its impact in other pre-existing formats.

Overview

There is no attempt here to gather together every passing reference to Irish cyberculture. Instead, these curated examples of novels, poems, videogames, apps and so on are suggestive of the variety of relevant sources already in circulation. Appropriately, the case studies produced here do not suggest a definitive account of cyberculture, but indicate instead a series of connections, links and networks. Chapter 1 begins with the important question of newness. If cyberculture is to be absorbed into the mainstream of Irish studies, where might we begin? Using Colum McCann's account of the birth of the internet in *Let the Great World Spin* (2010) and Mike McCormack's genre-bending *Notes from a Coma* (2006), this chapter ranges through the past, present and future of Irish cyberculture. The first chapter is also an introduction to some of the wider thematic aspects of the book, including the implicit poetry of coding languages and the complexity of relationships between humans and computers. From this contemporary perspective, Chapter 2 moves back to a period preceding the so-called digital era. James Joyce's *Ulysses* (1922) may well predate computers as we now think of them by some decades, but his masterpiece is nonetheless associated with cyberculture in its guise as a proto-hypertext. Beyond its printed manifestation, various apps and online interpretations have reimagined *Ulysses* as shorthand for cyberculture's engagement with Irish literature.

Building on this idea, the second chapter goes on to consider Enrique Vila-Matas' *Dublinesque* (2012), in which the protagonist's relationship with Joyce's writing is enacted via an internet addiction. Taking up the key refrain of Vila-Matas' novel, the chapter explores the inherent conflicts between the apparently conflicting ages of 'Gutenberg and Google'. In Chapter 3, the virtual world *Second Life* provides a framework for discussing the avatars and identity experiments that create overlaps with and between virtual- and real-world tourism. Opening up the questions raised about movement and displacement in online contexts, this chapter concludes with a discussion on the perceptions and practices of emigration and return. The fourth chapter is shaped by, if not fear, then by a generalised anxiety about cyberculture. There is an inevitable form of snobbery attached to some aspects of cyberculture which grows out of the limited reference points available in new contexts. Insightful parallels emerge in reactions to Irish 'chick lit', similarly disparaged or overlooked. In fact, chick lit emerges in this study as pioneering in terms of both content and form. In novels by Marian Keyes and Cecelia Ahern, instant messenger, emails, online booksellers and internet chat rooms dictate the course of the narrative. Perhaps the most telling aspect of this, however, is the resonant parallels with blogging which emerge through close comparison. While Chapter 4 is driven by questions of genre and convention, Chapter 5 is concerned with the way in which engagement with technology is shaped by wealth and social class. The chapter provides a more developed outline of the role of technology during the Celtic Tiger era, focussing in particular on Élís Ní Dhuibhne's *Fox, Swallow, Scarecrow* (2007), Anne Enright's *The Forgotten Waltz* (2012) and Roddy Doyle's *Paula Spencer* (2006). Finally, Chapter 6 takes on the somewhat unexpected topic of Cúchulainn as a hero of Celtic mythology, his reinvention in computer games and the subsequent echoes of both in Paul Murray's novel *Skippy Dies* (2010).

This book is only the start of a conversation. It is impossible and pointless to predict how relevant the questions asked here might become to the future study of Irish literature and culture. What is clear is that cyberculture already occupies our hopes and fears about our current age. As the examples sketched above demonstrate, its presence is already telling in politics, education, health, theatre, journalism and so many more arenas than can be contained herein. In terms of Irish literature, the fact is that the cyber and the literary are already hyperlinked. For some, this realisation is an opportunity, for others it fuels an anxiety that the elements we prize in literary culture will be displaced

or even destroyed. This book is a reassurance against these kinds of fears. While cutting-edge gadgets promise that we will soon all access the internet through the lenses of a pair of glasses, and science fiction and film predict a direct plugging into the matrix, at present, we still access cyberspace by looking into a screen. Whether attached to a desktop computer, laptop, tablet or smartphone, we see into the internet by looking through a piece of glass, just as we have learnt to do with television and, before that, the far more mundane technology of the window. It is small wonder that the idea of the window has proven so irresistible in the construction of cyberculture. As actual windows frame the divide between one place and another, on the computer screen:

> windows have become a potent metaphor for thinking about the self as a multiple, distributed system. According to the metaphor, the self is no longer simply playing different roles in different settings, something that people experience when, for example, a woman wakes up as a lover, makes breakfast as a mother, and drives to work as a lawyer. The life practice of windows is of a distributed self that exists in many worlds and plays many roles at the same time.
>
> (Turkle, 1997, p.159)

Turkle's notion of 'cycling through' windows – having multiple identities and completing multiple tasks at the same time – is evidenced further in social media technologies. Tellingly, these platforms arguably have even more in common with a non-digital window. In other words, mainstream technologies such as Facebook and Twitter are so compelling because of the ever-changing outlook they present us with. Similarly, the addictive quality of sites which provide news feeds and comments stems from the fact that they are in flux. The user may come back minutes, even seconds later to see that a new landscape has developed. Cyberculture is captivating, but also frustrating in its instability, refusing to pause for long enough to be written about. Of course, that is precisely the point – all this book can do is catch a glimpse of what is currently going on through the window. Literature is the core focus here because written narratives offer up a tangible reflection of these transient ideas, albeit in a form that remains open to multiple, even infinite, interpretations. The questions asked here are framed around reactions: how have books written within the age of cyberculture been influenced by it? How are books written before the fact seen differently as a result? How are books reconsidered in light of the way we now understand the narratives which come to us through these 'windows'?

Once more, Seamus Heaney is instructive. In part VII, 'The Skylight' from 'Glanmore Revisited' (1998, p.350), the poet recalls his reluctance to have a new window fitted into the roof of his study. Opposition to the skylight grows out of a sense of safety and comfort he feels in his hutch-like work space. Nonetheless, with the opening up to 'extravagant/Sky' (ll.9–10) comes a revelation, as the light and the 'surprise' of potential changes his perspective in the most literal of ways. In the poem, the skylight is aligned with miraculous healing; its presence is a reminder to have faith. Whether carved into the 'trunk-lid fit of the old ceiling' (l.6) then, or held in the hand as a mobile phone screen, windows, in any form, help us to train our vision outwards and onwards.

1
Out With the Old, in With the Boring

> In 1994, when Intel launched the Pentium processor that was central to the emergence of the personal computer as an everyday consumer product, more than half of worldwide production was based at Leixlip. Over the next decade, the Irish plant produced a billion Pentium chips.
>
> (O'Toole, 2013)

Placed alongside the Tara Torcs, Book of Kells and Clonmacnoise Crozier in Fintan O'Toole's *History of Ireland in 100 Objects*, the Intel microprocessor is transformed into an icon for the remarkable 'rise of information technology' in Ireland (O'Toole, 2013). In their own way, of course, all of the 100 objects are assertions of technological advancement. Whether they reflect a new age of sophistication in the hammering and twisting of gold or the dexterous production of illuminated manuscripts, all of these objects are touchstones in Irish techno-cultural evolution. In this sense, the inclusion of the Intel microprocessor in 98th position is no more than a matter of extending the timeline. More notable than the innovative nature of these objects, however, is their value as implicitly sacred artefacts. While many of the items served distinctly religious or spiritual functions, all can be read as objects of secular veneration, simply by virtue of their inclusion on the list. Reproduced in the printed book, the online exhibition, the phone and tablet apps, and available to view at the National Science Museum at Maynooth, the Intel microprocessor becomes, in a painfully literal sense, objectified by this project. Labelled, mapped and historicised by the *100 Objects* initiative, the microprocessor is plucked from its hidden location within the computer and made visible in both virtual and actual museum spaces. With good reason too, it is a truly remarkable object of Irish manufacture.

While the ancient objects on the list are admired for their rarity, Intel's 'billion Pentium chips' seem almost ludicrously numerous. In the book and the app, the associated image is an abstract blur of blues, pinks and greens, bringing the processor in line with the objects crafted centuries earlier by inviting the reader to admire the human capacity to produce objects which are both ingenious and beautiful. Perhaps most importantly, placing the Intel microprocessor on this long chronology also serves as an insight into its future as an archaeological relic. Future civilizations, the list implies, might one day marvel at this small object of sophistication in an otherwise primitive culture, in the same way that we might view a Mesolithic fish trap or flint macehead.

While the impact of Intel and other manufacturing plants was, as O'Toole has it, 'unimaginable' just a generation before, Ireland's early involvement in the computer revolution was as much driven by economic opportunity as by technological proclivity. The contributing factors which made Ireland so attractive to international investors, including tax breaks and a young, well-educated, English-speaking workforce are discussed in detail elsewhere in this book. Suffice to say here that from the late 1980s, limited industrial development and a relatively unsophisticated economic infrastructure made it uniquely possible for Ireland to 'leapfrog into the microelectronic age' (Foster, 2008, p.3). While the economic and political conditions which made this possible are vitally important in forming a history of the period, generalising structural overviews threaten to obscure the lasting cultural significance at an individual or experiential level. So, while the material fact that more than half of the world's processors were produced in County Kildare in the mid-1990s is indeed evidence of Ireland's transformed reputation in manufacture and export, it tells us very little about the correlated impact on Irish lives. As the *History of Ireland in 100 Objects* demonstrates, the value and meaning of any object, or even billions of them, whether a Neolithic bowl or a microprocessor, depends upon the associated narrative interpretation. With this in mind, O'Toole asks in his introduction to *100 Objects* whether a 'physical object, in our digital age, [can] still mean anything?' (O'Toole, 2013). Since the objects collated here are used as inspiration for broad and suggestive cultural commentaries, the more pertinent question might be whether objects are, in fact, expected to mean *everything* in the digital age. In the simplest terms then, the Intel microprocessor becomes symbolic of Ireland's more general engagement with cyberculture – not so much an object as a metaphor. Beyond the Irish context, the internal components of computers, the physical objects which facilitate access to cyberspace, are

well-established as portals to the imagination. As Margaret Wertheim argues:

> the electronic gates of the silicon chip have become, in a sense, a metaphysical gateway, for our modems transport us out of the reach of physicists' equations into an entirely 'other' realm.
>
> (2000, p.226)

While large multinational companies such as Intel, Dell and Apple are pragmatically recognised for the employment opportunities they created in Ireland, little has been done to understand the corresponding imaginative shift they initiated. As examined in this chapter, these aspects of Irish cyberculture, the way it is feared and the way it is anticipated, are explored most eagerly in one of the oldest technologies: writing. In the contemporary Irish texts explored below, the symbolic and poetic capacity of the computer as object emerges in ways which both reflect and create responses to this alternate 'realm' we now think of as cyberspace. For O'Toole, the selected 100 Irish objects are ultimately significant because they represent, albeit in complex ways, the people who made and preserved them. They are, in short, evidence of the Irish people's 'remarkable ability to invent new ways to say old things' (O'Toole, 2013). The presence of an Intel microprocessor is, no doubt, notable precisely because it places the self-consciously new among the conspicuously old. More than that, the contrast with the objects crafted out of iron, stone and vellum acts as a reminder that newness is finite. Just 20 years after the launch of the Pentium processor, Intel's miraculous technology which transformed the very idea of personal computers is already taken for granted.

Newness

According to Manuel Castells, newness is 'boring'. The fact that something is new, he argues, does not make it interesting by default (Castells & Ince, 2003, p.23). Certainly, in the parts of the world where access to generic web technology has moved banking, shopping and socialising online, discussing the newness of cyberculture already seems outdated. Yet newness is undoubtedly privileged by those willing to queue overnight for the new gadget running the new operating system. While these high-profile hardware releases construct a narrative of gadget reincarnation, it is widely understood that new technologies emerge out of incremental developments. At best, 'new technology' is

only newer and, very briefly, the newest. New or not, it is impossible to avoid the sense that cyberculture has already changed us all, and quickly. As Roy Foster observes, Ireland's supposed transformation from rural idyll to technological utopia seemed but the work of a moment, as 'the microelectronic age was embraced without impediment, and with one bound Ireland was modern' (2008, p.30). Castells' rejection of the new as boring and Foster's scepticism of the Irish 'Great Leap Forward' combine here to form a warning against taking an uncritical view of 'progress'. Access to and familiarity with communications technology has increased beyond all lay expectations. Yet, if we are already bored by the idea of computers, it is not because they are new, but because they are already so familiar as to have become prosaic. As David Bell explains, 'computers have become an everyday, banal part of many people's working lives, even those whose jobs are far, far away from computing' (2007, p.133). The point is somewhat self-evident, but no less useful in framing the way we respond, not only to computers (and their components) as objects, but also to their representation in cultural forms, such as literature and film. On the one hand, computers promise futuristic capacities, as the machines we use to make life-saving scientific breakthroughs, complex calculations and sophisticated financial analyses. In reality, as Bell has it, our uses are principally 'banal'; for all that computers can and do achieve, for most people they are machines that we use to send emails, enter data onto spreadsheets and share videos of cats.

This day-to-day experience of technology as domesticated and unremarkable is, as T. L. Taylor argues, in direct contrast to the advertising campaigns which promise apparently 'magical technologies':

> Our relationships with technological objects are always moving closer to the mundane. In fact, we might even say these objects are *always* mundane. [...] actual users are engaged in much more grounded practices with the technologies they encounter.
>
> (2009, p.152)

Videogame consoles, laptops, tablet computers and smartphones provide opportunities for play and entertainment, but they are also objects of productivity and duty. These same 'technological objects' are our calendars, train tickets, bank statements and, in some cases, offices. As Karlin Lillington observed a decade ago, computer technology makes 'working from home a real possibility' (2004, p.70) for many people in Ireland in numerous professions. These adjustments in daily life may appear mundane, but they are no less significant for that.

On the contrary, Castells is resolute in his assertion that the 'information age has never been a technological matter' and should be thought of instead as 'a process of social change in which technology is an element that is inseparable from social, economic, cultural and political trends' (2001, p.3). Simply, the transformation of computer technology which has led to its current status, in Castells' terms, cannot be separated from the transformations wrought by technology. In this book, one of the key areas of concern is our reluctance, or indeed failure, to observe those correlated 'trends', particularly within Irish literary culture. Encounters with technology have ceased to be remarkable, so that in life, as in literature, they have become merely 'a ubiquitous background hum' (Lillington, 2004, p.67). Perhaps as a consequence of this, scholars of Irish literature have, to borrow Foster's term, vaulted beyond the moment of transformation in 'one bound', landing directly in assumptions of the boring or mundane.

The literary texts discussed in this book have been selected based on the criteria that a future cultural historian might apply. They have all been chosen because of the contribution they make to the case that cyberculture is already a part of Irish literature and that our full understanding of this depends upon acknowledging and interrogating it. This kind of work is very much the responsibility of literary and cultural scholarship, forming part of the 'urgent need to theorise online identity' (Boon & Sinclair, 2009, p.99). With so many obvious overlaps, the lessons learnt from theorising fictional identity provide a sensible place to start. Literary and cultural studies also supply a number of useful frameworks for understanding responses to cyberculture, not least the tendency to divide it into the extremes of utopian, utilitarian and apocalyptic. There is surely something revealing in these limitations of the human imagination, which are themselves so familiar from literary forms. The concept of computer technology, and in particular the internet, as utopian is particularly prevalent in theories which extend beyond the purely practical capacity. Again, Castells is useful in his rejection of the internet as merely a system of computational communication and exchange, emphasising the need to understand it as an *idea*. The idea of the internet is paramount for Castells in making his claim that it is 'above all else, a cultural creation' (2001, p.33). The utilitarian response, by contrast, promotes established and practical achievements. In the field of health care, for instance, the fact that 'surgery can be (and has been) done remotely via the net' (Lillington, 2004, p.71) and the way the Irish education system has already been 'revolutionized by technology's ability to bring the world to the doorstep of all schools, courtesy

of the internet' (Lillington, 2004, p.71) are regularly cited. Despite all of the apparent advantages, apocalyptic responses, including the fear that we are all 'in danger of losing our humanity and becoming soulless machines' (Pastore, 2008, p.10) retain some currency for those less convinced about the benefits of cyberculture. All three of these perspectives are simply responses to the anxieties and ambitions inevitably provoked by computers. Whether our instincts lead us to praise the transformations they bring or fear the damage they might do, computers demand our attention. However, as O'Toole's selection of the microprocessor reminds us, computers are the product of human imagination. As they come to influence us in increasingly unexpected ways, we do well to refine our responses to them as a matter of expectations. On the one hand, computers go beyond our expectations and improve upon our capacities; on the other, they confound our expectations and fall short of our plans for them. In either case, even the most boring and mundane technologies have proven transformative and provocative for Irish people. Both O'Toole's veneration of Intel's 'billion Pentium chips' and Foster's acknowledgement of Ireland's 'microelectronic age' place these global concerns within an Irish framework. They also serve to pinpoint the historical moment when cyberculture became a meaningful concept in Irish discourse. As Jason Buchanan puts it, the symbolic value of computer technology is inseparable from the Celtic Tiger as a 'cultural signifier for progress and newness' (2009, p.301). New money, the 'new Irish' and new technology characterise this era, redefining 'the limits and borders of what could, or should, be considered Irish' (Buchanan, 2009, p.301). In the digital age, Irish writers have taken up these ideas, meeting the challenge of making it 'new', just as their predecessors had a century before.

In the beginning was the code

The movement towards a mundane relationship with 'technological objects', as described by Taylor, grows out of repetition and familiarity. Self-evidently, the more we use something, the less novel it becomes. It stands to reason then, that even with Castells' stricture on newness, early engagements with computers as a 'new' technology are more likely to be characterised by a greater degree of optimism and enthusiasm. Colum McCann's *Let the Great World Spin* offers an insightful example of this, reminding us that the technologies we now take for granted were once breathtakingly new. Winner of the National Book Award in 2009 and the International IMPAC Literary Award in 2011 (Lennon, 2012,

p.99), McCann's novel explores the compulsions and frailties which set people against one another, as well as the achievements in art and technology with the potential to bring them together. It is a novel of multiple protagonists, some Irish, many American. Although principally set in New York, the novel ranges back and forth to Ireland and beyond to Vietnam, so that the significance of place is not limited to particular cities or countries. Indeed, one of the novel's greatest achievements is the concealed bonds between the characters across borders of time and space. Although 'none of the characters see all the connections that link their lives with one another', McCann permits the reader to observe the web which links them 'both known and unknown, both witnessed and unnoticed' (Lennon, 2012, p.100). The connectivity which Joseph Lennon observes between lives and characters is further reinforced by the use of computers as agents of history in the novel. McCann not only historicises the internet by narrating its origins, but also awards the technology symbolic significance, presenting it as emblematic of hope and possibility, in Ireland and beyond.

McCann's narration of the historical context in which these tools and technologies were developed restores the human to the story of computer evolution. Through characters such as Joshua, a hacker or programmer, the author presents a newness so exhilarating that people are willing to risk their lives to see it made a reality. Far from boring or mundane then, the groups of programmers who populate the novel engage with new computer technology in definitively interesting ways. Computers are 'interesting' in the novel in the way Mikhail Epstein uses the term, relating it 'to the modal categories of the possible and the impossible, the probable and the improbable' (Epstein & Klyukanov, 2009, p.79). As Lennon observes in his interview with McCann, *Let the Great World Spin* is themed around creation, 'characters at their most daring, at the moments when things are beginning or about to begin' (Lennon, 2012, p.104). None more so than the programmers and technicians 'developing the dream of ARPANET' (McCann, 2010, p.83). These young men are revealed by McCann's narrative to be the fictional counterparts of those who stood at the 'dawn of cyber-creation' building the 'world's first long-distance computer network', a project funded by the US Department of Defense and the precursor of the internet (Wertheim, 2000, p.222). Their work is a direct challenge to the previously 'possible' or 'probable', reimagining computers as bound together by 'cables or wire connections', permitting computers to exchange information (Landow, 2006, p.62). Originally linking just two computers between the University of California, Los Angeles (UCLA) and the Stanford Research

Institute in 1969, the 'nascent net' grew slowly with only 61 ARPANET sites in place a decade later (Wertheim, 2000, p.223). It was, as the novel demonstrates, a military network, only becoming a 'a global network of networks' after the National Science Foundation's sponsorship in 1980, leading to standardisation of procedures and the coining of the term 'internet' (Wertheim, 2000, p.222). Returning to this historical moment, where the internet is thrilling potential rather than mundane reality, allows McCann to reimagine the constructions of cyberspace as either utopian, utilitarian or apocalyptic, with the benefit of hindsight. For these characters, operating at their 'most daring', the construction of the internet evokes frontierism; the formation of the new via the erasure of the old. There is a very clear reverence for newness here and a related rejection of history. For these fictional young programmers, as with their real-life counterparts, 'what *really* matters is the future, a glorious unprecedented future' (Wertheim, 2000, p.295).

Playing war

Contemporary fantasies of the internet as a utopian technology of global information exchange tend to omit the detail that the 'dream of ARPANET' was as a weapon of war. These roots are revived in *Let the Great World Spin,* when technological supremacy is equated with racial superiority as 'the best and brightest' (McCann, 2010, p.83) American programmers are sent to Vietnam to combat 'Charlie and the Viet Cong [who] didn't have any computers' (p.100). Already progressing towards the formative internet, their expertise is used for various auditing and planning tasks, rationalising and processing the practical business of war. Some, like Joshua, bring the realities of war into the virtual world of the screen, reducing the dead to data or, one might equally argue, raising their status by at least accounting for them. Passions for programming are transformed into patriotic obligation and prioritising the utilitarian. As the reasoning goes: 'If you can write a program that plays chess you surely can tell us how many are falling to the gooks' (p.84). But it is the programmers and not the 'program' under consideration here. Joshua's initial disconnection from the task he works on, for instance, is emphasised through his childlike glorification in the latest equipment, a 'room full of PDP-10's and Honeywells' in a 'candy store' of a base (p.84). His analogy acts as a reminder of his youth, but also (inadvertently) puns on the brand name; his pleasure in the well of sweet nectar, in clear distinction from the job and its ultimate consequences. Similarly boyish, Joshua's project, the 'Death Hack' (p.102), sounds to

twenty-first-century ears like any number of videogames in which, as Jon Dovey argues, 'Vietnam becomes neither historical event nor media franchise but an intermedial setting for actions amenable to gameplay adaptation' (Krzywinska & Atkins, 2007, p.78). The hugely popular sub-genre of videogames shaped around the Vietnam War is now largely responsible for contemporary images of the conflict in popular culture. As Dovey explains, the consequence is a diminishing of historical legacy and a merging of real loss of life with digital simulations. This too is an idea foreshadowed within *Let the Great World Spin* as Joshua and his colleagues become engaged in a war within the war through their computer screens. 'Wheel wars' place the army programmers in direct conflict with the anti-war protestors who attempt to hack their code. When Joshua is forced to watch as the 'small blipping cursor ate away what he'd been doing' (p.100), he is as resigned as any videogame player to the loss as his code is 'munched. No way to stop it' (p.100). Much more than that, he is thrilled by the idea that there is someone else at the other end of the wire, even if they are intent on sabotage. This is a real computer-based battle but it is also a game, interactive and competitive, with the aim 'to hack another man's code, to test his strength, find his vulnerability' (p.100). It is through this onscreen combat that Joshua conceives of himself as on 'the front line' and 'in the trenches' (p.101), riding his computer like a tank into battle: 'him and his machine against the other machine' (p.100). Joshua's perception of his actions, caught in a battle of wills against an enemy computer, predicts the rhetoric of videogames where war is simply play and lives are multiple and replaceable. Unlike in a game, of course, the deaths Joshua counts are real, however much he wishes for someone to 'hack his program from outside, chew it up, spit it all back out, give life again to those boys' (p.102).

Joshua's utopian vision for computer technology, even in the face of its gruesome appropriation for warfare, is as commendable as it is naive when he proclaims that there is 'nothing that a computer couldn't do' (p.89). Rather obviously, the one thing it cannot do is protect him from the realities of war, any more than it can revive his lost colleagues. When he too is killed, his death is understood not as a return to nature, ashes to ashes, but as an absorption into the computer; he 'became code. Written into his own numbers' (p.89). This mingling of man and machine is emphasised through his mother's grief, both before and after his death. When posted to Vietnam, Joshua's association with machines is such that his mother Claire imagines having the ability to 'travel through the electricity to see him' (p.86). Through electronic objects, she forges an imagined connection, gazing 'past the wires, the cathodes,

the transistors, the hand-set switches, through the ether' to 'console him' (p.87). Again, McCann seems to pun here on the mother's capacity to 'console' her son as he sits in front of the computer console. In the same way, the fridge becomes a shrine to him after his death, and is used to remember but also to reconnect with him as she pastes on 'Computer articles. Photos of circuit boards. A picture of a new building at PARC' (p.90) as if leaving flowers at a graveside. Claire's attempts to comfort Joshua in this way, both before and after death, represent a familiar trope in cyberfiction in which characters may be 'downloaded, uploaded, and off-loaded into cyberspace' (Wertheim, 2000, p.261). It is, as Wertheim continues, an equivalent of the medieval understanding of a Christian heaven in which cyberspace becomes 'a place *outside* of place and time, a place where the body can somehow be reconstituted in all its glory' (2000, p.261). In *Let the Great World Spin*, Claire grieves first for the absence, then for the destruction of Joshua's body. As she meets with other bereaved mothers in her efforts to come to terms with this, high-wire walker Philippe Petit hangs above their conversation. His dramatic non-suicide casts a warped echo of traumatised soldier Septimus Warren-Smith's absent presence at Mrs. Dalloway's party. For the bereaved mothers, his refusal to fall, alongside the apparent inevitability that he will, is seen as a mockery of their sons' deaths, since his life is seemingly so expendable as to be risked for performance. Further, the funambulist's apparent perception of life as disposable or no more than mass entertainment is interpreted by Claire as an act of aggression, an intrusion 'like a hack on her code' (p.113). Though she thinks here of the computer coding language which so delighted her son, Claire's distress also seems to call upon the very code of her body; her own DNA disrupted by the walker's presence in the sky and the absent body it recalls.

Later in the novel, Claire opens up Joshua's room, preserved like a crypt, to reveal shelves containing 'electronic gizmos, wires hanging down. Big batteries. Three screens, their backs open and tubes showing' (p.292). These disembowelled computers, now without purpose, reveal the potential, both individual and technological, cut short by Joshua's death. Having considered the Death Hack project as 'easy enough', Joshua writes to his mother with dreams of designing a programme capable of making sense out of the senseless loss of life. His confidence in the future is such that he optimistically imagines that 'One day the computers would bring all the great minds together [...] If we don't blow one another asunder first' (p.88). The idea here that computers mark a peak of human development, in contrast to war, which suggests

the opposite, is an underpinning theme to the novel. These predictions also capture Joshua's sense that his work is about something much larger than the war itself. As he tells Claire of the future possibility of communications, as if it were science fiction, describing 'messages that were able to go back and forth' and 'remote systems that could be manipulated through the telephone lines' (p.88), his evangelical belief in technology predicts the future in a way which now seems conservative. Later in the novel, McCann reignites some of Joshua's hope as his programming doubles in California begin to put the dreams into practice. Although not alive to witness this progress, Joshua's legacy is apparent in their work, just as the funambulist – the symbol of hope, possibility and the human capacity for fearlessness – embodies the internet in all of this. As with the early internet, the feat connects a wire between two points, permitting miraculous messages to pass back and forth between them with incomprehensible speed and grace.

Broken links

McCann's fictional reconstruction of the origins of the internet in *Let the Great World Spin* (2010) is also, of course, a commentary on its present and future. Computers are objects of hope in the novel, symbolising Joshua's capacity to dream and invent, but they are also machines of war. Lost in thought at the failed coffee morning, Claire begins to pray: 'Let our machines fight [...] Let them stare each other down the wires' (p.107). This imagined future, also a utopia of sorts, in which computers take the place of sacrificial sons, reinforces the trope of the young male body not only as the creator of the internet, but also somehow as a conduit for it. When Claire's husband, Judge Soderberg, faces the funambulist in court, he sees in him a reincarnation of his son's vitality, 'as if some brilliance had been deposited in his body, programmed in like one of Joshua's hacks' (p.265). Youth and newness are combined here; the energy and potential of the living made equivalent to the innovation and capacity of the machine. Yet even though both of Joshua's parents use the vocabulary and imagery of cyberculture, they remain sceptical as to how, for example, 'a series of tubes and wires know the difference between the living and the dead?' (p.87). McCann's exact phrasing here is a prominent echo of Joycean syntax. Recalling the closing lines of Joyce's 'The Dead', McCann calls up the ghost of Michael Furey; a young life similarly cut short, a passion derailed. The newness of the ARPANET and 'Joshua's hacks', in other words, are shown to be reiterations, evidence of the world now 'bigger and smaller

both' (p.101) ever spinning, but very much within the orbit of Irish literature.

Although much of the action in *Let the Great World Spin* takes place in 1974, the novel is clearly embedded in the present day, reflecting McCann's description of twenty-first-century Ireland as 'one of the most prosperous and arrogant countries around' (Lennon, 2012, p.105). Responding to the economic and social changes associated with McCann's verdict, Jason Buchanan similarly interprets Ireland's 'addiction to newness as a denial of contemporary reality and a dangerous form of cultural paralysis' (2009, p.301). No longer boring, newness in this construction is threatening, undermining the earlier utopian fantasies of progress and exploration. To be addicted to newness is to be powerless over it, leading to the behavioural and societal responses categorised by McCann as 'arrogant'. Ireland's dependence on newness at the turn of the twenty-first century, Buchanan goes on, is a symptom of the failed attempts to 'authenticate the "new" Ireland' which result in the dislocation of 'both history and the present' (p.301). It is perhaps because of this that such an established contrivance, the young man as nation, has retained currency in contemporary attempts to engage with these ideas. If the young male bodies in *Let the Great World Spin* are put at risk and destroyed by an 'addiction to newness', Mike McCormack's *Notes from a Coma* takes the prospect of 'cultural paralysis' even further.

The novel takes place in a present or near future which is sufficiently recognisable as to be easily plausible. If not apocalyptic, it is certainly dystopian, engaging with matters of consciousness and conscience and the relationship between humans and machines. The protagonist of *Notes from a Coma*, JJ O'Malley, is 'New Irish' in several key ways. Eastern European by birth and politically and technologically open-minded, the novel charts the events which lead to him becoming a conduit for Ireland's orchestration of an EU-wide penal experiment. JJ's tragic flaw is his excessive (dare one say, pseudo-artificial) intelligence. Too much for his time and place, his 'problem' is identified as his ability to see 'signs everywhere' and a tendency to make 'too many connections' (McCormack, 2006, p.46). The death of his best friend, his more earthly double, highlights his exceptional intelligence coupled with somewhat limited interpersonal sensitivity. Classified in the novel as 'mindrot', JJ's overthinking leads to a perception that 'his own mind was eating itself up' (p.51). Like the hacks which eat up Joshua's code line by line in *Let the Great World Spin*, JJ's memories and ideas are vulnerable to attack. McCormack's novel is also stylistically important since it takes

on elements of the hypertext, split between the narratives of the full page and the extensive footnotes which often run on for several pages. Chapters are divided by different character perspectives, directing their recollections to an undisclosed narratee, a technique which similarly recreates the structure of online reading, clicking and browsing between windows. Far from being stereotypically futuristic, *Notes from a Coma* engages with the semi-possible in a recognisable present-future, since McCormack's approach demonstrates that the plausibility of an imagined scenario increases the impact of its imagined consequences. The plot is structured around the coma of the title; JJ, an innocent man, volunteers to be placed in a coma alongside representative prisoners from across Europe. It is to be an experiment of suspended-animation sentencing:

> in a county with the lowest crime figures in the country and the country itself with the lowest crime figures in the entire EU – this was the paradox which had to be sold to the electorate, the Irish people.
>
> (p.61)

Throughout the novel, the present and the future merge, as malevolent technologies of science fiction are shown alongside the everyday when observers of the experimental prison ship are encouraged to 'read a more detailed account of the whole thing on the official website' (p.109). Indeed, it is through mainstream platforms on the internet that the Irish people take ownership of this 'public experiment', precisely because they are able to access private information.

The Somnos project on which the novel hinges, plays up to several contemporary anxieties about the cult of celebrity and the iniquity of technology. As a consequence of his involvement in the research, JJ's body is translated into a commercial object via the projection of his image onto large screens at music festivals, the trace of his ECG on t-shirts and the 'looped précis of JJ's ditonal heartbeat' becoming the most 'downloaded ring tone for mobile phone users' (p.196). Familiar online services add to the mania as JJ's hair clippings become a modern-day relic:

> Listed on ebay.co.uk on the seventeenth of July this item drew a steady stream of bids to its online auction. Ten minutes before the close of its seven-day listing a bid of €1,000 secured the trophy.
>
> (p.175)

Yet it is really the 'voice' of the footnotes, the notes within the notes, which captures the multi-layered reading so characteristic of online texts. The notes offer supplementary information, glossing and expansion, and are provided alongside the main narrative, just as another window might be opened on an internet browser to define an unusual word or to follow up a digression. The similarity extends, since the footnotes, like the ubiquitous web search, are taken to be reliable and omniscient, even against better judgement. As with the results of a web search, the footnotes exude a comforting authority, discretely merging opinion with purported fact. They are also a subtext in the most literal sense, providing a subtle counter narrative against the chronology of the main plot. More than all of this, the notes mark out the limbo between our present fears of technology's potential and McCormack's premonition of what it might become. On the night of Owen's death, for example, after hours of drinking and deep conversation, death appears in the footnotes, transmitted into their real lives like a computer virus:

> He has fallen into step with the rest of the foot traffic through the broadband, those scholars still up burning the midnight oil: porn queens ranked by the star system; terrorists and arms dealers fencing the latest ordnance and intel; conspiracy theorists.
>
> (p.69)

The late-night internet users cast ominous shadows; 'mules', 'paedophiles', 'bedroom-floor traders' are all death's 'fellow pilgrims at this late hour' (p.70). The appearance of death 'through the broadband' underlines one of the first challenges for the burgeoning study of cyberculture within Irish studies – the need to define key terms and ideas. The very nature of 'cyberspace', for instance, the locale for so many interconnected ideas, has particular importance when considering online forms within a specifically Irish context. Bell provides a useful starting point by reminding us that cyberspace is fundamentally a 'metaphor for imaginary space' (2001, p.1). As the metaphor of choice within the media, academia and day-to-day conversation, the concept of cyberspace is testament to a shared understanding that the internet is ultimately a destination for the imagination. Yet as McCormack suggests, if the imagination can go to cyberspace, is it not also possible for cyberspace to infiltrate the imagination? The pace and scale of the growth of the internet far exceeds the estimations of the early programmers of Joshua's generation. As a result, cyberspace, a 'hitherto nonexistent space' has become a 'new digital domain' which continues

to play 'a greater role in more and more people's lives' (Wertheim, 2000, p.224). McCormack's image of the grim reaper, moving along the broadband cables into Irish homes, reinforces the construction of cyberspace as otherworldly. In an inversion of Wertheim's comparison with a medieval heaven, the technique is nonetheless a reinforcement of the internet opening up access to a space and time beyond the lived present. Most striking in McCormack's image is the implicit darkness of the internet; this is not just a site of death but also of danger and depravity. The internet emerges as forbidding in this construction because it is perpetually incomplete, even inevitably deformed by the type of people associated with it. Interestingly, it is the organic rather than the technological nature of the internet which seems to make it so repellent here as it grows unchecked. Studies of Irish literature and culture, by contrast, are drawn towards pseudoscientific concepts, engineering the field through precise invention, reinvention and transformation (Kiberd, 1995; Kirby et al., 2002; Gibbons, 1996). The concept of cyberspace, both imagined and programmed, builds on these terms by locating the unlocatable. As Bell puts it, 'cyberspace also exists in the imagination, in fiction, in the stories we tell ourselves about this world' (2007, p.2). Since stories are the means of invention and transformation, cyberspace might itself be considered as a manifestation of the human imagination rather than as a by-product of the internet. This idea similarly resonates with the core ideas of 'science fiction', a term bound up in the utopia of what it may be possible to achieve and the dystopia of what it might be impossible to avoid.

McCormack acknowledges elements of science fiction here, yet the plausibility of the novel depends upon its reliance on proven science and technology. So while ventilators and monitors keep JJ alive during his coma, the internet, through the live 'Web cast' and the streaming of his heart rate and brain waves, keeps him alive in the minds of the Irish people. As the notes confirm, the project's grasp on the public imagination is measured in the most reliable of ways at the moment ' "coma" overtook "sex" as the entry of choice in the nation's Web search engines' (p.152). While JJ takes part in the project to find some respite from the excess of information which is his own mind, others such as politician Kevin Barret TD, seek to gain from linking Ireland, through JJ's Irish body, to a technologically competitive Europe. Barret's plan to demonstrate 'We're not just a nation of mobile-phone salesmen or telesales spooks [...] we're out there now with a shiny piece of R & D of our own' (p.160) speaks to the larger priorities of newness in twenty-first-century Ireland. The Somnos project creates an opportunity to build status,

demonstrate competency and, above all, showcase faith in technology. Nevertheless, when JJ's medical history is posted on the official website, breaching the government's security systems, the whole idea of the web is inverted. In its unpredictability we are forced to think of the 'web' not as a series of interconnected wires, but rather a collection of holes loosely bound together, as Barret acknowledges: 'That is the difficulty of the Web, its openness and anonymity' (p.110).

Brave new world

These two novels reflect typical reactions to new technology: the utopian, utilitarian and apocalyptic (see Lohr, 1995). While the birth of the internet in McCann's *Let the Great World Spin* is shown as both utilitarian and utopian, McCormack's biosurveillance is charted towards an altogether more apocalyptic future in *Notes from a Coma*. In their exploration of 'new' technology, the novels contribute to the cultural circumstances identified by Buchanan in which 'newness is the actualization of the promise of globalization' conflating 'what a culture once thought was only possible with an immediately achievable reality' (2009, p.307). Indeed, when the previously 'only possible' becomes 'achievable reality' in these novels, all former limitations and established markers of stability are deconstructed. Both McCann and McCormack use computer technology as a byword for disorientating change; since all this is possible, they suggest, perhaps anything is. Albeit it in very different ways, these two authors react to what Foster describes as a 'bewildering' rate of change in Ireland, during which the 'shock of the new could only be all the more radical' (2008, p.3) when seen in contrast to the preceding decades. *Notes from a Coma* builds on this by presenting an Ireland only just over the horizon. If the present is already so radically different from the recent past, McCormack implies, the near future will surely be impenetrable. Submerged in a footnote towards the end of the novel, McCormack includes a dystopian techno-fantasy in which domestic appliances stage a revolution. Rather than remain the subjects of human domination, the 'vigilant machines' demand universal suffrage, 'the Internet, gathering in all it constituencies under one banner and making a case for full statehood before the UN General Assembly' (p.138). One of the common anxieties about the internet is that it is already too widespread to be easily dominated by any single government. Indeed, as Barlow has argued, since the internet is, by definition, borderless and unregulatable, it calls into question the very idea of a nation state (Spiller, 2002, p.272). Yet for all the

generalised concerns that we are building an internet we can no longer control, few go so far as to worry that it might one day learn to control itself. McCormack's vision of self-determining machines is far from new, but his explanation that 'in the dead of night [...] the human [is] flowing from us into these machines' (2006, p.138) is particularly sinister. McCormack's insurgent machines, his 'Robo Sapiens' (p.138), are unsettling because they step outside of their designated roles. The paradox is clear, while these machines, 'petitioning for various constitutional amendments' (p.138), are implicitly designated as going too far, technology is, in effect, defined by the act of challenging and exceeding previous limitations.

McCann's second group of programmers in *Let the Great World Spin* returns to the question of innovation and risk. Similarly comprised of precocious young men, the oldest, not yet 30 ('Grandpa'), has, like Joshua, been to Vietnam, but has survived to continue working on the precursor of the internet as a civilian. This section of the novel is narrated by 'the Kid', a technical genius mitching from school to spend time at the institute until he becomes 'the best hacker they got' (p.176). There is something undeniably machine-like about these young men; working antisocial hours, sleeping under their desks, they echo in both their lifestyle and commitment to technology Joshua and his comrades in Vietnam. As the novel implies, this is the life he might have led, the friends he might have had. Shifting into the narrative perspective of 'the Kid', McCann's novel crosses over with the genre of 'techno-thrillers', providing detailed and apparently realistic accounts of machines and their uses, including 'blue-boxing through the computer' (p.177) to access telephones around the world. An elaborate form of prank phone call, 'blue-boxing' allows the young men to test their limits (and push their luck) in a show of bravado. Yet for all the fun, all of this is really a step in a much bigger ambition; that is, bringing humans and machines closer together.

Having seen the news about the funambulist on the ARPANET message board, the hackers get through to a public phone in New York. José, the unsuspecting interlocutor, is unable to believe that he is 'talking to a computer' (p.180), creating a scenario of multiple unknowns. The hackers try to verify the wire-walker, the phone conversation is derailed by the mysteries of the new technology and for all their bravado, the ARPANET is superseded by human verification; they need to hear it from a human voice. But if the machines are inadequately human at this moment, McCann's novel takes on the ultimate feared (or anticipated) future in which humans become more like their machines:

One of these centuries we're all going to have ARPANET in our heads, he says. There'll be a little computer chip in our minds. They'll embed it at the base of our skulls and we'll be able to send each other messages on the electronic board, just by thinking.

(p.187)

This ultimate merging of human and computer, incorporating the internet within the body, is as much a fantasy of the early twenty-first century as it was for those 40 years previously. McCann's positioning of this idea within the context of his novel is, therefore, also a contribution to the historiography of how we have thought and continue to think about computers and the relationships we form with them. In 1973, a year before the novel is set, Arthur W. Burks, mathematician and contributor to the earliest digital computer, proposed a philosophical treatise comparing a computer with a human:

Imagine television cameras for eyes, microphones for ears, and sensory devices for odors, tastes, temperatures, etc. As motor outputs, the machine has mechanical arms whose hands and fingers can manipulate objects, and it has wheels and motors for locomotion.

(1973, p.39)

Burks' proposition was radical, a computer capable of movement, sensitive to the environment and yet, to our twenty-first-century eyes, it already seems amateurish. The Frankenstein creation of patched-together analogue technologies fails to impress, not least because several of these functions are already within the capacity of a standard smartphone. Nevertheless, Burks' humanoid computer is vitally important because of its capacity to emphasise the gap between the original impact of his vision and how it now appears several decades later. This said, some of Burks' arguments (or at least the anticipated objections) remain prescient, including the complex arena in which physical impulses and emotional desires coalesce. In 1973, Burks did not and could not imagine that people would, if not love, then certainly fetishise their gadgets when he asks:

How could a machine interact with a human in a loving way? The human just wouldn't respond. Who could love a bunch of hardware?

(1973, p.43)

There is no criticism here for the failure to predict the future, simply an acknowledgement of the rate, as well as the state of change within the time period covered in *Let the Great World Spin*. McCann's reimagined anthem, 'My country, 'tis of thee, we've got technology' (p.83) encapsulates this paradigm shift. Joshua's combat takes place at a computer screen, not on a battlefield, a scenario made possible through reliance on a machine. His life is lost, in contradiction to Burks, precisely because he could, in fact, 'love a bunch of hardware'.

Only connect

It is indeed a type of love which allows Joshua to imagine an exchange of life force between the programmer and his computer, as he declares that 'just being at a computer made him so giddy that he felt he was sliding down the bannisters' (p.87). His relationship with the machine is distinctly generative as he punches 'the buttons alive' seeing the 'crisp cursor flicking in front of his eyes' (p.87). If Joshua brings the computer to life, the opposite is also true, since he only truly feels alive when connected to it. More than this, as he confesses to his mother Claire, his ultimate wish is for the machine 'to speak back [...] It almost has to be human' (p.89). This symbiosis between computer and programmer is an extension of the physical space in which the work takes place. Oppressively hot and uncomfortable, the room is nonetheless fetishised by the hackers so that they seem to become living components within a giant computer, functioning among 'The web of wires. The whirl of switches. The purr of fans' (p.87). The use of insider language is similarly revealing about the programmers' relationship with their computers, which is presented not so much as technical mastery but as a kind of code whispering. Described as knowing 'the inner mysteries of each and every computer' (p.88), the men engage with their computers as if they are ancient artefacts from O'Toole's list of 100 objects. The sense of physical connection, even interdependence, is taken to a further extreme as the programmers sleep under their desks 'too tired to dream' (p.88) but always within touching distance of their computers.

There is in all of this a kind of cyber romance, the hacker so absorbed in his task that 'the world grows small and still' (p.188) until all other distractions are obscured. At the same time, of course, such absorption in the computer is discouraged, even distasteful. The adoration the programmer feels for his computer is at worst perverse to the lay reader, at

best, as boring as Castells could hope for. Repetitious programming tasks certainly seem monotonous to those not as 'giddy' about computers as the recruits, who 'divided, linked, nested, chained, deleted. Rerouted switched. Cracked passwords. Changed memory boards' (p.87). Unappealing to outsiders, Joshua and his colleagues still think of this work as 'a sort of black magic' (p.87). Indeed, their fidelity to computers is arguably delusional, contradicting some of the earliest theories including the well-known 'Lovelace Objection'. In 1842, Lady Ava Lovelace posited that the 'analytical engine has no pretensions whatever to originate anything. It can do whatever we know how to order it to perform', or simply, as Sherry Turkle updates, 'computers only do what you tell them to do, nothing more, nothing less' (1996, p.134). This foundational idea returns us to the concept of a computer and its component parts as objects onto which humans project their own narratives. The Lovelace Objection defines the relationship between humans and computers by undermining the threat or potential for machines to act independently. Although this nineteenth-century theory has been challenged by more recent technologies, with suggestions that machines could, in fact, be unpredictable, even spontaneous, the conceptual power dynamic remains instructive. As if maintaining nineteenth-century propriety between the human and the computer, the Lovelace Objection is equally a reminder that, unlike computers, people do not always follow rules. Lovelace's distinction between the 'order' provided by the human and the response or performance of the machine is also still pertinent in these literary examples. When, in *Notes from a Coma*, machines remove the inconveniences of JJ's body and conscious mind, the paradox remains that people are still needed to keep those machines running:

> They drift in from the wings, rotating through six-hour shifts, the supporting cast of neuro ICU nurses. Moving in the hyphenated time-lapse motion of the Web cast there is something of the crisis apparition about them.
>
> (p.37)

These ghostly nurses, barely manifest in physical form at all, are still necessary, in Lovelace's terms, to give the orders. The relationship between human and computer then is not so much a matter of romance as dictatorship. By contrast, the dynamic is nuanced in McCann's novel, constructing programmers as 'the artisans of the future' (p.89).

It is a crucial phrase, not only reinforcing the role of programmer as building the tools and artefacts of the future in the way blacksmiths and carpenters of previous centuries had, but also portraying them as actually crafting the future itself.

Nonetheless, the point remains that however new and exciting the work is for the hackers in *Let the Great World Spin*, it still strikes twenty-first-century readers as such an unlikely source of literary inspiration that, even when so clearly presented, it is easily overlooked. As discussed above, the technology of networked computers and online message boards is now so regularly used as to have already become mundane. That said, the historical context from which these processes emerged or the cultural frameworks in which they are now explored remain somehow avant-garde. If Castell's newness is boring, this new literary subgenre is best understood through its euphemistic antonym 'interesting'. As Epstein explains, describing something as interesting provides 'a convenient way to say something positive and pleasant about a work without giving it any substantial consideration' (Epstein & Klyukanov, 2009, p.77). The fact that explorations of cyberculture have been produced by Irish writers is indeed 'interesting' in this sense, but there is surely more to be said than that. By taking the time to give these texts more 'substantial consideration', a remarkable intersection between the digital and the literary is revealed. Among all the narrative complexity of *Let the Great World Spin*, McCann takes the technical language of 'protocols and bulk erasers and teletype printouts and memory and RAM' (p.88) and translates it into poetry.

Codebreakers

In the very simplest terms, Joshua's potentially inexplicable obsession with computers is made vibrant and meaningful because it is translated into a recognisable literary form. Presenting him as a man who talks about 'circuit boards like some people described icicles' (p.88), for example, places the technical alongside the natural in an unexpectedly powerful way. Of course, this should be anything but unexpected, since literature was an established portal to the imagination long before the computer was. As Wertheim puts it, in presenting reading as an equivalent route to 'cyberspace', 'Operating purely on the power of words, books project us into utterly absorbing alternative realities' (Wertheim, 2000, p.49). McCann's *Let the Great World Spin* follows this, offering Joshua's passion for programming as an elegy in praise of computer technology. Its setting, before our own moment in which technology

is ubiquitous, redraws cyberculture as anything but boring. Instead, the early computer chip, precursor of the Intel microprocessor, is for Joshua:

> about the deepest sort of beauty, the product of the human mind being stamped onto a piece of silicon that you might one day cart around in your briefcase. A poem in a rock.

<div align="right">(p.88)</div>

This image, perhaps the most significant to have emerged so far in Irish writing on cyberculture, is so striking because it makes such an obvious point: computers are powered by language. McCann is not the first Irish writer to have made this connection however. At least as momentous, Eavan Boland's poem 'Code' (2001) is an ode to Grace Murray Hopper, an indomitable computer scientist and muse for the Irish poet. Boland addresses Hopper, 'Poet to poet' (l.1), drawing out the connection between their comparable positions at 'the edge of language' (l.2). Geographically and temporally separated from Hopper, Boland envisages an alternate creation, an 'eighth day' on which the pioneering compiler controls and creates time with her instructions *'when yet now never* and *once'* (l.7). In Boland's poem, the creation of code is also a decoding of the physical world, a translation from the real to the virtual. 'Code', like the early ARPANET, is a network between two points; the suburban Dublin of the poet's home and the 'grey workstation' of the programmer's lab are the nodes on a small network across time and space, but also in terms of language, the world and 'Its words' (l.24). Both in content and in form, Boland expresses the revealing overlaps between the language of poetry and of coding. In its theme, 'Code' foreshadows the growing trend for curating Irish poetry online. Ireland's presidency of the EU in 2013, for example, saw the initiation of the Poetry Project, disseminating Irish poetry and art into email inboxes around the world each week (Poetry, 2013). Just as Boland's poem challenges the predictable subjects of an ode, projects like this have opened up the audience for Irish poetry in ways not previously imaginable. Where 'Code' is most remarkable, however, is in the parallel drawn between the actual work of the poet and the programmer. Rejecting romantic notions of ethereal inspiration or mechanical assembly which respectively limit each type of writer, Boland compares the time and effort they both commit to their work in order to become successful. So while Hopper's work is plainly admired by Boland, it is also recognised as inevitably boring. Any task which requires such absorption, the poem implies, whether programming or poetry, is also an alienation

from the real world. There is, Boland suggests, a necessary boredom, as well as pleasure, in the parallel circumstances of the poet 'writing at a screen as blue/as any hill' (ll.50–51) and the programmer working through the night until dawn. This kind of existential boredom, a poetic resignation to the work of creation, is captured by Boruch, who explains that 'Boredom isn't monotony, isn't depression' but rather a 'sweet stinging strangeness in the middle' (2013, p.118).

For all of the technological innovation embedded in these texts, the narratives propose a surrender to a particular type of boredom. The repetition of tasks for McCann's hackers, the literal unconsciousness of McCormack's coma patients and the scholarly isolation of Boland's poets and programmers all grow out of silence and isolation. In 'Code', both 'writers' are shown to be at risk of missing out on the 'Creation' that surrounds them due to the sheer amount of time spent on their own creations. Indeed, it is perhaps only in acknowledging their shared project, the poem implies, that they might remain connected to the real world: 'Let there be language/even if we use it differently' (ll.31–32). This analogy between two different forms of writing is also an act of deference, as Boland acknowledges the lessons in language to be learnt from coding by poetry, regretting how 'I never made it timeless as you have' (l.33). Boland's 'Code' is a lucid example of the impact of cyberculture in Irish writing. Along with the history of the internet as explored in McCann's *Let the Great World Spin*, and its imagined (or threatened) future by way of McCormack's *Notes from a Coma*, this chapter has set the foundations for intersections between cyberculture and Irish literature examined throughout this book. As all of these initial examples have demonstrated, engagements with cyberculture are global by their very nature. Major interactions with America in particular, as well as the European Union and Vietnam, as outlined in these texts, ensure that the concept of 'Ourselves Online' as uniquely Irish becomes necessarily a contradiction in terms. In these texts, cyberspace is, by definition, the absence of a fixed physical *place*. To be sure, media concern that the internet is a lawless wasteland of child pornography and banking fraud reflects this anxiety with concerns that nations themselves have become obsolete. John Perry Barlow, declaring independence for cyberspace, makes this idea explicit when he insists: 'Your legal concepts of property, expression, identity, movement, and context do not apply to us. They are based on matter. There is no matter here' (Spiller, 2002, p.272). At the end of *Let the Great World Spin*, the narrative moves forward in time and spins back to its starting point: Ireland. Ciaran is now 'the CEO of an internet company in the high glass towers along the Liffey'

with an office in Dublin and another in Silicon Valley (p.341). Evidently upwardly mobile, the Irishman has profited, at least materially, from the global adoption of cyberculture, but he is also caught between his past and present, the *'when yet now never* and *once'* (Boland, 2001, p.7) of the narrative. His life story stands as a testament to the plurality of links and networks, human and otherwise, on which the novel stands. Indeed, throughout the texts discussed here, cyberculture is definitively flexible, used to shape character traits, critique societies and symbolise art forms and ideas. In combination, these approaches highlight the opportunities posed for writers and readers by the inconceivable scale of the internet down to the minute detail of the microprocessor.

2
Lost in Cyberspace

> Here, in Joyce's imagination was born in May 1866 Leopold
> Bloom
>
> Plaque, 52 Upper Clanbrassil Street, Dublin

As every tourist and undergraduate knows, should Dublin ever be razed to the ground, James Joyce's novel *Ulysses* can be called upon as a blueprint from which to rebuild the city. In reality, of course, Joyce's boast that his novel might ever serve such a practical function simply draws closer attention to the fact that his is 'a city made of words' (Eagleton, 2012, p.30). Whether built brick-by-brick or word-by-word, the Dublin of *Ulysses* is understood by readers to be both a substantive and an imagined place or, as Derek Attridge puts it, 'neither wholly identifiable with nor wholly distinguishable from the real city' (2004, p.24). Such characteristic Joycean ficto-geography is conveyed on a plaque at 52 Upper Clanbrassil Street, locating Leopold Bloom's birth 'in Joyce's imagination' as well as in this Dublin building. While this and other shrines to the novel annotate Dublin's buildings and pavements, Joyce's cityscape is inevitably being replaced and renewed over time. So, where once the city shaped the text, the text now haunts the city, as visitors adapt to reading locations increasingly unfamiliar from those found in the pages of *Ulysses*. Contemporary visitors to the city, whether or not they are readers of Joyce's novel, are offered this simulacrum as a way to navigate the physical spaces, allowing real people to retrace the steps of fictional characters. In the digital age, smartphone technology has joined the cause, chaperoning the ersatz reader of *Ulysses* with content-rich apps such as *JoyceWays*, providing guided walks, expert commentary and photographic images of Dublin in 1904, helping those who wander to find their way.

Created by Joseph Nugent and his team at Boston College, the *JoyceWays* app has been designed for virtual visitors, as well as for those who would actually be 'led across Dublin's streets' via the app's use of global positioning system (GPS) technology. The availability of GPS on smartphones, via navigation and map applications, has contributed to one of the central paradoxes of the twenty-first century; the same devices which prevent us from getting lost also invite us to drift through cyberspace, and in the era of wifi and mobile networks, this is all the more evident. The *JoyceWays* app uses GPS technology to guide users around the physical place of contemporary Dublin while overlaying it with images, readings and analysis, framed by the screen of the device. As such, the user's physical movement across the city of Dublin is at best a supplement to the on-screen material, at worst an irrelevance. In seeking to connect the app user with the text of *Ulysses,* the developers have, understandably, sought to replicate the routes taken by Stephen Dedalus and Leopold Bloom in the novel. At the same time, they recognise that these journeys only form part of the novel's dynamism; as the description of the app makes clear, you might use it just as well 'at home in your armchair'. In its very design, the app reminds us that although we now access cyberspace on the move as much as from the traditionally static position in front of a computer, we have retained the sense that a perspectival journey takes place online. This idea – that going online means on some level *moving* from the physical place we occupy in the real world to the conceptual space within and beyond the screen – is reinforced by the language we use to describe the process and the names for the tools we use. Microsoft's 'Internet Explorer' and Apple's 'Safari', for example, propose adventure in exotic online travels as well as foreshadowing the implicit risk of danger. Although written decades before even the earliest manifestations of the internet, *Ulysses* is seen by many as a form of precursive template for this kind of online multidirectional movement. As a narrative which presents characters traversing the city through physical space, as well as through the more complex routes of imagination, memory and thought, *Ulysses* undermines conventions of literary time and space. Since Joyce's novel is so obviously multilinear, a novel of wandering minds as much as of wandering feet, it has come to be seen in recent decades as having the qualities of a hypertext. The term 'hypertext', coined in the 1960s by Theodor H. Nelson, refers to nonsequential writing which provides choices to readers about how they progress. In the main, a hypertext is understood to be produced and read via some form of interactive screen, such as a computer, which allows readers to navigate between blocks of text via electronic links. This form

of narrative, in which the reader navigates through and between texts via hyperlinks rather than from start to finish, is familiar to all internet users. Anyone who has read an online news story and clicked on a link for more information or a related story has read a hypertext. While this has understandably been of great interest to scholars of computing, in the past few decades, literary theorists have contributed to debates with Joyce's *Ulysses* proving a central resource, seen by many as 'both the dream text and the ancestor' (Marino, 2008, p.475).

Joyceware

The appropriation of *Ulysses* (1922) as the 'dream text' of hypertextual literature or cyberliterature grows out of an argument of resemblance. In the first instance, the non-sequential nature of the text, the flux of progression and regression, the plurality of links and multiplicity of readings, all conform to general definitions of both *Ulysses* and hypertext. Although Joyce's text clearly precedes the kind of computer technology needed for on-screen hypertexts, it remains reasonable to suggest, as George Landow does, that Joyce's resistance to 'one or more of the characteristics of literature associated with print form, particularly linear narrative' (2006, p.219) positions it as comparable. The argument has significant implications for the way we read not only Joyce, but also modern and contemporary Irish literature more generally, since here too a similar tendency to read *Ulysses* as the 'ancestor' is prevalent. In this sense at least, *Ulysses* is a 'hyper text' in the most obvious way; a text operating beyond previous limits in its complexity and suitability for interpretation. In both senses, Landow's comparison is certainly tempting, if not thoroughly convincing to all critics. For Jacques Derrida, for instance, Joyce's innovation and resistance is insufficiently described by the notion of hypertext. Instead, he argues, *Ulysses* is not simply equivalent to the language of computers, but is far more powerful than the computers themselves. This too is an argument of comparison, similarly drawn from the grammar of cyberculture, in which each new version of the same machine is understood as more potent than the last. As Zena Meadowsong summarises, Derrida's evaluation of Joyce's writing classifies it as exceeding 'all existing and imaginable computers' in its complexity and efficiency (2010, p.55). For Derrida, there is no version 2.0, no new release possible which can outstrip the text's ability 'to compute you, control you, forbid you the slightest inaugural syllable because you can say nothing that is not programmed on this 1000th generation computer' (1984, p.147). All that has been achieved by computer technology and all that ever will be is, therefore,

'of a slowness incommensurable with the quasi-infinite speed of Joyce's cables' (Derrida, 1984, p.147). Joyce's text, in other words, is already more sophisticated and powerful than any computer we could ever design as a tool to understand it.

Derrida's argument is revealing in many ways. For all its eulogising of the Joycean text as superior to the meagre machines we call computers, it remains, nonetheless, a computer too. In this, Derrida maintains a reverence for the computer, establishing it as a metaphor for systems of language too advanced to be readily understood via the traditional methods by which we 'compute' text, in simple terms, by reading. Derrida is of course right to say that no computer has been or could be developed to 'read' *Ulysses* as we might understand that term, but this is not due to the want of processing power or speed, but rather to the implicit instability of meaning on which the text depends. When literary theorists use computers to assist them, it is not to pass over the work of interpretation to a machine, but to illuminate aspects for the purposes of our increased (though never complete) understanding. A crucial aspect of this, as Derrida suggests, is to think of texts and computers as intrinsically interconnected, if not analogous. It is vital in this to recall that a 'computer' has no more fixed meaning than a 'novel'. Depending on, among other things, the historical context, a computer may fit in the palm of one's hand or take up several large rooms. Again, contingent on the user's needs and the functionality of the computer, it may be primarily a tool for calculation, for communication or for entertainment. Simply, computers are designed according to our needs as much as they are limited by our capacity to make them. Novels too, it goes without saying, are shaped by the moment of their conception while also revealing new potential interpretations through subsequent readings. From the outset, *Ulysses* challenged readers to reconsider the potential and functionality of the novel, transforming what a novel could *do*. Nevertheless, Derrida's construction of *Ulysses* as an all-powerful computer is not simply a question of function but also of usability. In literature, the book is the object which creates an interface between the text and the reader. This now workaday technology, ink applied to paper, remains, even in digital form, the operating system on which Derrida's 'Joyceware' functions.

Too much information

Joyce's typographical experiments, in common with other modernist writers, revealed the potential as well as the perils of the printed word. In *Ulysses*, the insertion of headlines or the formatting of text

as a play, catechism or unpunctuated thought, for example, challenged expectations about what one might expect to *see* between the pages of a novel. While the experiments were (at least principally) the work of the writer, by necessity, the production of the published text required the collaborative expertise of both writer and printer in order to produce the object which might be distributed to the world as a '1000th-generation computer'. While the history of *Ulysses* coming to press often appears as much in spite of as thanks to the hard work of the printers, the book as object is a testament to both mind and machine. Yet, for those scholars who identify Joyce's writing as hypertextual, the printed text of *Ulysses* is understood to be incomplete, held back by the inherent limits of paper-based reading. As discussed above, hypertexts allow us to read *through* and *across* by challenging the chronological aspect of reading. In this way at least, the printed version of the novel corresponds to this idea since, as Jennifer Levine observes, 'reading *Ulysses* is often a case of moving backward through the pages (to check a detail, note an echo, revise an interpretation) as much as forward' (Attridge, 2004, p.131). To truly be a hypertext, however, these reading pathways must be facilitated by linking technologies; in short, by transferring words from the page to the screen. As Michael Groden, a leading scholar in Joycean hypertext studies acknowledges, this migration constructs an on-screen *Ulysses* which 'can never be the same as *Ulysses* in the pages of a book' (2004, p.121). As Groden continues, while hypertextual links facilitate multidirectional reading on a computer screen, they also remove 'all sense of the book's physical pages' including 'the bulk that makes the printed versions so distinctive and also so imposing' (p.121). On screen, the book as object is no longer tangible, disconnecting the reader from what we might think of as the sensuous elements of reading. Similarly, by negating the reader's ability to perceive the size and weight of a book, the on-screen version removes all of the signifiers which present the 'bulk' of *Ulysses* as serious, challenging and canonical. However, what is lost in the transmutation of the 'imposing' book, Groden suggests, is gained by placing the hypertext at readers' fingertips.

Computer-based hypertextual versions of *Ulysses* must navigate the paradox that they simultaneously open up access to the text at the same time as emphasising its complexity. As Liu has observed, while Derrida's concept of the Joycean text as an inexhaustible computer might be an inspiring idea, it is also a 'terrifying one', since it endlessly resists our efforts to decipher it (2006, p.521). Is the hypertext useful at all then in improving our understanding? In the first instance, since

hypertexts depend on linking not dissecting, they offer approaches to reading which counteract some of the reverence in which *Ulysses* can be held by moving away from expectations that the text is a puzzle to be solved. Furthermore, critics have proposed that the same multidirectional understanding of text could be fruitfully applied to writing about *Ulysses*, as much as to the text itself. George Landow explains this by considering the construction of a typical scholarly article. When a literary critic comes to write about *Ulysses*, they do so with the assumption that the text is privileged, yet in reality, the form of the academic article demands that they subordinate it through the practice of quotation and paraphrasing. In Landow's reimagining of this, in place of citation, the scholar would create 'an electronic link between one's own text and one or more sections of the Joycean text', and from there, further links within and beyond the text (2006, p.121). The concept is a reversal of traditional text-based scholarship. Rather than inserting extracts from *Ulysses* in order to write about it, the scholar would instead attach their 'commentary to a passage from Joyce', disrupting the traditional power structures and destroying 'all possibility of the bipartite hierarchy of footnotes and main text' (Landow, 2006, p.122). Landow's approach has clear ideological imperatives, shifting the dynamic in which the body of the text is read as central and the paratextual information as inferior. In printed forms, this is marked spatially by placing notes at the foot of the page or end of the article, and through scale, using smaller fonts for notes and further information. On the computer screen, by contrast, the limits of pages and spaces have been reimagined. If this could be used, as Landow proposes, to challenge the way scholars write about *Ulysses*, how might it impact on our reading of the novel itself?

Ulysses on screen

As we have already seen, the term 'hypertext' can be understood both as a metaphor for understanding Joyce's writing and as a technology for revealing it in a non-print context. In one sense, these reworkings of the text which make use of new technology are not radically different in purpose or functionality from footnotes or a concordance. Nevertheless, since they are more malleable and more capacious, they undoubtedly have the potential to change reading practices. From the 1990s, an international community of Joycean scholars moved beyond theoretical discussions to produce prototype hypertexts of the major works. Several notable projects emerged during this decade including Fritz Senn's 1991 *Hyperwake* at the Zurich Joyce Foundation, David Gold's

1996 proposals for *Ulysses* enhanced with hyperlinks to critical articles, Heyward Ehrlich's 'James Joyce Text Machine' and Donald F. Theall's e-texts among many others (Marino, 2008, p.477). Perhaps most significant among these was Michael Groden's 'Digital *Ulysses*' project, discussed in further detail below. This generation of scholars held a shared faith in digital media to illuminate Joyce's writings, maintaining a community 'on the pages of *Hypermedia Joyce Studies* and *Genetic Joyce Studies*, on listservs, such as the J-Joyce Internet List, and at conferences' (Marino, 2008, p.475). Their research was timely, linking a renewed interest in the Joycean text with a funding trend for exploring the capacity of computer technology within the humanities. While Derrida's 'Joyceware' established a language in which to reimagine texts such as *Ulysses* in the age of computers, Nunes' coining of 'JoyceMedia' opened up new ways to use it (Armand, 2004).

While these research projects were, undoubtedly, highly conceptual, they also took on the more practical questions of what a hypertext would look like. Even the most basic aspects needed consideration, as Marino points out, for example, the 'bottom of the screen doesn't mean the same thing spatially as the foot of a page' (2008, p.483). It was from within this context that hypermedia Joyceans explored the potential of pop-ups, split screens and changing font colours as approaches to visualise the unique nature of the text. While many revealed innovative and enabling techniques, there remained the fear that 'an onslaught of commentary' and 'a vortex of links' would obscure rather than reveal the potential of *Ulysses*, creating a subdiscipline in which scholars might 'cite, and annotate the text to death' (Marino, 2008, p.476). In the end, this period of innovation was brought to a halt by the more inevitable frustration – controversy over copyright. By 2004, Michael Groden was forced to indefinitely suspend work on his Digital *Ulysses* project after estate executor Stephen Joyce demanded $3 million for permission to reproduce key texts, making the research untenable (Armand, 2004, p.8). In his 2001 introduction to the forerunner '*Ulysses* in Hypermedia' project, Groden's enthusiasm for this work is tangible. His intention to utilise all available forms of new media to unravel the obscurities which plague new readers, while allowing experts to revel in the production of a never-ending concordance, is admirable, if potentially overambitious. Today, a static pea-green web page marks the 2004 cessation of the project, standing as an online memorial to its early demise. While the restrictions on Groden's work and what it might have become are regrettable, it by no means marked the end of hypermedia Joyceana. In the intervening years since the project's suspension, technological

developments and a lifting of copyright restrictions have allowed both scholarly and commercial interventions to follow in its wake.

Avant la lettre

Although the focus of this chapter is primarily *Ulysses* as hypertext, it is important to recognise that scholarship in the field has applied at least equal attention to Joyce's later work *Finnegan's Wake* (1939). For those interested in Ireland in the digital age, Joyce's literary experiment in which language seems to go beyond avant-garde into eerily clairvoyant is almost irresistible. Joyce's coining of 'iSpace' (2000, p.124), for instance, seems to contemporary readers to belong to twenty-first-century California rather than mid-twentieth century Ireland. These aspects of Joyce's writing supplement the image of the author as a 'modernist engineer of a cyberspace avant la lettre', in particular, via his production 'of outrageous signs and letter sequences' (Liu, 2006, p.517) which seem not only ahead of his time, but also of ours. Joyce's writing, as Liu points out, seems to engage with technologies not yet invented. Both *Ulysses* and *Finnegan's Wake* are not only adaptable to contemporary technologies then, but also somehow anticipate, even predict them.

Donald Theall usefully explains this concept by describing the 'pre-cyberfied Joyce' as a 'precursor of hypermedia' (2004, p.28). In this way, Joyce's writings are not simply raw material for hypertextual practitioners, they also provide templates for innovation, since the literary practice precedes the technology. In the simplest terms, this positions Joyce's writing as hypertextual before and after the term was coined, with or without the technology to facilitate it. George Landow has explained this by recounting a typical reading experience. In a standard text, a reader knows to pause at the symbol for a footnote in order to leave 'the main text to read that note, which can contain a citation of passages in *Ulysses* that supposedly support the argument in question' (1992, p.100). Of course, the footnote itself may yet be subject to further complexities. The note may provide caveats, parallels, exceptions or supporting evidence, all of which invite the reader to divert to yet another text, perhaps a dictionary or concordance. All of this takes place before we even begin to take on the implications of a text like *Ulysses*, the pages of which are barely imaginable without the stigmata of schemata in the notes and margins. In this way, *Ulysses* is not only hypertext but ubertext of cross references, codes and clues. This drift between texts, this multidimensional reading, defines

the experience of hypertext. The difference, as Landow makes clear, is that digital technologies provide solutions to 'instantly bring into view the material contained in a note or even the entire other text – here all of *Ulysses* – to which that note refers' with a simple click (1992, p.100). Whether this necessarily enhances reading is still to be established; certainly it makes the temptation to ignore footnotes altogether less excusable.

These arguments point to a congenital suitability for experimentation. Joyce's writing, in other words, so closely bound up with the literary experiments of the last century, seems destined to be irrevocably linked with the technological advances of this one. In reference to both *Ulysses* and *Finnegan's Wake*, Jay David Bolter goes so far as to argue that both are 'hypertexts that have been flattened out to fit on the printed page' (1991, p.24). This inversion of technological development is an echo of Derrida's high praise; *Ulysses* is a computer above all computers, a hypertext before hypertexts. But for this to be convincing rather than just convenient, it is useful to return to the core of cyberculture, at the very least by thinking of a hypertext as both a technological function and the work of the imagination. The idea that writing can be seen as hypertextual before and without the associated web technology to create it is a challenging one. When Landow argues that *Ulysses* is an 'implicit hypertext in non-electronic form' (1992, p.10), for example, he subverts our sense of how both technology and language evolve, claiming that Joyce's novels were hypertexts before the technology was developed to animate them, or the language to name them. They might, more reasonably, be thought of as hypertexts in the pre-cyberculture translation of that term, since they are more than, extreme, excessive, beyond the norm. But for these critics, it is not just that the texts are particularly well suited to hypertextual readings, but rather, as Bolter puts it, that they 'had been waiting for the computer to free them from print' (1991, p.132). For Bolter, the relationship is such that he is able to think of *Ulysses* as 'flattened' hypertext, seeing its other dimensions as merely limited by the technological capacities at the time of publication. In this interpretation, the notes and analyses which surround *Ulysses* can be read not as paratextual material but metadata, information in the most literal sense, which stands behind the text. As with any metadata, this material is required to add meaning, particularly for a novice reader to make the text readable, or if you will, possible to compute. As Groden describes, this is already the case with readers of *Ulysses* who adopt various approaches from 'reading the text right through to jumping around in the book (or simply skipping sections) to moving back and forth

between the text and secondary materials' (2001, p.360). It is unsurprising then that it was with this reading process in mind that Groden had hoped to update *Ulysses* from proto-hypertext to the real thing. Plans had extended beyond definitions and analyses to 'photographs, videos, maps, songs, an oral pronunciation guide, and audio readings' (Groden, 2001, p.360). In addition to these elements, presumably produced by experts, Groden envisaged the capacity for readers to add their own notes and bookmarks, making cross references back to various translations of *The Odyssey* and so on. As sceptics have understandably noted, such a fathomless project may well have furthered the cause of complexity rather than clarity. One of the key issues, and no doubt one of the reservations held by the infamously strict Joyce estate, was the handover of authorial power implied by all of these interventions. The content of scholarly annotations, not to mention the decisions about what to annotate and what not to, could spawn a theoretically endless supply of new material. Such projects, proposed and ongoing, contribute to the immeasurable growth of material available to twenty-first-century readers of *Ulysses*. How intriguing then that as Joyce's already enormous texts continue to grow and grow, the frames in which we read them only shrink. Already, you may hold more texts than it is possible to read in a lifetime in a device that sits in the palm of your hand.

Small but plentiful

Unlike the Lilliputian devices on which contemporary readers may access Joycean apps or hypertexts, the turn-of-the-century technology within *Ulysses* is conspicuously large. As with the book itself, power and size are correlated. Think, for example, of the monstrous printing presses at the newspaper offices, churning out Bloom's copy, over and over again. Yet for all the largeness (and largess) of the whole enterprise, *Ulysses* is equally a novel of minutiae, or as Eagleton describes it, 'a relentlessly trivial book' in which even the smallest details can be read as vitally significant (2012, p.29). These fluctuations in perspective and narrative point of view are characteristically modern, while echoing earlier literary experiments. It is, of course, the dual aspects of the epic narrative and the details of a single day which make *Ulysses* so implicitly hypertextual. Similarly, when Swift's Gulliver finds himself in Brobdingnag, his combined smallness and curiosity provide just such a warped perspective. Rendered a reluctant microscopist, Gulliver views things 'he would rather not see' (Armintor, 2007, p.622) while at the same time struggling to see beyond his own misconceptions.

There is a crude comparison to be drawn here with the numerous digital engagements with *Ulysses*; on the one hand, so vast as to become obscured, on the other, so detailed as to be rendered meaningless. The projects referred to above represent only a sample of the past and present schemes to enhance *Ulysses* for a digital platform. Whether designed to capture the materiality of the first edition, the transition from notebook to print or the hypertextual potential of digital platforms, they are all in some way engagements with the modernist project to shift perspectives and channel 'the new'. Throughout this book I will return to this question of 'newness' and the allied concepts of revision and evolution. For now, however, I want to focus on 'new' forms made manifest through an altered sense of size and scale. There seems, for instance, to be a direct correlation between the decreasing size of devices we use to access digital texts and the increase in their cultural currency. At the same time, as new media forms of writing become more prevalent, the texts get shorter and shorter.

Online as on the page, form and style are shaped by both implicit and explicit genre expectations. On the microblogging platform Twitter, for example, both the restriction of 140 characters and the capacity for real-time 'publication' result in the production of short self-conscious texts. The content of tweets is naturally varied by purpose; some are self-promoting outpourings, some politically minded reflections, some astute social commentary and so on. In tone, tweets range from amusing to vitriolic, in subject, from international breaking news to banal personal revelations. Yet for all of the implicit variety, users of Twitter are bound together by the presumption of both community and audience. A tool for advertisers, bullies and narcissists, Twitter also houses a virtual playground for word lovers. Through the paradigm of followers and the organisation of keywords and phrases via hashtags, Tweeters can share observations and opinions with a global group of co-conspirators. Both amateur and professional book critics, for instance, have adopted the platform as a means to share recommendations and reviews. Librarians, publishers, authors and readers can discuss books in a way previously unimaginable. One spin-off from this is the trend for tweeting canonical works of literature. Two University of Chicago students, Alexander Aciman and Emmett Rensin, were sufficiently dedicated to this task to secure a publishing deal with Penguin, using the subtitle 'The World's Greatest Books Retold Through Twitter' (Aciman & Rensin, 2009). The book is a novelty publication, capitalising on the juxtaposition of high literary culture and mainstream social media. As ever, the cover endorsements provide an insight to the book's contemporary

reception, albeit mediated by the publisher. While to some the project is juvenile and reductive (*The Wall Street Journal* review calls readers' attention to the sound of Shakespeare 'rolling over in his grave'), for others, the form refreshes classic works making them accessible to new audiences (*The Guardian* more generously describes the book as 'a tool to aid the digestion of great literature'). The *Twitterature* book and the ongoing trend on Twitter may appear insubstantial, but they nonetheless reflect a phenomenon in which contemporary users employ their 'machines' as well as their minds to engage with literary texts. The choice of texts is similarly revealing. No doubt with a good degree of self-awareness, Swift's *Gulliver's Travels* has been shrunken down to tweet size, as has Wilde's *The Picture of Dorian Gray*, with both *Twitterature* versions notable for their inevitable reduction of wit as well as size. Importantly, these micro-texts would not really provide any help to a novice reader. Rather, they are inside jokes, relying on a reader's knowledge of the full text in order to understand how it has been satirised. Indeed, it is exactly this need for prior knowledge which leaves some novels too large to fit into the magical shrinking machine. On the last page of the book, in the final lines of the acknowledgements, James Joyce is among those thanked for guiding the authors 'on the daring righteous path of enlightenment' (Aciman & Rensin, 2009, p.146). Not quite daring enough, it would appear, to take on the might of *Ulysses* in tweet form.

Twitterature

The sheer size of Joyce's *Ulysses* might have been a deterrent for the two authors of *Twitterature*, but it was no match for the collaborative effort of the web. In recent years, Twitter has emerged as a self-perpetuating reading group, allowing novice and experienced readers to play with language, share quotations and repurpose the text for the digital age via projects such as LiberateUlysses.com. On 16 June 2011, using #Bloomsday, 'Stephen' tweeted his intention for *Ulysses* to be 'cut up, condensed, and tweeted every few seconds for 24 hours straight' (@11ysses, 2011). For all its confidence, the language is brutal, proposing the dismemberment of the masterpiece and the mechanistic output of the finished product. It is also markedly collaborative; this is to be the work of many hands, tapping out the novel in shreds on smartphones, tablets and computers. At first glance, it might appear that this is not so much progress as returning the novel to the prepublication stage, creating notes out of a finished novel. Yet it is also,

of course, just another example of Bloomsday reflecting a particular context; from Sylvia Beach's *Ulysses* lunch in France in June 1929 to Patrick Kavanagh and Flann O'Brien drinking and reading their way around Dublin in 1954. In fact, the #Bloomsday instigators had thought about this carefully, explaining:

> This is not an attempt to tweet mindlessly the entire contents of *Ulysses*, word-for-word, 140 characters at a time. That would be dull and impossible. What is proposed here is a recasting or a reimagining of the reading experience of this novel, start to finish, within the confines of a day-long series of tweets from a global volunteer army of Joyce-sodden tweeps.
>
> (@11ysses, 2011)

This 'reimagining' of the 'reading experience' depends upon users' creative interpretation both of the text and the Twitter framework. In doing so, an important question is raised about authorial primacy. Simply put, if *Ulysses* is repurposed into snippets of 140 characters and shared in cyberspace, is it still Joyce's writing? The 'Joyce-sodden tweeps', clearly inspired by the novel, also feel a sense of entitlement, a right as well as an imperative to engage with the text in this manner. In this way, their supposedly 'new' approach to *Ulysses* seems rather more like a simple revision of modernist experiments with telecommunications. As Liu explains, early twentieth-century observations of technological development had combined fascination, confusion and parody, but most significantly 'fetishism for the printed word and typographical design' (2006, p.519). The numerous planned projects and spontaneous engagements with Joyce's *Ulysses* on Twitter take on the first of these, admiring as well as experimenting with the language of the novel. Nevertheless, the restrictions of the Twitter format, being primarily textual, necessarily limit expressions that would be possible in more aural and visual formats. For those contemporary readers who would rather use new technologies to read rather than rewrite *Ulysses*, there is, unsurprisingly, an app for that.

One such project is *Ulysses 'Seen'*, a graphic narrative reworking of Joyce's novel for the Apple iPad which hopes to foster understanding of classic texts 'by joining the visual aid of the graphic novel with the explicatory aid of the internet' (Berry et al., 2012). Those responsible for the project are clear about their 'hope to proliferate [...] not only preserve', by opening the novel up to a new generation of readers. In practical terms, *Ulysses 'Seen'* is widely accessible, available to download as any movie, music or game might be. In this sense at least, it has the

platform to move high modernism into the mainstream. By translating *Ulysses* into graphic novel form, the app illustrates and glosses, adding, for instance, episode titles and times of day which many new readers are frustrated at not finding in the printed text. The graphic form also offers several advantages for new readers, conveniently distinguishing the elements of narrative using the convention of speech and thought bubbles, for instance. It is also a project dependent on innumerable aesthetic and editorial decisions. As in any adaptation, experienced readers can be alienated when treasured characters are rendered differently from the products of their imagination. For new readers, the cartoonish images may, almost inevitably, act as a template onto which a first reading is projected (See Fig 2.1). Since the methodology of *Ulysses 'Seen'* is so evidently time-consuming, it remains, as yet, in the early stages and so cannot be judged for long-term impact. Nevertheless, it remains significant at the time of writing, in no small part for its role in signposting what born-digital engagements with Joyce's *Ulysses* may become. While *Ulysses 'Seen'* grows out of several literary traditions, including the novel, graphic narratives and serialised fiction, it is not by any conventional standards, a book.

Figure 2.1 'I: Telemachus' *Ulysses* 'Seen' for the iPad, artwork by Robert Berry on behalf of Throwaway Horse, LLC with BunsenTech, 47

A book by any other name

Twenty-first-century readers are increasingly familiar with the idea of the multi-format book, as evidenced by the fact that online sales of e-books now exceed those of printed ones (*Guardian*, 2012). While newly published books are typically issued in both digital and print formats, predigital texts are also being repurposed for compatible e-reader devices, with large corporations and libraries establishing monumental digital repositories. Whether born digital or subsequently digitised, these books are recognised as contributing to a new age of reading which many theorists feel unprepared for. Yet as Dorothee Birke and Birte Christ calmly put it, the advent of digital texts should not be viewed as an instant revolution, but rather as part of a long process 'that is in close dialogue with the printed book as the longterm cultural paradigm' (2013, p.66). In this way, we are reminded that a book is simply the hardware on which the operating system of the text is made visible and accessible, whether that be on the surface of vellum or on the screen of a Kindle. Birke and Christ's consoling reminder of the long process of textual evolution might even act as a prompt to reconsider our milestones in the history of the book. Perhaps the biggest shift in this, of which e-readers are just an extension, is the transformation of the book from a static to a portable technology. Being able to carry a book in one's pocket, or in the case of e-readers, thousands of books on one device, has dramatically transformed how and where we read. This expectation of the reader in transit has, according to Miall, also transferred to the reader of hypertext who 'must be active in moving about the screen, clicking links, making decisions' (2012, p.203). More symbolically, we might apply this idea of movement to our engagement with and responses to texts. As established above, we do not actually *go* anywhere when we 'go online', nor do we *move* when great literature moves us, rather, we see in these expressions a compulsion to embody texts in some way, to be relocated by reading.

At its most effective, we conceive of this relationship between reader and text through the concept of being 'lost in a book'. This form of concentrated and immersive reading can, albeit temporarily, cause the reader to dislocate from the time and place of their bodily reality, imaginatively resurfacing 'within' the book. From an early stage, readers of books learn to reroute any self-awareness of the act of reading to the content of the text itself. By contrast, readers of hypertexts, since they are expected to click, navigate and in some cases shape the narrative, rather than feeling liberated by the text's fluidity, can come to

'feel trapped within its machinery' (Miall, 2012, p.205). Similarly, while being 'lost in a book' is the highest of praise, becoming lost within a hypertext or in an online context has rather less comforting connotations. The next section of this chapter follows up on these ideas through a consideration of Enrique Vila-Matas' *Dublinesque* (2012), a novel in which the protagonist is equally lost in his imaginative wanderings through the pages of books as through the screen of his computer. Described accurately, if a little pompously, by Terry Eagleton as 'a postmodern meditation on a high modernist text' (2012, p.28), *Dublinesque* is informed by its protagonist's reading of *Ulysses* in print, as well as by the unmapped territory it has engendered online.

A funeral passes

Like the Larkin poem from which it takes its name, Vila-Matas' novel *Dublinesque* (2012) is an act of mourning. Originally published in Spanish in 2010, the novel is a meta-fictional homage in which *Ulysses* is reimagined as a postmodern fiction only possible in the age of the internet. The protagonist, Samuel Riba, described by Eagleton as 'Unhinged from the workaday world in the manner of Stephen Dedalus, yet given to free association in the style of Leopold Bloom' (2012, p.29) is addicted to the internet and inclined to read Joyce as a clairvoyant. In Riba, Vila-Matas presents a twenty-first-century reader, dedicated to books, yet unable to resist the siren call of Google. The novel is narrated through Riba's consciousness, a muddle of literary references, flashbacks, digressions and internet detritus, which, in turn, tempts readers of *Dublinesque* towards similarly compulsive Googling. Since the novel is built on multiple cross references, pastiche and name-dropping, which takes *Ulysses* – with all its attendant extra-textual material – as the major source, the internet offers either a welcome concordance or an endless series of wild goose chases to keep professors busy for a few more centuries. It is, in other words, a novel which encourages, perhaps even expects, reading beyond the limits of the book itself. At the very least, readers of *Dublinesque* might find a working knowledge of Joyce's *Ulysses* helpful in their navigations through the novel, particularly in recognising the motifs of movement and travel. This is not to suggest that *Dublinesque* is a retelling of *Ulysses*, but rather to point to the reimaginings which grow out of the contemporary period. Unlike the GPS-guided users of *JoyceWays*, Samuel Riba does not visit Dublin guided by his smartphone; instead, the city comes to him as a vision in a 'strange, striking dream' of 'a long walk through the streets of the Irish capital, a city he has never

been to, but which, in the dream, he knew perfectly well, as if he'd lived there in another life' (Vila-Matas, 2012, p.14). For Riba, a recovering alcoholic and recently retired publisher from Barcelona, the Irish capital becomes the imagined site of personal salvation and a symbol of his anxiety for the future of literary culture. Mapping a personal crisis onto a literary one, Riba fabricates an invitation to lecture in Dublin on Joyce's *Ulysses* and 'the Gutenberg constellation giving way to the digital age' (p.16), hyperlinking the dreamscape to his obsession with the World Wide Web.

After a lifetime professionally and personally absorbed by literature, Riba's retirement is characterised by his 'hypnotic journeys' online (p.7). As his wife complains, he has become 'too isolated [...] too disconnected from the real world and seduced by his computer' (p.8). This perceived intimacy between Riba and his computer, the seduction by cyberculture, is central to contemporary anxieties around new technology. In Vila-Matas' novel, Riba's body is fragile, involuntarily abstentious after an alcoholic breakdown and increasingly inert as he ages. It is in this state that his mind–body connection is replaced by mind–machine as he comes to spend 14 hours a day in front of the computer screen. Here, Riba views himself, sometimes with regret, but often with pride, as a 'hikikomori', the Japanese term for (typically young) people who suffer from extreme isolation and computer addiction (Tamaki, 2013). It is evident from the start of the novel that Riba has replaced one addiction for another and in doing so he demonstrates the destructive potential of computers. Slavoj Žižek's notion of computers as 'thinking machines' offers a useful insight into Riba's predicament. As Žižek explains, a computer is ultimately 'a fantasy screen on which is projected the field of miscellaneous social reactions' (2001, p.19). As a 'thinking machine' a computer thinks, at least apparently, on our behalf, but also facilitates our thinking. As a 'fantasy screen' it does not simply project what is 'inside' *it*, but reflects back that which is inside us. Riba's internet addiction is both a symptom of his isolation from society, but also a consequence of his lifelong dependence on literature which has led to a 'tendency to read life like a literary text' (p.32). This compulsive close reading (and here perhaps lies a warning for us all) mutates into an interminable search for patterns, coincidences and information, both in books and online. It is this rereading of *Ulysses* in light of personal coincidences and parallels that leads Riba to plan 'the funeral, ever delayed, of literature as an endangered art' (p.25) in parallel with his personal demise.

As Castells reminds us, the internet is often held responsible for 'enticing people to live their own fantasies online, escaping the real world'

(2001, p.116) or abandoning lived experience for the sanctuary of virtual reality. For literary scholars, it is always striking how similar these fears are to those which accompanied the rise of the novel. In both the eighteenth and nineteenth centuries, fears that fiction would overstimulate or unduly influence 'vulnerable' readers were prevalent. Whether marked as susceptible by gender, age, class or race, some readers, it was argued, simply lacked the moral and intellectual resources to perceive the limits between fiction and reality. While these particular modes of literary gatekeeping now seem archaic, we retain the idea that the imagination is under threat from virtual realities which are simply *too* realistic. Although these concerns are often attributed to videogames and film in the contemporary era, fiction too remains a subversive technology of escapism. That Riba identifies Dublin as the sacred space in which to mark the end of the Gutenberg era and the birth of the digital age is significant in a number of ways. In the first instance, Riba considers Joyce to be a literary prophet, having taken the printed word to its apotheosis. Yet, it is equally relevant that the genesis of the digital age is marked in his shadow. It is in this context then, that Riba commits himself to the computer to plan 'an Irish wake for the end of a Gutenberg era obliterated by Google's avatars' (Corral, 2012, p.70).

O'Donnell Bridge?

Increasingly reliant on *Ulysses* as a framework for the trip and his life, the first part of *Dublinesque*, 'May', presents Riba as the anti-Bloom, virtually housebound, cultivating multiple Dublins out of prophetic dreams, Joycean readings and neurotic Googling. For his wife Celia, this personal collapse can be read as symptomatic of a wider crisis as she warns Riba that his fixation with search engines will cause him to 'lose the ability to read literary works with any kind of depth' (p.39). Acting on this warning, Riba tries to break away from the control of his computer, symbolically moving between Windows and *the window* to look out at the rain-sodden cityscape of Barcelona in a 'modest, fleeting liberation from the digital world' (p.41). As his thoughts return to Dublin, and with that *Dubliners*, Riba tries to recall the name of the bridge crossed in Joyce's short story 'The Dead' and is forced to make the decision about where to find the answer. He sees in this choice between book and computer a tension between 'remaining, heroically, in the Gutenberg age – or else surfing the net and entering the digital world' (p.46). It is a dilemma framed in movement, a decision to visit the past or the future. Valiantly turning to his bookshelf, he reads the following: 'As the cab drove across O'Connell Bridge Miss O'Callaghan said: "They say you never

cross O'Donnell Bridge without seeing a white horse" ' (p.46). With this misplaced letter, Riba is failed by the printed word and reflects:

> It's either O'Connell, or O'Donnell. Anyone who knows Dublin would surely resolve this in a fraction of a second [...] In terms of finding the name of the bridge, the digital world is more use to him than the print one. He has no choice but to turn to Google.
>
> (p.47)

The error, poor transcription or typesetting, is itself, of course, a Joycean joke. Just as the, inadvertently amusing, substitution of Daniel O'Connell with Daniel *O'Donnell* provides echoes of Joyce's commitment to both high and low culture. Nevertheless, Riba is only finally reassured by checking another print edition of *Dubliners*, feeling himself 'condemned to go from Gutenberg to Google, from Google to Gutenberg, moving back and forth between the two, between the world of books and that of the web' (p.47). Such movements are physically small, hands and eyes flicking between pages of a book and pages on a screen, all within the study of his apartment. Nevertheless, in both acts, Riba thinks of himself travelling across time and space in his efforts to understand Dublin as both fictional and physical. It is only once these virtual Dublins are aligned, therefore, that he is able to begin his own odyssey.

Gutenberg and beyond

While the ostensible purpose of Riba's trip to Dublin is the funeral for the Gutenberg age, it might be more accurate to think of it as marking a reincarnation; one form of technology supplanting another. Like the internet, the invention of moveable type is often described in hyperbolic terms as 'the clearest and most profound example of how a new medium altered human life forever' (Koch & Lockwood, 2010, p.100). The rhetoric is revealing, the new technology which facilitated a mass readership is praised above the human impulse to write and read narratives which instigated and sustained it. The same is repeated in our own age with enabling computers elevated above the insatiable human drive to narrate which inspired them. Certainly, both the computer and the printing press have 'altered human life forever' and, importantly, they have done so by supplanting their predecessor. Technological development is driven by the desire to provide an improved alternative, making the antecedent obsolete. This was as true for the production

and distribution of books as it is for software updates. This process of flux and upgrade is welcomed by many, leaving others resistant to the destabilising, if not frightening, pace of change. As Hubbard puts it:

> A brief trawl through the histories of new technologies – printing, steam power, gas lighting, electrification, the motor car, the telephone, television, computers – confirms that all innovations are greeted with some level of moral approbation and talk about the erosion of society.
>
> (2006, p.127)

Riba's apocalyptic vision of the future of literature is driven by this overriding sense that with technological advancement comes inevitable moral decay. Imagining the final shift of power from print to digital, Riba has a vision of the ultimate hypertext, 'a single universal book; an almost infinite flow of words' born of the internet (p.32). For all he fears this prospect, Riba is only able to conceive of its potential at all by reading an online article on the topic. In this, the former publisher's fanatical attachment to the internet highlights a central paradox of the digital age; the same computers which threaten literature are essential to its production, consumption and distribution. While these logistical matters implicate computers in the business of literature, it is at the level of artistic production where this becomes most revealing. In *Dublinesque,* for example, computers and the everyday technologies of word processing and search engines feature as both content and context. They are, in short, made into literary apparatus. As Ryan has it:

> Computers were once thought of as number-crunching machines; but for most of us it is their ability to create worlds and process words that have made them into a nearly indispensable part of life.
>
> (1999, p.1)

If Žižek's term, 'thinking machines', is too esoteric for common use, we might remember that we have described computers as 'writing machines' or word processors for generations. Similarly, the various handheld devices marketed specifically for the purpose of reading indicate an era which might be said to bolster rather than impede literary culture. Computers are, evidently, tools for creativity, allowing humans to explore and enact aspects of the imagination, just as books have always done. Indeed, it is this imaginative link which binds them, since, as Mark Poster points out, 'novels are just as much virtual realities

as computer generated immersive environments' (Nunes, 1999, p.44). *Dublinesque* makes this explicit with a protagonist equally immersed in both print and online virtual realities.

Bloomsday/Doomsday

The apparent shift from print to digital is often reduced to a question of authority or authenticity and it is here that the word 'virtual' becomes so crucial. Simultaneously, 'almost' and, not at all, the real thing, the connection with fiction is clear when we acknowledge, as Ryan puts it, that the suspension of disbelief is no more than 'the literary-theoretical equivalent of the VR concept of immersion' (1999, p.89). The idea of virtual reality and its shared ground with fiction is demonstrably important when dealing with a text such as *Dublinesque*. For the greater part of the novel, Riba's relationship with Ireland is purely virtual, 'travelling' there only in his mind via a book or a computer. In fiction, we conceive of this as the imagination; online, this is most typically referred to as going into cyberspace. Indeed, in Nunes' terms, millions of people now think of cyberspace existing 'as a *place*, as real as the work and play conducted in it' (1999, p.61). Certainly, many people conceive of their online experiences as no less real than those conducted away from the computer. Like the imaginative impact of fiction, cyberspace permits an interplay with fantasy, leading Ryan to describe it as 'foremost a catalyzer of dreams' (1999, p.83). For Riba, the journey to Dublin which begins as a dream is extended through reading books and browsing the web before finally becoming real. While this suggests a hierarchy, from the virtual to reality, Vila-Matas creates something far more fluid. Readers of *Dublinesque*, just like readers of *Ulysses*, must remain attuned to concurrent layers of cross reference, pastiche and homage. This mode of reading also finds an overlap in contemporary computer habits in which users navigate between multiple windows or tabs, demanding plurality of focus. While these multilinear narratives divert attention outwards, they also require the reader to closely observe the text itself via the trend for self-referentiality. In the 'June' section of the novel, for instance, we find Riba (fictional) channelling Bloom (fictional), lamenting the supposed death of literature (fiction), in the company of, and with reference to, other authors (fictionalised). More than that, these events take place in the shadow of *Ulysses*, which the characters variously parody, re-enact or refute, and all of this on that high holiday of fiction, Bloomsday.

In his review of *Dublinesque*, Terry Eagleton describes Bloomsday as an Irish commemoration of fiction: 'It is as if,' he writes, 'Britain were to

dedicate a feast day to Falstaff or to the Artful Dodger' (2012, p.27). By the time events in *Dublinesque* reach 16 June, Riba has come to openly identify with Bloom, surrounding himself with a group of contemporary avatars in a borrowed Chrysler in place of those who sat in Paddy Dignam's mourning coach. Resisting turning to drink with the relish he once applied, Riba abstains in the clear knowledge that he has already irrevocably damaged his inner organs. Since he is now physically in the city of Dublin, Riba's bodily awareness is magnified, further binding it to the internal structures of *Ulysses*. So, just as Joyce's mapping of organs onto the episodes of *Ulysses* echoes city planners and their anatomical analogies of arterial roads and heartlands, projecting the human onto the built environment, now metaphors of the city explain the web with highways, routes and 'home' pages. Since the 'cultural turn' of the 1990s, urban geographers have increasingly conceived of the city as a text. Accordingly, Riba now reads Dublin with his own eyes, but both *Ulysses* and Google provide the map. As Dublin has always been a fictional place for Riba, even when he is really there he remains lost in a virtual reality. Having witnessed him earlier in the novel in his own country and city, navigating Barcelona via the bakery, the bookshop and the bank, we understand the connection between his mind and the spaces he occupies. Barcelona is a city shaped by a geography of avoidance: the bars he can no longer go to, the office he no longer works at. Dublin is familiar as well as unknown, since it is, in this case quite literally, a dream location. Bloom, as the plaque notes, really only traversed Dublin 'in Joyce's imagination' so that those who follow in his footsteps on Bloomsday step into a version of this virtual reality. Bloomsday maps, whether followed on a smartphone or on the pages of a book, lead real people to recreate imagined routes. Within these novels, it is similarly the map which finally divides the protagonists. When Riba and his cohort engage in Bloomsday, they have a route to follow, a series of events to re-enact. On the contrary, when Stephen and Bloom set out from their respective homes that morning, the day is unknown and unmapped. Their wanderings and distractions find a contemporary echo online, as the web, by its nature, 'encourages users to navigate [the] space primarily by way of drift: "browsing" from link to link, rather than moving from destination to destination' (Nunes, 1999, p.70). At the same time, internet users, just like Bloom, are eventually expected to return home. As we know, while Bloom's return home marks the end of his physical journey for the day, it does not stop the momentum of his imagination. The same might be said of home pages, which as Nunes notes, 'function less as architectural homes than as points of

passage in a multiplicity' (1999, p.70). While *Ulysses* and *Dublinesque* intersect in numerous obvious ways, it is this convergence of the physical and imagined movement through a city which illuminates both. Joyce's text, written from multiple locations, reconstructs a city from the interrelated metadata of memory, imagination and research. This construction of a 'place' which is both real and virtual binds together the print and digital age, or, in Riba's terms, admiration for 'writers who each day begin a journey toward the unknown, and who nevertheless spend all their time sitting in a room' (p.35).

The knowledge engine

Riba's compulsion to hold a funeral for the end of the age of print necessarily suggests a context in which literature as we know it is already dead. That the wake takes place within such a self-consciously literary book and in the coterminous geography of Joyce's *Ulysses*, however, indicates quite the opposite. As with the shift from manuscript to print culture, the encroachment of the digital age on the printed text is incremental. The invention of the printing press, for instance, did not instantly usurp manuscript production, taking instead 'several hundred years of gradual change and accommodation' (Landow, 2006, p.50). At all of these junctures new technology has provoked a range of reactions, including, of course, ambivalence. Yet the presence of new technology is by its nature disruptive and provocative. As Meadowsong notes, the 'power and potential violence' of the printing-press machines in *Ulysses* with their noisy and aggressive production also hint at the malevolence of machines (2010, p.56). At the same time, they are necessary, not only in producing Bloom's advertising copy, but also in reminding us that '*Ulysses* itself is not just a written document (a human production) but a printed one (the product of a machine)' (Meadowsong, 2010, p.58). For some contemporary scholars, however, it is precisely this relationship between the writer and the analogue technology of print which leaves the text incomplete. Hypertextual theorists such as Landow, for example, have promoted the application of new technologies to texts such as *Ulysses* precisely because it 'opens them up' (2006, p.113). Landow's cybercultural incision hyperlinks us back in time to 1726 when Jonathan Swift had surgeon Gulliver stumble upon the Knowledge Engine, the use of which would allow

> the most ignorant Person, at a reasonable Charge, and with a little bodily Labour, [to] write books in Philosophy, Poetry, Politics, Law,

Mathematics, and Theology, without the least assistance from Genius or Study.

<div align="right">(2012, p.193)</div>

This complex machine made of 'wood' and 'wires' is seen by many as the earliest literary portrait of a computer, a machine which reorders words into new compositions. Yet for all its automation, the machine still needs a professor to set the 'engine at work', numerous pupils to turn the iron handles, 'six-and-thirty of the lads' to read aloud the output and a further 'four remaining boys' who act as 'scribes'. In short, without the input from humans, even Swift's early computer says no. As Swearingen has argued, Swift's capacity to contemplate the 'destiny of technological culture' only begins to be fully appreciated as his predictions are realised (1982, p.45). Gulliver's account of the 'The Academy of Lagado' is prescient because it so clearly observes that computers do not work without people, and the same is true of cyberculture in literature. Reading Joyce's *Ulysses* as a hypertext or analysing Vila-Matas' Riba and his fixation with Dublin and the internet, opens up the multiple ways in which cyberculture is emerging in Ireland-centric novels. While in practical terms computers are now necessarily used to write and to sell books, much as Swift imagined, the end point is still the human reader. The discussion in this chapter supports the case for a broad outlook when thinking about cyberculture and Irish literature. Texts which predate the digital age, texts about Ireland but not by Irish writers and so on, all contribute to a more complete overview. These texts also reframe the type of work that is to be done in this field and where it is likely to occur. At the very least, scholars of modernism, the history of technology, genetic criticism and comparative literature have much to offer these debates. The size of the opportunity (or the obstacle), as Gulliver knew all too well, rather depends on your perspective.

3
Discovering Ireland

> Whoever had resprayed the ambulance had missed the top rim of the doors [...] The top of the paramedic's hat was speckled with flecks of dandruff and when he lifted his head from my chest I could see my face staring up, crisscrossed with streaks of blood.
>
> (Bolger, 1995, p.1)

Dermot Bolger's novel, *A Second Life*, first published in the early 1990s and reissued in a 'renewed' version in 2010, opens with protagonist Sean Blake in an apparently fatal car accident. The perspectival shorthand of the soul looking down upon the body from an elevated unearthly position allows Sean to observe himself dying. Yet rather than marking the end of his life, the vantage point captures a moment of renewal, the inevitable reuniting of body and soul in order that an incomplete task may be faced. Following Sean's survival of the near-death experience, the second life of the title takes on multiple meanings. It is at once a life regained and an (after)life to come, as well as an awareness of alternate parallel lives that might have been. For Sean, a Dublin photographer and father of a young family, this involves unpicking the secrets of his adoption. As the novel progresses, discovering his birth mother's experience of unplanned pregnancy in the 1950s allows Sean to glimpse the alternate second life he might have otherwise led. While Sean's imagined second life provides a vital commentary on this important aspect of Irish social history, early twenty-first-century readers of the novel will be struck by the title's echoing of an altogether different example of doubling and duality. The infamous virtual world platform, *Second Life*, was launched in 2003, coming between the two versions of Bolger's novel. Just as the novel and the online world share a name, they also overlap

in their use of gravity-defying perspectives. Here too, people may soar above the world below, looking down upon the lives of others. Flying notwithstanding, it is important to remember that this online *Second Life* is not a computer 'game' in the way we typically understand it; there are no points to be won or levels to complete. Rather, it is a platform in which real people enact an alternate life (or indeed lives). Most famously, the platform allows people to choose the body they want, indeed, the gender or even the species, by creating an avatar. The experience can be compelling and, as Boon and Sinclair point out, there are some people for whom 'Second Life proves to be just that: a second life, an escape from the real world and all its messiness, its problems and limitations' (2009, p.107). Real-life divorces have cited *Second Life* affairs and real fortunes are made and lost through the exchange of virtual goods. It should hardly be surprising then that people also use their *Second Life* avatars to experiment with the already highly performative act of national identity.

There is, I think, more than just the coincidence of names linking these two expressions of a second life. Both the novel and the virtual word are characteristic of the early years of the new century from which they emerged, sharing anxieties over representation and identity politics. Both also raise questions about place and belonging and, as such, will help shape the discussion below around the themes of tourism, emigration and diaspora. My aim here is not to make crude comparisons between technologies and texts (*A Second Life* on the page vs *Second Life* on screen), but rather to see how intersections may come to shape some of these concepts which are so central to contemporary Irish studies. Take, for example, the perennial theme of emigration. In living memory, the ubiquity of affordable air travel and accessible communications technology has shifted our conception of global movement so that:

> The notion of the finality of the act of emigration has been replaced by a much more fluid reality of sojourners, circular migration, and transnational experiences and identities.
>
> (Mac Éinrí & O'Toole, 2012, p.10)

This fluidity, characterised by movement back and forth across a network of nodes and multiple 'homes', is a case in point. The vocabulary of online technology, the network, the web and virtual reality can all be put to work here, made useful in explaining contemporary situations as well as phenomena that precede them. Bolger's novel does not engage with cyberculture overtly (although computers are used to trace official

records). It is used here simply as a useful touchstone, capturing that symptom of the human condition, the spectre of another life one could, should or ought to be living.

Life, but not as we know it

Created by Linden Lab in 2003, *Second Life* is described by founder Philip Rosedale as 'a place where you can turn the pictures in your head into a kind of pixelated reality' (Rymaszewski et al., 2007, p.iv). From modest origins, by 2007 Rosedale could boast of 'close to a million registered users' (Rymaszewski et al., 2007, p.iv); by August 2008, it was over 12 million (Bell & Trueman, 2008, p.3). It was during this period of growth that *Second Life* attracted a great deal of academic and media attention, in part it may be assumed, as a response to the platform's apparent capacity to make science fiction a reality. Certainly, the flare of popular interest, which accompanied the emergence of *Second Life* into the mainstream, grew out of its clear potential to serve so many masters. It was at once put to work by entrepreneurs, selling real estate (which was, of course, not *real* at all) and designer clothes (to fit virtual bodies); in short, it became a marketplace for trading in new 'lives'. While the popular media exhibited a prurient interest in the potential to form relationships and have sex in *Second Life,* universities, galleries and museums constructed their own parallel universes, keen to cash in on the virtual gold rush. What was so intriguing about these responses, however, was not that they proposed something wholly unique, but that they were typically versions of places and experiences already available in the real world. The premise of *Second Life*, as Rosedale puts it, is 'an almost empty world' populated by the landscapes, objects and inhabitants the users choose to create (Rymaszewski et al., 2007, p.iv). As the marketing narrative emphasises, the limits are only those of the users' imaginations. It is precisely this aspect which makes *Second Life* so enthralling to dedicated users and somewhat sinister to observers looking down upon the virtual world from an imperious height. As Boon and Sinclair explain, *Second Life* is 'highly seductive' because of its capacity to offer people 'experiences that could never be had in the real world, removed from risk and consequences' (2009, p.109). Yet it is not simply that *Second Life* allows people to *do* new and fantastic things that is of interest here. More revealing, surely, is the opportunity to *be* someone else.

Within *Second Life*, each 'inhabitant' is represented on screen by an avatar, a three-dimensional digital persona, customised and

manipulated within the virtual world. As Taylor explains, avatars are the 'mediators between personal identity and social life', constructing the user's sense of online identity and shaping the way they are perceived by the wider community (2009, p.110). How an avatar looks and behaves, therefore, is central to 'producing a sense of presence' in Taylor's terms, just as 'corporeal bodies are integral to our personal and social lives' (p.117) in the real world. Adopting a human form is typical, although by no means necessary. There is no expectation that the avatar should be modelled on the user's physical body. At the very least, one might experiment with eye colour or fashion sense; the more dedicated construct bionic attachments or historically accurate virtual costumes. Template body shapes are highly gendered with narrow-waisted, large-bosomed women and broad-chested, square-jawed men prevalent, or as Tom Peters put it, avatars who appear 'genetically related to Barbie and Ken' (Bell & Trueman, 2008, p.3). Yet for all of these Western conventions of hyperreal physicality, many users praise *Second Life* for the opportunity it provides to present oneself outside of limiting gender binaries. Ultimately, whatever the form adopted, the *Second Life* avatar inhabits the virtual world in a very physical sense, wearing clothes, dancing, running and otherwise moving through space. At the same time, these virtual bodies transcend many of the limitations of the human body, as they are able to breathe underwater or walk through walls. No doubt, this capacity to sculpt an invincible avatar is a primary attraction for some users. The stylised figures can be shaped by pure fantasy or as a 'corrective' to perceived 'flaws' in real human features. This said, while an avatar can be as tall, muscular or beautiful as its user desires, it is never truly realistic; in the end, avatars look like the computer-generated people they are. For dedicated users, however, the bond is palpable. Even though an avatar may appear 'cartoonish', as Sharon Collingwood argues, 'the social exchange that takes place can have a deep psychological reality' (2012, p.278). Indeed, it may be just this fact which confirms *Second Life's* primary function as a catalyst for the imagination. Those fully immersed in an alternate life, building houses, careers and relationships, are clearly engaged in an advanced exercise of the imagination. While both Linden Lab and dedicated inhabitants are keen to point out that *Second Life* is not a game, there is clearly an aspect of play that is implicit. As with a children's game of 'make believe', all users inhabit the same shared world within expressed parameters, while ultimately investing in individual manifestations of their imaginations. The immersive experience on which this depends is also the source of concern for those disturbed by the idea that

any second life might become the life of preference. Although there are people committed to a virtual life in the ways described, the majority of *Second Life* users are just visitors, or one might argue, virtual tourists. People sign up for the experience of creating an avatar, intrigued to see the 'place', but only remain willing to make a limited investment of time. In other words, they enter *Second Life* not to emulate the day-to-day business of living, but for the virtual sabbatical it offers from their first life.

Wish you were here?

Second Life 'population' statistics are often taken as an indicator of its financial success or cultural significance. Yet as Meadows observes, 'the number of "residents" [does] not equal the number of people' (2008, p.108). While an individual can generate several avatars, the presentation of this data as a 'census' also obscures the number of dormant accounts or short-term 'visitors'. Although, as noted, there are some users who are able to generate a living or construct a social life through the platform, many more are there simply to witness the spectacle. A consequence, as with any real-life community, is a division between the high-profile 'SL movers and shakers' and the 'newbies' who come just to marvel at the complexity of the virtual environments (Rymaszewski et al., 2007, p.258). Typically early adopters, these established residents shape the culture of *Second Life* and its projected community image within and beyond the virtual world. By contrast, many more casual users register for *Second Life* accounts to attend an exhibition or complete a coursework assignment, never to log in again. The behaviours and experiences of these latter users are of particular interest here, as is the way established residents respond to them. While long-term residents are understandably resistant to purely voyeuristic new users, the dynamic of the virtual community is, by its nature, open to those who conduct themselves as interested visitors. The attitude is expressed via 'in-world' help structures and online support forums as well as print guidebooks such as *How to Do Everything with Second Life* (Mansfield, 2008) or *Designing Your Second Life* (Tapley, 2008). These guidebooks are built on the model of the interested visitor, taking the reader on 'a tour of the virtual world, just as if you were touring a location in the real world' (Rymaszewski et al., 2007, p.x). For the casual visitor then, *Second Life* provides a virtual outlet for the instincts to explore, converse and observe; all considered commonplace

in real-life tourism. For those not engaged in the hard work of construction or commerce, that is, it is easy to read *Second Life* as a vast virtual playground, or as Alison McMahan has it, a three-dimensional virtual theme park (Krzywinska & Atkins, 2007, p.159). Yet even if the multiple fantasy locations and inexhaustible leisure activities construct *Second Life* as the ideal virtual holiday location, can it really compete with that essential aspect of tourism – the desire for 'authenticity'? It is surely significant that even though the locations within *Second Life* are as limitless as the human imagination and technology will permit, many designers have turned to the real world for inspiration, with Ireland proving no exception.

A virtual Dublin, complete with the GPO, Trinity College and O'Connell Bridge, is the creation of John Mahon, known within *Second Life* via his avatar 'Ham Rambler'. As Mahon has explained in numerous media interviews, the inspiration for his project began with the concept of the Irish pub as an international symbol of community and conviviality. Beginning with his *Second Life* pub 'The Blarney Stone', Mahon went on to build a detailed replica of the city. Although consciously designed as a space for conversation and entertainment, visitors to this virtual Dublin are immediately made aware of a more sociohistorical function, with the opportunity, for example, to walk through the gates of Trinity College to look at the Book of Kells. Real care has also been taken with the landscape including key landmarks such as the Millennium Spire on O'Connell Street and the Ha'penny Bridge, as well as famous shops such as Brown Thomas. Nevertheless, the lack of cars, buses and trams, as well as the ghostly emptiness of the streets, distinguish the virtual Dublin in several obvious ways from the real city. These absences withstanding, the virtual city is 'praised by real Dubliners for its realism and accuracy' in promotional material and in their enthusiastic endorsements that 'it's just like being there!' (Dublin VL, 2009). Of course, it is not like being there at all. Being in the real Dublin rarely involves coming across an angel on Grafton Street or jumping into the air and flying over the Liffey, both of which are commonplace in *Second Life*. In fact, 'being there' is only made possible at all by being elsewhere; that is, in front of a computer screen. However realistic the experience, the virtual body of the avatar remains dependent upon the bodily functions of the real self who manipulates the mouse and keyboard. Such a willing division of physical body and imaginative experience is not, of course, peculiar to the digital age. Think of Yeats, with his feet fixed to London's 'pavements grey' while the avatar of his imagination is immersed in the soundscape

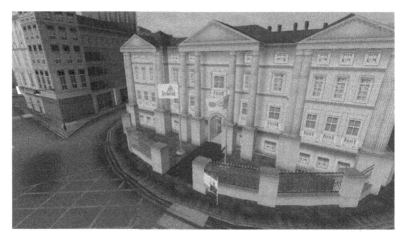

Figure 3.1 'Trinity College at Sunset', artwork by John Mahon on behalf of Dublin Virtually Live

of Innisfree. The novelty of *Second Life* is simply in the witnessing of *communal* flights of the imagination, each avatar standing in for a real person who is drawn to imagine himself or herself as 'other'. Indeed, as Meadows puts it, an avatar is simply a 'literary device', a protagonist within an interactive narrative (2008, p.13). Here too, the avatar (or the protagonist) is read against the backdrop of the mise en scène, since in *Second Life* it is 'not just your virtual body but also your sculpted virtual landscape which broadcasts your intended self' (Guest, 2007, p.21). *Dublin Virtually Live* might not be wholly realistic, but it is impressively recognisable. The potential for immersion is necessarily limited for now by the artificial clarity of shapes and colours produced by the software, steering it into the hyperreal. It is a portrait of Dublin overlain with the sort of fantasy cartoon Irishness and the dazzling colours of well-worn tourist images; in other words, it is a three-dimensional postcard (See Fig 3.1).

It is perhaps this echo which led to projects linking the real and the virtual tourist experience. Between October 2007 and March 2008, Tourism Ireland engaged in what their central marketing director described as 'a co-operative marketing endeavour' (Henry & Johnston, 2009). As Sam Johnston, the Leisure Tourism Manager who coordinated the project explained, 'the motivation was to try something different', with the specific aim of reaching a target market outside of Ireland 'including Great Britain and Mainland Europe' (Henry & Johnston,

2009). The concept was clear – tourists were to be encouraged to visit this virtual Dublin before or perhaps instead of visiting the real place. Rather than transport their physical bodies by plane or ferry, they could sit in the comfort of their own homes and send an avatar to enjoy the vicarious craic. The creation of this virtual Dublin (and its swift adoption as a tourism stream) might well be seen as a simple case of digital art imitating life. As Andrew Kincaid pointed out in 2005, the previous decade had seen Temple Bar transformed from 'a shabby, run-down, forgotten part of Dublin' to a hub of restaurants and entertainment venues with a backdrop of 're-cobbled' streets and 'fake reproduction Victorian lamps' (2005, p.26). Since areas of Dublin were being reborn as virtual reality versions of themselves, the creation of an online equivalent seems mere logical extension. The imperative was the same at least – the creation of clean, comfortable, welcoming environments designed to attract visitors. Tourism Ireland's efforts to drive visitors towards Dublin in *Second Life* built on this through the sponsorship of two festivals, including a St Patrick's Day parade. However, since the server capacity provided by Linden Lab limits the number of visitors within a virtual space, these live events were primarily effective for the media attention they attracted, rather than for any party atmosphere that they created. The partnership was more successful, however, in terms of branding the landscape, as Tourism Ireland made their presence clear with the addition of virtual flags and sponsorship information boards on key virtual landmarks. These markers helped to complete the circuit, allowing *Second Life* users to click through to the 'Discover Ireland' website, perhaps to plan a 'first-life' trip. It was a bold move surely to use a virtual version of Ireland to market the real one. As Johnston remarks, the attraction was in part the opportunity to use a 'different platform for communicating our message' (Henry & Johnston, 2009); but what exactly is the message? Is it that Ireland embraces new technology or that the tourist industry's version of Ireland is just a simulacrum? In one sense, the motivation to use *Second Life* as a platform for marketing is clear. Ireland's largest visitor marketplaces in descending order were the USA, the UK, Germany and France at the time of the partnership, exactly replicating the dominant countries represented by *Second Life* residents (KZero, 2009). But of course there's more to it than that. At its most basic level, Tourism Ireland's message is 'come to Ireland' and the relationship with *Second Life* does nothing to dilute this. As Mark Henry of Tourism Ireland puts it, 'Once they have experienced the simulated Ireland, we hope these potential visitors will come and see the real thing' (Henry & Johnston, 2009).

Arguably, the most interesting aspect of Tourism Ireland's work with *Second Life* is not its innovation but its similitude. In spite of this being one of the most overtly virtual ways of experiencing Dublin that we can currently conceive of, the marketing of the *Second Life* destination continues to depend on stereotypical imagery used in traditional tourist campaigns. Consider the following description used to attract online visitors to the virtual Dublin:

> *Dublin Virtually Live* is known for its warmth and sense of community. Drop by The Blarney Stone for a pint and chat with the regulars. Catch a live show, or go shopping at one of our many stores and boutiques. [...] Fáilte! Welcome to Dublin Virtually Live, Gathering Place for the World!
>
> (Dublin VL, 2009)

The language has distinctive similarities with recent Fáilte Ireland campaigns designed to encourage tourists to 'Discover Ireland'. On the tourist board website and app, members can log in to access the 'My Ireland' section to make their own 'personal travel brochure', or use the 'augmented reality' app feature to overwrite the real experience with digital imagery. Yet even in these contemporary manifestations, the trusted values of 'warmth' and a 'sense of community' are promoted. While this shared message is evidently advantageous for the real-life tourist industry, why would *Second Life* Dublin seek to align itself so closely with such an unreconstructed image of Irishness? There are surely some scenarios in which the virtual Dublin is superior to the real place, not least of all the reliability of the virtual weather. At least one answer comes in the promotion of the social aspect of *Second Life*. Within Ham Rambler's Dublin, virtual Irish bars provide the focus for communication, yet, inevitably, they are unable to fully reproduce the experience they seek to replicate. Visually, the use of Guinness posters, and pictures of James Joyce and Sean O'Casey add to the unfortunate sense that the virtual Irish bars look to an already inauthentic sense of Irishness as their model, complicating further the currency of such images to capture the essence of Irish identity. The result is an unconscious parody with two equally contrived forms of fantasy Irishness overlain; one built up from years of tourist industry propaganda, the other a virtual reality copy. This is not to say that the Irish bars of *Second Life* are incapable of providing a sense of community and sociability to those who frequent them, quite the opposite, simply

that the interaction with tourism narratives has necessarily changed their function. In establishing a relationship with *Second Life*, Tourism Ireland made their intentions clear; they wanted to use new media to attract a new audience to the real Ireland via a virtual one (See Fig 3.2). In order to do so, they simply engaged with a pre-existing phenomenon, using the images already established within *Second Life* as the backdrop for their promotions. Although the platform was most certainly new, the approach might easily be compared to the notion of 'Ballykissangel Tourism', in which locations made popular in television and film become tourist hotspots as visitors attempt to cross the barrier between fiction and reality (Bolan et al., 2007; Crouch, 2000). Similar transitions between virtual and real spaces have, in this way, always been an element of tourism, with visitors moving between the two-dimensional image in a brochure to a week in a B&B, from a website to a coastal walk or from *Second Life* to a city break. When asked if he would ever consider the virtual Dublin an alternative to visiting the real place, Ham Rambler agreed that it might 'encourage' people, describing it as 'much better than a glossy magazine ad and at a fraction of the cost' (Rambler, 2009). It is a revealing statement. Without doubt, cost effectiveness is a strong motivator for the tourist industry and visitors alike. But this is a perception of tourism in which 'visiting' is optional; if the images are good enough, simply looking will do.

Figure 3.2 'View from O'Connell Bridge', artwork by John Mahon on behalf of Dublin Virtually Live

Your very own Ireland

While on the one hand the emergence of mixed-reality tourism seems disquietingly new, on the other, it appears determined to reinforce the most traditional of ideas. Tourism has always provided people with an opportunity to role-play an alternate life, free from the constraints of work or domestic responsibilities. Recent official advertising campaigns with the imperative to 'Discover your very own Ireland' underline this, portraying a malleable country, pliantly shaping around tourist needs and expectations. It is an approach which concerns some critics, particularly when visitor expectations are compounded by traditional marketing imagery to produce limiting and stereotypical depictions of Ireland. In his scrutiny of this topic, Roy Foster points to the omnipresent 'synthesized Irish pub' with faux authentic decor designed to elicit 'nostalgia for something that never was' (2008, p.156). The pubs are an easy target, not least in the way their 'churns, whiskey jars, clay pipes, scythes [and] horse collars' represent a literal staging of dubious expressions of Irishness in locations as diverse as 'Abu Dhabi, Reykjavik and Shanghai' (p.156). How much more revealing it is then that it was precisely this location, the 'Irish pub' as icon for Irishness, which inspired Ham Rambler to build Dublin in *Second Life*. In Rambler's 'The Blarney Stone', patrons are identity tourists, taking vacations from real lives to virtual ones. If anything, the 'astonishingly fabricated notion of the Irish pub' (Foster, 2008) seems an entirely apt meeting place for what are, after all, fabricated Irish people.

The establishment of *Dublin Virtually Live* and its formal relationship with Tourism Ireland hint at a future in which immersive virtual reality may replace actual travel. Fantasies of the future aside, the recent past is helpful in contextualising this, for example, the fact that for the first half of the twentieth century, tourism was an untapped source of economic potential in Ireland. While other areas of the economy were seen as greater political priorities, tourism remained overlooked until a slow and haphazard growth followed World War II, reaching eventual stagnation from the mid-1960s onwards. Finally, membership of the European Economic Community (EEC) in 1972 and government investment in the sector kick-started the move towards a thriving tourist industry via initiatives such as *The Programme for National Recovery* (1987) and *The National Development Plan* (1987–1993) (Baum et al., 2008, pp.49–50). Alongside these political drivers, the increased convenience and affordability of travelling to Ireland made possible by low cost airfares and value added tax (VAT) reductions, led to a steady increase in numbers.

By 2004, Fáilte Ireland was able to boast of 6.5 million annual visitors, predicted to rise to ten million by 2012 (Fáilte Ireland, 2005). In fact, the intervening years saw a period euphemistically described as having 'extremely challenging trading conditions'; 2012 was at best a turning point from 'merely surviving towards seeking growth once more' (Fáilte Ireland, 2012a, p.5). While the figures fluctuated along with the economy, the establishment of tourism as a mainstay in state infrastructure was inevitably followed by a tradition of cultural critique. As scholars observed, the continued growth in tourist numbers was in part a result of the clear brand identity which had been established, not only through the tourist board's official output, but also through mainstream cultural production, including film and literature. As the line between marketable image and stereotype became increasingly blurred, Irish people were at risk of being reduced to 'largely homogenous images' of hospitality and friendliness in the tourist imagination (Baum et al., 2008, p.45). By trading off the Holy Trinity of 'people, place and pace' (O'Leary & Deegan, 2003, p.213), Ireland was effectively marketed as uncontaminated by the stresses of the modern world, while at the same time having a surprisingly advanced grip on building five-star spa hotels, golf courses and business lounges with wifi facilities. Even in the more contemporary manifestations, the imagined Ireland of postcards and guidebooks was bewilderingly drawn as simultaneously rural and untouched, as well as urban and modern. Images of fetishised empty landscapes were seen as particularly evocative, triggering 'flights of imagination of what might happen if one were to go there' (Wulff, 2007, p.540). The wild beauty of the empty Irish landscape in these images symbolises freedom, while also promising power. Apparently belonging to nobody, the land in the brochure or on the website stands fallow, waiting for the visitor to write meaning onto blank fields.

The great paradox of these apparently unpopulated landscapes, of course, is that they are also home to numerous friendly locals. More recently, this marketing of Irish people as the key tourist attraction has faced a significant obstacle. Since 2008, estimates show that over 22 per cent of workers in the hospitality sector of tourism are 'non-Irish', with numbers predicted to grow due to the ever-increasing numbers of international students enrolled on hospitality and tourism programmes in Irish institutions (Baum et al., 2008, p.47). In a market where 'authenticity' is so highly prized, migrant workers can be viewed as diluting the tourist experience where 'Irish people' are advertised as a standard 'part of the tourism product' (Baum et al., 2008, p.48). Viewed as not quite the

real thing, migrant workers engage with tourists at a level we might awkwardly describe as one of 'real authenticity'. That is, meeting the people who actually live and work in Ireland can be perversely interpreted as an *in*authentic experience by those still bound up in a rigid interpretation of the 1990s' slogan 'Ireland – come for the landscapes; experience the people' (Baum et al., 2008, p.52). While increasing racial and national diversity in Ireland has resulted in some pressure on the tourist industry to represent reality, the lucrative 'exploitation of nostalgia' is hard to abandon (Baum et al., 2008, p.52). Whatever the priorities might be for those keen to maintain the traditional brand integrity, the call to update the sales pitch has been intensified in light of online resources. Visitors to Ireland are no longer dependent on the official material produced by state-sponsored organisations but rather engage in a 'sandwich' of travel information; first researching their trip online, then recording the experience in the form of digital photos and social media and finally, sharing their images and reviews online with other prospective visitors.

Recommended for you

At a purely practical level, use of the internet has dramatically changed how people plan and pay for visits to Ireland, with the majority of overseas holidaymakers going online to book or purchase some element of their trip (Fáilte Ireland, 2012a). Yet the internet does more than allow visitors to book their flights or ferry tickets more efficiently. Panoramic digital images, satellite maps, video clips and virtual tours allow potential visitors to view Irish locations from anywhere in the world through mainstream online technologies. A dress rehearsal for the actual visit, this form of virtual tourism provides the potential visitor with a source of instant comparison and evaluation. For the more cynical prospective visitor, online reviews and visitor blogs also present an opportunity to read between the lines of the official version. As Wulff sensibly argues, the Irish tourist industry can have a tendency to overstate the case:

> Everyone is surely not all that hospitable, and there are also prejudices, criminality and economic problems in Ireland. There are cities with stressful settings, air pollution and not very attractive concrete suburbs.
>
> (2007, p.538)

Online reviews, ratings and amateur photographs allow prospective tourists to judge for themselves any disparity between the brochure images and the reality experienced by other visitors. Nevertheless,

the various stakeholders involved with promoting Ireland to overseas tourists, whether they be state-sponsored organisations or independent travel companies, do an impressive job of presenting a united front in their online presence. The potential visitor to Ireland is faced with numerous websites, highly stylised and sophisticated, able to target specific groups directly with bespoke travel information. Tourism Ireland's corporate webpage, for instance, provides clear breakdowns of the target markets, their needs and expectations. Similarly, the 'Discover Ireland' website filters users depending on country of origin, going beyond a change of language to alter the perspective from which Ireland is viewed. In 2009, inputting the information that you were travelling to Ireland from Thailand, for example, resulted in a rudimentary geography lesson showing Ireland's position on a cartoonish map of Europe. Telling the website that you were travelling from the USA, by contrast, would lead you to a page providing guidance on tracing your ancestors. This differentiation of users is an approach born out of web 2.0 techniques, which both highlights the limitations of making assumptions about users as well as demonstrating clear marketing priorities. Like any industry, tourism thrives by identifying the key areas of the market and classifying people not only by where they are coming from, but by *why* they might be coming. Perhaps more so than any other target group, these techniques often attempt to manipulate the Irish-American visitor in search of their 'roots' by drawing on imagery passed on through generations (Cawley, 2003, p.71). Directly targeting a subset of the potential customers is common practice in retail and has long been employed in the tourist industry in order to capitalise on the broad range of visitor needs and budgets. By using new forms of technology, the sales process has been inverted, so that rather than a user-driven dynamic where the tourist looks to a website to seek out information, contemporary tourist imagery is sent directly to the inbox or smartphone. In a crude sense, this allows organisations to target the traditional Irish-American tourist with images of nostalgic rural landscapes at the same time as attracting young Australian backpackers to the nightclubs of Dublin and Belfast. In other words, by using rudimentary demographic profiles to make assumptions about an individual's leisure interests, websites match stereotype to stereotype.

Scatter/Gather

Whether in the form of migration or tourism, the movement of people into, out of and within Ireland is central to any discussion of contemporary Irish culture. While the semi-permanent and permanent movement

of migrants represents the direct consequences of fiscal ebb and flow, temporary visitors are also indicative of economic stability. Furthermore, the number of visitors Ireland attracts, what they come for and, most importantly, what they find, contributes to international perceptions at a cultural and political level. As explored above, the branding of Ireland for the benefit of these visitors involves not just marketing Irish locations, but also identities, by employing 'positive' stereotypes of Irish warmth and hospitality. It is also a rhetoric of distinction. Necessarily, Irish people must be marketed as more friendly, more humorous, more welcoming than your own to persuade you to visit. The approach is, understandably, appealing to new visitors, but how can it hope to attract people who are themselves Irish to come (back) to Ireland? While Irish tourist organisations aim to reach as wide an audience as possible, it remains the case that significant numbers of visitors each year are returned emigrants and members of the diaspora. In 2013, the two state agencies, Fáilte Ireland, the national tourism development authority, and Tourism Ireland, the organisation responsible for marketing Ireland overseas, combined forces to capitalise on the particular needs and expectations of this cohort. Described by Jim Miley, the Project Director, as ' "the largest ever tourism initiative" in Ireland' (Fáilte Ireland, 2013, p.3), The Gathering proposed a year of events to bring the diaspora 'home'. From the outset, little effort was made to disguise the fact that The Gathering was designed to counter the post-2007 decline in the tourist industry. Plans were supported at the highest level including by the Minister for Transport, Tourism and Sport, Leo Varadkar TD, and outlined at the high-profile Global Irish Forum in October 2011 (Fáilte Ireland, 2013, p.8). Influenced by Scotland's 2009 'The Homecoming', Ireland's The Gathering also bore comparison with the 1953 An Bórd Fáilte initiative An Tóstal, or the Ireland at Home Festival. Christopher Fitz-Simon's description of the original An Tóstal highlights the comparison as he recalls, 'a nationwide festival of cultural and sporting events' devised 'to attract visitors from abroad, more especially people of Irish descent who might be encouraged to seek familial roots in parts of the country that hitherto might not have received a fair share of tourists' (Grene et al., 2008, pp.205–6). While the premise, and indeed the motivation for An Tóstal and The Gathering were virtually indistinguishable, the content and organisational structures had been transformed in the 60-year interim.

Despite the initially conservative plans for a few hundred events, the tally at the end of The Gathering totalled almost 5000, including family reunions, testimonial hurling matches, a national leprechaun hunt

and a redhead convention. While a number of smaller events were pre-existing, taking the opportunity to leverage funding, The Gathering also inspired some large-scale national events such as Rebel Week in Cork, Tailteann Nua in Limerick and a record-breaking Riverdance performance in Dublin (Fáilte Ireland, 2013, p.32). The programme of national and local events involved a wide range of community networks, particularly those involved in the promotion of sport, music and food, meeting the organisers' vision of The Gathering as 'a "People's Project"' (Fáilte Ireland, 2013, p.3). For the more cynical, however, the reliance on goodwill and volunteering as a 'boost to economic re-growth' appeared rather less egalitarian (Fáilte Ireland, 2013, p.8). While promotional campaigns presented The Gathering as a collective act of familial feeling, industry documents highlight an economic urgency, speaking of the need to 'mobilise' the public (Fáilte Ireland, 2013, p.5). Alongside the more patriotic aims to promote 'pride in Ireland' and raise Ireland's international profile, the core purpose was simply to bring more tourists and their money into the country (Fáilte Ireland, 2013, p.9). Dissenting critics were quick to note the wage bill for Project Director Miley, and actor Gabriel Byrne's comments that the whole thing was a scam received wide media coverage (Byrne, 2012). In its financial goals at least, The Gathering met quantitative targets, brokering thousands more airline seats per week on North American routes and delivering around '275,000 incremental tourists' with an additional revenue of at least €170 million (Fáilte Ireland, 2013, p.3).

Be part of it

While some cited The Gathering's reliance on community participation as its greatest legacy, others saw it as a form of exploitation, both of the hosts and their guests. The event differed from previous tourism initiatives by placing the emphasis on the invitation. Print and digital advertising issued global invitations, while on a domestic scale, blank postcards were sent to every household in Ireland and a children's letter-writing campaign promoted a more personal approach. In the end, however, it was through digital technology and social media that the invitation really spread. Cheap and with a global reach, the social media campaign achieved over 27,000 Twitter followers and 110,000 'Likes' on Facebook (Fáilte Ireland, 2013, p.34) with the 78 promotional YouTube videos reaching in excess of 3.7 million views (Fáilte Ireland, 2013, p.42). As well as making use of these established platforms, The Gathering also developed a bespoke *Invite and Attend* Facebook app and

an open access website for registering events which was considered to be 'a very successful innovation' (Fáilte Ireland, 2013, p.4). The introduction of user-generated content and peer-to-peer marketing exceeded anything previously attempted by the Irish tourist industry. While dedicated resources such as The Gathering website captured the scale of the event, with cumulative visitor numbers of more than 2.1 million, unmeasurable interventions such as government departments providing a link to the website as part of their standard email signatures also contributed to the overall success (Fáilte Ireland, 2013, p.24). The strategic use of social media was, of course, a further reinforcement of the tourist narrative in which Irish people were part of the 'product'. Here they were, not only willing to welcome visitors, but actively inviting them. It was, as the final report has it, a 'game changer' (Fáilte Ireland, 2013, p.40).

While the various gatherings in 2013 generated experiences and memories for those attending, it was the technology that produced the mementoes. Through digital photos, video clips and social media narratives, new documents were produced, destined perhaps to become valuable source material for future cultural historians. Indeed, it was partly the opportunity to integrate one's own life into 'history' that attracted many of the visitors to The Gathering. The organisers took care to promote this, in particular through a partnership with 'Ireland Reaching Out' (IRO), a reverse genealogy project which aims to help members of the diaspora reconnect with their place of origin. A 32-county organisation, the programme works at parish level with volunteers, inviting living diaspora back to visit during 'Weeks of Welcome', as well as creating online resources and contacts via the IRO website (IRO, 2013). As the name suggests, the IRO project takes its message directly to the diaspora. While traditional genealogy relies on the individual tracing their origins back to a place, in this project, the place traces the person. Again, the intention is overt. In the first instance, the project provides extra resources for keen amateur genealogists, with the parish link perhaps helping to convert online research into a real visit. As success stories on the website indicate, those with no prior knowledge of Irish ancestry are also often inspired to put the theory of their newfound Irishness into practice by visiting ancestral gravestones and so on. Less romantically, the approach simply brings people to places otherwise overlooked on tourist maps. Simply, parishes help to construct a local tourist industry by directly inviting people to come to them. At the same time, as organisers acknowledge, the apparently altruistic project also functions on the premise that the favour might just be returned. Who knows what

international celebrity or millionaire entrepreneur might be able to shed some refracted glow onto a previously unheard of place?

Irish enough?

This last point, an altogether more calculated approach to the diaspora, is characteristic of contemporary initiatives. Although the search for Irish 'roots' is far from new, current manifestations appear particularly well shaped to respond to a contemporary need to see one's life within a wider network. It is, in part, an offshoot of the popularity of televised history and online genealogy as well as a symptom of social networking in which we are forced to see ourselves within a matrix of tangential contacts. In addition to these influences, increasing dependence on the digital has also led to a, frankly understandable, fetish for the solidity of printed documents. At a time when lived experiences are increasingly mediated through screens, it is hardly surprising that people are drawn to tangible birth certificates and parish records. Through numerous online resources and community organisations, tracing Irish ancestry has become big business. Once again, the cynical would have ample case for viewing all this as an extension of the 'shakedown', an attempt to profit from what some people evidently experience as a sense of dislocation. The *How Irish Are You?* app released on Facebook by The Gathering is a case in point. Designed for the US market, the app actively 'sought to trigger the interest of those with Irish links, however distant' (Fáilte Ireland, 2013, p.58). They were effective too, gaining 80,000 new fans for Tourism Ireland's US Facebook page (Fáilte Ireland, 2013, p.58). The app provided users with an indication of their Irishness, expressed as a percentage, allowing them to post their results for other Facebook users to see. While clearly just a novelty marketing ploy, the app nevertheless echoed a question at the core of diasporic identity. In the lead up to the 2011 census for England and Wales, the very same question had been asked across blogs, news websites and social networks. In this instance, the 'How Irish Are You?' campaign sought to redress 'the undercount of the Irish in official government statistics' by encouraging '1st, 2nd and 3rd generation Irish to register their Irish ethnicity' (IB, 2011). Galvanising local and national organisations and promoting the campaign through traditional and digital media, the Irish in Britain organisation highlighted the institutional invisibility of their community. The campaign was timely, reflecting the status of the Irish community as the largest and longest established immigrant group in Britain (Walter, 2006). By 2011, the children and grandchildren of the

cohort who had arrived during a peak period between the 1930s to the early 1960s were among the largest demographic using social media in the UK. It is perhaps a consequence of this that the online response to the campaign's question 'How Irish Are You?' reopened the perennial discussion of how Irish was Irish enough. Across the blogosphere, many expressed their support for the project as a counterbalance to the perceptions of second- and third-generation migrants as 'plastic Paddies'. Although motivated by practical concerns such as the opportunity to lobby for specific health care needs and so on, the 'How Irish Are You?' project mobilised the Irish diaspora in Britain. By making a distinction between nationality and ethnicity, the campaign repackaged the census as an official sphere through which to formalise an often cautiously owned identity.

The global Irish family

In the final report summarising the success of The Gathering, the organisers proudly recall meeting their 'ambitious goal of engaging the people of Ireland to invite diaspora and friends' (Fáilte Ireland, 2013, p.4). Whether through social media marketing campaigns or personal letters, people were indeed invited, but to what? Specially laid on events, some personal, some national and a general sense of renewed energy and charisma across the tourist industry certainly. But far more than that, The Gathering, just like An Tóstal 60 years previously, depended on the idea of inviting people 'home'. Equally, through the concept of The Gathering, the Irish tourist industry encouraged members of the diaspora to play a version of themselves in which Irishness was not only legitimised, but sought after. Since the diaspora now far exceeds the population of Ireland, these return visits, as well as return migration, form part of the established cultural landscape (Tovey & Share, 2000). For people of Irish birth and their descendants, sometimes at several generations removed, this reimagining of the diaspora creates an Irishness version 2.0, driven by identification, not location. The Gathering capitalised on this by promoting a diasporic identity built on long-lost family connections, anecdotes or surnames, granting visitors a licence to express an identity that might otherwise be unstable. The partnership with IRO is a strong example of this, reinforcing the sense that Irishness can, and perhaps should be corroborated in the archives. As already noted, amateur family history research is a popular hobby among members of the diaspora, supported by organisations such as the Irish Family History Foundation, the National Library of Ireland, the National Archives of Ireland, the Public Record Office Northern

Ireland and, of course, Tourism Ireland. With the support and resources offered by these organisations, amateur researchers gather documents, as if the only meaningful form of Irishness is one that can be captured in writing.

In Sebastian Barry's *The Secret Scripture* (2008), a novel wrought around family secrets and the archival detective work needed to unpick them, Roseanne remarks on an individual's responsibility to 'nurse' and pass on anecdotes to avoid having one's life reduced 'no matter how vivid and wonderful, to those sad black names on withering family trees' (Barry, 2008, p.15). While exploring the desire to know one's origins, the novel also recounts the need to *narrate* one's existence and the associated faith in the documents that make this possible. In recent decades, genealogy has provided the Irish diaspora with a new sticking plaster for identity-crisis wounds. Behind the files of death certificates and parish registers lies a core belief that humans are, as Julia Watson has it, 'defined by who and where we are "from"' (1996, p.297). There is, in other words, a sense that the question 'How Irish Are You?' *can* be answered if the right documents are uncovered. In practical terms, access to online public records and ancestry support websites has changed the way previous waves of Irish emigration can be understood by amateur and professional researchers alike. Yet in the rush to collect 'sad black names' on family trees, the people and the stories behind them can be obscured. The Gathering could not fail to be successful as a marketing exercise due to the sheer size of the target audience and its susceptibility to the invitation to come 'home'. It was precisely for this reason, however, that critics objected to the rhetoric of responsibility placed on both visitors and citizens to use community and familial connections as an economic lifeboat. Unsurprisingly, The Gathering report concluded that Tourism Ireland should 'include diaspora engagement as an intrinsic part of their marketing strategy' in future as part of 'the wider government strategy on diaspora engagement' (Fáilte Ireland, 2013, p.6). It remains to be seen, of course, just how this translates into changed practice. Emigration has always created a sense of 'virtual' nationality; being of one place but in another, disrupting the sense of self by changing the sense of place. Being invited to return 'home', under any circumstances or level of removal, does little to simplify this.

Generation emigration

As many of the 2013 gatherings demonstrated, the construction of an Irish diaspora is far from historical. While the advertising rhetoric may have tended towards second, third and later generations getting

in touch with their 'roots', local events were just as likely to reunite a community in the present. Rather than focussing on 'tourists', these events invited home an absent generation of young people, forced by economic circumstances to emigrate for work (Glynn et al., 2013). One such event, the 'Clash of the Ash – Bunclody Vs Central Coast' hurling match is represented in an official Gathering video as a joyful reunion, which it no doubt was. Yet the tragedy of the scale of contemporary emigration is also unavoidable in the more than 50 players coming 'home to play' for the away club and 'a further 100 people who had emigrated to Australia in the last two years' in the stands (Gathering, 2013, p.7). For new emigrants based closer to home, such as in the UK or Europe, cheap air travel makes regular return not only possible, but expected. As Mac Éinrí argues, the 'fluid reality' for some recent emigrants transforms movement between Britain and Ireland, for example, into not so much migration, as long-distance commuting. The emotional cost of repeatedly leaving and arriving creates, for some, a sense of living a double life, never quite fully in either place. In literature, as in emergent identity technologies such as *Second Life*, the fragmentation of 'lives' is made all too clear. In both cases too, the term 'virtual' is informative. The virtual is not physically tangible, yet it is often vividly realistic. In cyberspace, the virtual is partly perceived in the images and sounds produced on screen, but in the most part, it exists in the imagination. The virtual goes beyond the laws of physical reality to become more than real, but at the same time it is only almost, not quite, the thing itself. This aspect of 'virtual belonging' (that is, partial and alternate) has obvious resonances with the representation of the Irish diaspora. It is telling, for example, that the 'How Irish Are You?' campaign was established within a British context. The question speaks to a wider political rhetoric of 'multiculturalism', so resonant in British cultural politics, as well as revealing the friction that comes from this particular composite identity. As numerous critics have noted, the absence of a satisfactory equivalent to the term 'Irish American' and the relative ethnic invisibility construed through whiteness have limited the available vocabulary for discussing the imaginative experiences of the Irish in Britain. More recently, the work of Mary Hickman (2012) and others to unpick race-based assumptions can now be read alongside observations of the ' "Ryanair Generation", frequently engaging in circular migration' of both 'departure and return' (Mac Éinrí & O'Toole, 2012, p.12). The distinction is well established in literary representations. In her discussion of Colm Tóibíns' *Brooklyn* (2009) and Edna O'Brien's *The Light of the Evening* (2006), for instance, Eve Walsh Stoddard argues that:

At least in literature, there is a sense that once an Irish person moved to America or Australia, though not to Britain, an attempt to return would be disruptive to the Irish place whence they migrated.

(2012, p.157)

Physical proximity differentiates Britain from destinations such as America and Australia, which are seemingly *more* different, not only in terms of space, but also time. Since return is eminently more possible from Britain, it is often expected, not least in times of celebration or crisis. As a result, at least in previous generations, the disruption, unexpected and less rarely caused by the returning migrant from America or Australia, might be repeated, perhaps at painful cost, by those who have relocated to Britain. The potential, if not the reality of being caught between two places (or two lives) is, very clearly, to experience the virtual. The term 'London-Irish' (or, indeed 'Birmingham-' or 'Liverpool-Irish') attempts to capture this sense of being from two places at once, and, as a consequence, neither and both. Self-evidently, experiences and representations of Irish emigration to Britain are as varied as they are numerous. To conclude this chapter, I will consider just one text, William Trevor's short story 'Another Christmas', published in *Lovers of Their Time* (1978). The story, written and set in the 1970s, is literally and figuratively miles away from the first home computers being built in San Francisco garages during the same decade. Technology here comes in the form of the television, and when the characters discuss the 'gadgets' their son wants for Christmas, they are referring to a chemistry set (Trevor, 1978, p.1). The internet and cyberculture are only hinted at in this story (a grown-up son has just left home to work for 'a firm of computer manufacturers' in Liverpool [p.29]), yet nothing so well describes the protagonist's experience than virtual reality.

Loading world

The background to this story, so familiar among diaspora narratives as to become clichéd, presents Norah and Dermot having moved from Waterford to London in search of opportunity. Raising their children within the teachings of the Church, they live lives of restraint and limited ambition. The narrative opens in the quiet inertia of the domestic space, as the couple repeat their annual preparations for Christmas, replicating the atmosphere and appearance of the previous years. For Norah, Christmas is a prompt to memory as she reflects, 'always [looking] back at other years' (p.27). Her thoughts, of both how things have

changed and how they have not, reinforce the sense that what might have once been imagined as a temporary relocation is undeniably permanent. As the narrative pans out from the living room to the house, 'a terrace in Fulham', it seems frozen in the moment of relocation, since the family have been forced to adapt to the house that 'had always been too small' for them (p.28). The older children, now marrying or moving elsewhere for work, make space for the younger ones still at school and so the years continue, 'another Christmas' after 'another Christmas'. Prompted by her awareness of time passing, Norah's thoughts unfurl across multiple timeframes, the present, the recent past and the turning point of her life 'twenty-two years ago, when she'd suggested they move to England' (p.31). While her body sips tea in an armchair in Fulham, Norah re-embodies her younger self, imaginatively relocating to the Savoy Cinema and Tara Ballroom in Waterford. She recalls her astonishment at Dermot's proposal, since it was 'his brother Ned [...] whom she'd been expecting to make it' (p.27). Here, the second life starts to be revealed, the virtual marriage with one brother running parallel to the reality of life with the other.

In her analysis of female protagonists who have emigrated to America, Eve Walsh Stoddard has described the 'haunting' of Ireland, both by the 'ghosts of the diaspora' and the Ireland that might have been 'had the Irish state taken a different direction, especially with regard to women's roles' (2012, p.151). Here, Norah does not seem to haunt or be haunted by her past, but rather remains always partially within it so as to never fully inhabit the present. Potential reasons for this become clear as the story unfolds. For all of the repetition and stability expressed in the Christmas preparations, Norah is pained by the disruption to a long friendship. Mr Joyce, neighbour and landlord, is connected to the family on multiple levels, simultaneously personal, contractual and national. They are his 'tenants and his friends', but more than this:

When the Irish bombed English people to death in Birmingham and Guildford he did not cease to arrive every Friday evening and on Christmas Day.

(p.33)

This Christmas Day, however, is to be the exception. While the act of the Irish bombing 'English people to death' is not enough to deter Mr Joyce's friendship, Dermot's failure to join him in condemnation through the rebuttal that 'while the bombs were a crime [...] it didn't do to forget that the crime would not be there if generations of Catholics in the North had not been treated as animals' (p.35) is seen by both

Mr Joyce and Norah as unforgivable complicity. No argument takes place, only silent and permanent withdrawal, echoed in a wider shift in the way Norah perceives her own Irishness within London, reflecting that 'she'd begun to feel embarrassed because of her Waterford accent' (p.36). The story points to a particular moment in the history of the Irish diaspora in London. While some socio-economic limitations are implied by the too small house and the semi-manual jobs, the couple have worked, made friends and become part of the community. Now, as Norah knows too well, her accent signifies her position as 'other'. As Mary Hickman reminds us, diasporas are 'historical formations in process because they change over time' within the wider socio-economic context and 'between various places of settlement (including "the homeland")' (2012, p.23). Even within the course of a lifetime, the relationship between the place of settlement and homeland can shift. The same accent can signal fecklessness, humour, terrorism or fashionability depending on where and when it is heard, and of course, by whom.

Within Trevor's story, Dermot's persistent refusal to acknowledge the rift leads Norah to retreat again to her alternate, imagined second life. Norah blames her ambition to lead a new life for her children speaking 'with London accents', working for 'English firms' and marrying English people; she concedes that although '[t]hey were Catholics and they had Irish names [...] home for them was not Waterford' (p.34). This is the price she has paid. While she names her children to brand them as Irish, their accents and choice of partners roots them in England. For them, home is not the imagined Waterford of their parents' youth, but the London they have grown up in. As Norah acknowledges, her relocation to London has, in a sense, ensured a dislocation from her children. They too live in a London in which names and accents are markers of dangerous otherness; they too must balance versions of reality. As Hickman explains:

> For the second and subsequent generations of immigrant origin the identifications that are lived and experienced are not necessarily about perceiving themselves as *members* of two (or more) societies, the hallmark of transnationalism. Rather it is about a *relationship* to/with two or more societies that may impact on identification processes in meaningful ways.
>
> (2012, p.23)

Norah's anxiety about the way her children speak may belie a fear of how they think. Do they share the attitudes of their Irish father or those of the exiled English neighbour? While Norah's thoughts focus

on her children, it is in fact her own 'relationship to/with' both Irish and English societies that is revealed by the rift. Her husband's conviction that the bombings are justifiable appals Norah because it seems to contradict her affinity with Londoners. In response, she imagines not a parallel past, but rather an imagined future. Imaginatively breaking away from the self-imposed limitations of her role of wife and mammy, Norah creates an avatar. Becoming a banshee, she condemns the bombers as murderers, imagining herself:

> out on the streets, shouting in her Waterford accent [...] haranguing the passers-by, her greying hair blown in the wind, her voice more passionate than it had ever been before. But none of it was the kind of thing she could do because she was not that kind of woman.
>
> (p.36)

As with explorers of the virtual world, Norah's physical body remains silent and passive, while her imagined alternate-self marauds through the streets of London. The story hangs on this moment; Norah, simultaneously the woman she is and the woman she might have hoped to be.

Building bridges

When President Mary McAleese paid tribute to the 'global Irish family' at her inauguration speech in 1997, she was describing a network. Like any network, the diaspora has a hub and numerous nodes through which exchange takes place, in this case, the men and women who 'bridged the gap between the Ireland they'd left and the Ireland which greets them today when they return as tourists and return to stay' (McAleese, 1997). McAleese thanked the members of the 'global Irish family', noting, somewhat romantically, that they had 'kept their love of Ireland, its traditions and its culture deep in their hearts'. Those who had left were praised for maintaining an imaginative link with place and past, whatever its relationship to reality. In recent years, the 'letters home' cited in McAleese's speech may well have been replaced with emails and Skype calls, but they are really only evolutions in the same process of maintaining networks. Even for those for whom physical return remains financially untenable or personally unappealing, online technologies permit ease of contact between family and friends. Similarly, online technologies have also supported contemporary migrants in making plans for work and accommodation in contrast to previous

generations for whom familial or parochial networks rather than wifi were key. These transformations in technology simply remind us that both the scattering out and indeed the gathering back in of Irish people is a process not only of physical relocation, but also of flights of the imagination. The language, and of course the imagery of cyberculture, is useful, not least of all as a reminder of the inherent malleability of the online world and its presence in our real lives. Just as users are transformed by their encounters online, so too is the environment they interact with permanently changed. The internet bends and expands around those who build and use it, just as any city (real or virtual) is marked and shaped by all those who live there. Mary Hickman captures this succinctly when she reminds us that the 'point about diaspora space is that all who inhabit it are subject to transformation, including long-term settled populations' (2012, p.24). It is an argument made clear in William Trevor's short story in which all characters are necessarily transformed by the act of emigration. While the Irish-born characters are displaced by their various attempts to adapt or maintain national identities, their children occupy a third space, inflected by both 'homelands'. Here, too, as Hickman predicts, the English characters are equally transformed, some by marrying into the family, while others are forced to test the boundaries between the personal and the political. Norah, the protagonist, is caught between the life she leads because of her emigration and the life she might have led had she stayed at home. She is in this sense caught up in virtual reality, just like those immersed in online worlds; body in one place, mind in another. The language of virtual reality allows us to think about this experience, simultaneously here and there, then and now. Indeed, more thoughtful use of this vocabulary is becoming increasingly relevant. Unlike McAleese's emigrants holding Ireland 'deep in their hearts', those leaving today hold it in their pockets.

Using messaging apps, video calls, emails and social networking, contemporary Irish emigrants maintain a presence in the lives of their loved ones via the screens of their online devices. These new forms of communication disrupt the finality of emigration seen in previous generations, maintaining the exchange of news, gossip and conversation across time zones and continents. Nevertheless, as helpful as these technologies are in maintaining channels of communication, they cannot replace human contact. If anything, these acts are simply further moments of migration, this time from the real to the virtual. Logging in to Facebook to communicate with a friend from home, for example, does not return an emigrant to Ireland, but rather allows both to meet in cyberspace. In this sense, the very act of going online can be expressed

as a form of emigration for the imagination. During the establishment of *Second Life*, users clearly recognised themselves as enacting a 'strange migration', as Meadows puts it, to the land of 'easy luxury, inexpensive fun, and independence' (2008, p.8). As the platform's reputation as a cyberutopia spread, 'waves of Net-based cultures arrived', with many 'expatriates from other online worlds, seeking a place where they could make their own rules' (Rymaszewski et al., 2007, p.286). While other virtual worlds had created opportunities for role play and adventure, *Second Life* seemed to offer the emigrant dream, the chance to build a new life *and* a new world. The scale too bears attention. Writing in 2007, Tim Guest observed that the 25–30 million people then regularly connecting 'to virtual worlds, to abandon our reality in search of a better place' already exceeded the number of people who had 'passed through US immigration at Ellis Island throughout the whole of the twentieth century' (2007, pp.22–23). The very notion of the Irish diaspora, as well as the traditions of nostalgia and 'return' implicit in Irish tourism, converge in the twenty-first century with the act of moving between real and virtual worlds. As these worlds become more convincing and increasingly immersive, the Irish experience will surely become central, just as it ever was, in mapping the movements into and beyond virtual ports. For now, these second lives remain barely disclosed and the places we go to no more than 'a perverse Ellis Island' (Meadows, 2008, p.64).

4
What Came First, the Chick Lit or the Blog?

> I don't know where dead websites go. Perhaps they are not dead in any real sense, just lost, or inaccessible. This worries me – if the Internet is to evolve, surely it must both reproduce and die.
>
> (Enright, 2000, p.3)

Every technological revolution is accompanied by an allied fear; the fear of human redundancy. Innovations in computer manufacture and software design provide manifold evidence of the power of human ingenuity. At the same time, these new products and the new capabilities they permit have the capacity to render people, or at least their roles, superfluous. After all, we invent machines precisely so that they might take over the jobs we are reluctant or unable to do. Computers are no exception to this, used to analyse data and make complex calculations, as well as the more elementary matters of spelling or managing appointments. Since we expect our computers to share in our day-to-day responsibilities in this way, a form of interdependence develops – the computer becomes both subservient to our instructions and the driving force behind our needs. For techno-sceptics, however, the extension of this relationship is a feared scenario in which machines might ultimately 'take over'. Whether forged out of probability or paranoia, the concept is based on an innate suspicion that machines, including computers, have a life of their own. The threat of living machines, a staple of science fiction and sensationalist journalism, reflects an anxiety that we are only barely in control of the products of our imaginations. In the age of surgical robots and artificial intelligence, our contemporary anxieties have been allowed to grow out of gothic roots. If machines could (and can) be life-giving, might life not also be transferred to machines? From the earliest experiments in computing, programmers

have developed this idea by attempting to imitate life; that is, imbuing computers with the appearance of independent thought. The famous Turing Test, proposed in 1950, does not measure a computer's ability to 'think' as a human, but rather, the human capacity to distinguish a computer's 'thought' processes from one of its own species. While contemporary benchmarks of a computer's sophistication are measured by other means, the Turing Test is surely telling of a human desire to create machines in our own image. We give computers language in the hope (and fear) that they might speak back to us.

In the first few months of the new millennium, the acclaimed Irish writer Anne Enright took up this idea, reflecting not on living computers, but on the 'dead websites' that might haunt them. As she proposes, websites

> certainly cross-fertilise, or cross-infect. But when people say 'what will the Internet turn into?' maybe it won't 'turn into' anything, it will just spread (get less accurate at the edges, more stodgy in the middle).
>
> (p.3)

Enright's essay for the *London Review of Books* was aptly timed, following the anticlimax of the millennium bug – the collective panic that computers, after lulling us into a state of dependence, would universally fail on the stroke of midnight like a conspiracy of cyber Cinderellas. The realisation that a system failure of this sort could compromise the infrastructures of government, banking and health care led to an increase in public discussion in Ireland, as elsewhere, on the potential implications of relying on new technology. Enright's article engages with these concepts obliquely, recounting her own online odyssey for Henrietta Lacks. Lacks' cancerous cells, the HeLa cell line, were the first human sample to be cultured beyond the 50th generation, forming the basis of numerous scientific discoveries. The story of the HeLa line is recounted by Enright as uncanny; the subsequent cell reproduction having outgrown the original body which produced them. The article recalls Enright's attempts to corral the details of those events, reflecting the amorphous growth of data as the websites she consults contradict one another, containing both too much and too little information. For those reading the article over a decade later, the essay also reveals the parallel metastasis of the internet. When Enright types Henrietta Lacks' name into a search engine in 2000, she retrieves 52 results 'within minutes'; by 2014, Google is able to provide 1,160,000 results in 0.27 seconds.

The growth in results over the 14-year period is not simply a result of further research on Henrietta Lacks, but rather evidence that the information available has been replicated and redistributed, filling the vacuum as the web expands. The speed and scale of this growth reflects the impossibility of containing it; as with an aggressive cancer, the cure cannot keep pace with the proliferation. Indeed, as Enright points out, online, the 'more often a piece of information is used, the more likely it is to mutate' (p.2), as she identifies the misspellings, unlabelled images and unreferenced hypotheses which corrupt her search. This aspect of Enright's essay, the author narrating and contextualising the act of being online, makes it a small but potent contribution to our understanding of the crossover between cyber and literary culture during this period. A central element of this is Enright's commentary on her own judgement and interpretation as she examines the search engine's results 'in all their glorious irrelevancy' (p.2). As she does so, Enright must rely on a predigital skill, reading, having only the 'quality of the writing' on which to assess whether a website can be trusted. It is notable then that the one website she trusts implicitly is the reassuring reproduction of a 'proper book' (p.6).

Old habits die hard

Unlike the high-profile innovations of the digital age, the technology used to produce books has long since lost its capacity to inspire awe or fear. With printers now commonplace in homes and workplaces, the production of typescript is simply unremarkable to twenty-first-century readers. Nevertheless, as Enright's instincts suggest, books have retained a unique credibility in the information marketplace. Far from being simply sidelined by the digital age, printed books have been restored to the status of treasured artefacts. Since Enright's article was published seven years before Amazon's Kindle was launched, the author could not have predicted the seismic shift in how books are distributed and consumed in the digital age. While the late 1990s had seen booksellers striving to outdo one another by offering larger and larger discounts, independent retailers and publishers appeared barely cognisant of the growing online competition. Quoting from *The Bookseller* website from 1999, Clive Bloom observes the naivety of those who viewed Amazon as a benign early outrider, heroically ensuring that 'the written word' would become 'central to the e-revolution' (2008, p.373). As time would tell, colossal online retailers and the manufacture of affordable e-reader devices would shift the ground again, seen by some as the twenty-first-century

equivalent of moveable type, and by others as the latest threat to literary culture.

While the impact of these new modes of reading might well be thought of as revolutionary with retrospect, their emergence was, in practice, far more subtle. As Enright had observed, by 2000, books were regularly appearing on websites, just as websites now routinely appear in books. Yet it is a mistake to characterise these developments as an unrelenting drive towards change. Technology, and more importantly our use of technology, evolves in line with our broader needs and capacities. All too often there is a tendency to measure technology solely against itself; this email is faster than that letter, this laptop makes a relic out of that typewriter. The more useful barometer, however, is the measure of cultural osmosis. From the outset, the internet provoked the need for new types of reading, practices which had grown out of our already flexible capacity to deal with different forms of printed text. As Enright puts it, websites 'cross-fertilise' and 'cross-infect' each other (2000, p.3); they also, inevitably, mutate beyond that into other cultural forms. Among those who are sceptical about the emergence of digital books, arguments often centre on the corruption of the printed word, simply by means of its transfer from page to screen. Far less attention is paid to the possibility of exchange in the opposite direction; that is, when the screen gets onto the page.

From the late 1990s, changing market forces, including the impending reality that the internet would irrevocably change publishing from a commercial perspective, refocused the concept of the book as a commodity. Popularity meant profitability, and by the mid-2000s onwards an e-reader became a familiar accessory across generations. The instant (and cheap) access to books which this permitted changed the way readers browsed for and purchased their reading material. Online recommendations from peers (i.e., fellow customers) replaced the traditional expertise of the bookseller. Online bestseller lists and algorithms of recommended reading led to barely disguised intellectual snobbery at the very idea that taste might be so brutally measured. While it is equally plausible to argue that the e-reader provided new opportunities for readers, classic texts which are out of copyright, for example, can often be downloaded for free; nevertheless, the mourning of the 'proper book' took hold. For one thing, the purchase of digital books removed the materiality of the process. Without the opportunity to handle the book as an object, the extra-textual material of cover blurbs and jacket images are displaced by reader ratings and reviews. That said, even if the modalities of persuasion are changed, whether in a real bookshop or a virtual

one, the reader must still *choose* the book. Without the pleasure (or distraction) of the book as object, one might argue, the reader becomes exclusively focussed on the text itself. What is clear is that the act of choosing a digital book owes as much to the reader's proficiency on the internet as it does to their prior experience of browsing the shelves in a bookshop. When choosing a book, in any format, both the context and the product are under scrutiny, just as designs, fonts and logos project a website's respectability and function. An experienced internet user knows instinctively if a website is trustworthy, attractive, user-friendly and so on. As Enright surfs the web, moving between medical journals and high school biology class notes, she dismisses a site 'because the background was pink', admitting 'I think this means that I didn't trust it because I knew it was written by a woman. Oh well' (p.5). The untrusted website, too feminine to be technically convincing, signifies the standards and judgements Enright has brought from the 'real world' of books into the virtual reality of cyberspace. As we know, books are wrapped in a cover which marks them as serious or thrilling or romantic. Reading in public, therefore, transforms the reader into a human advertisement for the book. One of the advantages of the e-reader, by contrast, is the privacy created by the absent cover.

Judging a book by its cover

The pink website, so easily dismissed by Enright, finds its literary parallel in the garish covers of so-called chick lit, marked out by the hieroglyphs of embossed lettering, stiletto heels and cocktail glasses. These 'clearly marked jacket designs (day-glo or pastel, with cartoon style illustrations)' (Gill & Herdieckerhoff, 2006, p.489) are taken as a licence by some critics to overlook their contents. As far as scholars of the form are concerned, despite huge commercial success, chick lit's reputation is still eclipsed by a lack of proper critical scrutiny. Emerging in the mid- to late 1990s, this new publishing phenomenon moved away from the convention of the romance novel, introducing humour and career ambitions to the protagonist's traditional quest for love. The popularity of the formula led several publishers to introduce chick lit imprints, a commitment scorned by those who saw the novels as reductive and frivolous. From the start, the form was contentious since, as Ferriss and Young point out, chick lit simultaneously attracts 'the unquestioning adoration of fans' while also drawing 'the unmitigated disdain of critics' (2006, p.1). That the content, women's careers and relationships, is frequently cited as a basis for this academic oversight

is a clear statement about wider societal attitudes to such matters. That the idiomatic covers are so often brought into the debate as supporting evidence seems difficult to countenance. Indeed, even to engage in the discussion as to whether these works have literary merit is to risk being complicit with a well-established tradition of discrediting women as writers and readers axiomatically. The very term chick lit, the combination of the vernacular and the diminutive, is telling. Fluffy and immature, the name suggests, this is almost literature, but not quite.

If chick lit isn't quite 'literature', it certainly is popular fiction and as such capitalises on the generic and reproducible elements expected and enjoyed by readers. A key example of this is found in the overt consumerism in the novels, with a typical focus on brands, fashion and shopping. This internal marketing is a reflection of the wider process by which the books are marketed to readers. Through advertising campaigns in magazines and at train stations, publishers acknowledge the book as a product, just as the characters within the books fetishise the act of shopping. This thread of fashionability and fetishised purchasing within and around chick lit is further emphasised by shared reference points and product placement. As Anthea Taylor astutely points out, in chick lit, the 'implied reader is presumed to mirror their protagonists' (2011, p.75), at the very least in regard to shared tastes. It is precisely this mythology of shared experience and consumerist propaganda which places chick lit outside of mainstream critical attention. The plots too are frequently predictable and the representations of privileged women, solving their ostensibly minor problems with a restorative bout of consumerism, are easily satirised. If, that is, one operates on a limited and limiting scale of comparison. Chick lit novels are unabashed celebrations of popular culture and are much more profitably read when accepted as such. The themes, characterisation and narrative construction are provocatively commercial and popularist, but then so is the society which consumes them. Further, as supporters of the genre have claimed, the expansion of female protagonists' desires from a man to Manolos can in fact be viewed as challenging the heteronormative assumptions of earlier romance novels. Certainly, the themes and approaches adopted by many of chick lit's key proponents subvert historical romantic ideals of marriage and family life. This is where the difficulty lies. While fans of chick lit are often keen to point out the rejection of hegemony, it is equally clear that stereotypes are perpetuated in the texts. The contradictions can be troubling:

Is chick lit advancing the cause of feminism by appealing to female audiences and featuring empowered, professional women? Or does it rehearse the same patriarchal narrative of romance and performance of femininity that feminists once rejected?

(Ferriss & Young, 2006, p.9)

Irish chick lit

Far from the marketing shorthand that it has become, the term chick lit was originally coined as a rejection of female stereotypes by Cris Mazza and Jeffrey DeShell in their anthology *Chick Lit: Postfeminist Fiction* (1995). For Mazza and DeShell, this was a sharp-edged term, designating women's writing at its most boundary-pushing. Its reappropriation by publishers is, in marked contrast, a signifier of conventionality. Whether or not the popularity of chick lit is seen as retrograde to the feminist movement, it is clear that these books, like any other aspect of popular culture, provide an insight into a particular time and place. Of more specific interest here, however, is the fact that so many of the most notable proponents are Irish. In an Irish context, key figures such as Marian Keyes, Cecelia Ahern and Cathy Kelly dominate bestseller lists alongside the late Maeve Binchy, whose work in the nomenclature of the form is delicately upgraded to 'hen lit', acknowledging the subgenre shaped around the lives of more mature women. In all of these cases, the use of Irish settings and speech patterns has served to increase the international success of the novels. In terms of both popularity and critical attention received, these writers are the market leaders, representing a particular version of Irish womanhood to readers worldwide. Irish chick lit, in other words, is a global phenomenon. The emergence of this literary fashion may be at least partly explained in relation to broader social trends, in this case the evident popularity of 'Irishness' during this period. As Roy Foster puts it, from the 1980s onwards, 'the Irish Republic seemed wafted on a tide of wealth, fashionability and the heady excesses of popular culture' (2001, p.xiii). These books, amusing and accessible, support Foster's case, washing up an apparently endless supply of young Irish women to readers within and beyond the country. It is also surely no coincidence that the height of Irish chick lit's success coincided with the peak of Celtic Tiger excess. On the most basic level, increased disposable income boosted book sales. Conceptually, the economic boom permitted, or rather encouraged, the glorification of spending. Whereas earlier romance novels had been shaped around the love object as the only prize, according to Harzewski, in chick lit, 'Eros is

manifest instead in the protagonist's longing for luxury goods and professional or literary achievement' (2011, p.36). This is not, of course, to suggest that these protagonists eschew the search for love; simply that they are also in pursuit of a better job and some nicer shoes at the same time. Simply dismissing these elements of chick lit is to overlook their value as 'a reflection of consumer culture' (Ferriss & Young, 2006, p.4). Certainly, the non-Irish readers of these books expect to buy more than a romance plot, investing in the complete lifestyle of these cosmopolitan and typically funny Irish women. Writers such as Keyes and Ahern are international bestsellers and prize winners, whose work has been translated into numerous languages and adapted for film and television. Perhaps inevitably, their particular manifestations of the Irish 'chick' have also proven extremely popular in the form of digital books.

Marian Keyes, seen by many as the 'godmother of Chick Lit' (Yardley, 2007, p.7), achieved bestseller success with her novel *Watermelon* (1995), at least a year before the 'ur-text' (Ferriss & Young, 2006, p.4) Helen Fielding's *Bridget Jones's Diary* was published. Noted for her ability to take on weighty issues such as depression, addiction and infidelity, Keyes' fans applaud her skill in engaging with serious matters while remaining 'funny about them, in startlingly effective ways' (Yardley, 2007, p.5). Indeed, it is precisely this inclusion of a particular type of humour which is seen to set these books apart from previous forms of popular fiction for women. Yet while Keyes' dark humour is frequently identified by her readers as a distinguishing strength, the same quality is invoked by critics as a means to disparage the genre. As Ferriss and Young put it, in 'the minds of many chick lit detractors, feminist means serious, and chick lit's humor marks it as unserious' (2006, p.9). In fact, Keyes' own experiences with addiction and depression, filtered through her witty characters, are manifestly serious and this too contributes to the high regard in which both the author and writing are held. For her fans, however, the archetypal plots of self-destructive protagonists becoming gradually self-aware only accounts for half of the attraction. For many readers, as Keyes has acknowledged, the specifically 'Irish' elements of her novels, captured through the syntax and slang used by the characters, provide a powerful draw. As Yardley similarly notes, the Dublin setting also offers a welcome contrast from the customary London or New York. Consequently, Keyes' books are rightly celebrated as contributing to the global industry of popular fiction for women in general, as well as manifesting a consciously Irish model of the genre.

While many writers have attempted to emulate Keyes' formula, few have attained an equivalent public profile. Cecelia Ahern, daughter of

former Taoiseach Bertie, can certainly be viewed as a comparator, with successes including the number one bestseller *PS I Love You* (2004). Ahern is credited by her fans with producing books which reflect moments of social change. While her novels fall clearly within the traditional chick lit category of 'uplifting and sentimental' (Bloom, 2008, p.229), they are also trendsetting, establishing, for instance, subgenres of chick lit, such as the extremely popular 'Widow Lit' (Harzewski, 2011, p.77). As well as a shared Irish context in the broader sense, Keyes and Ahern both capture the zeitgeist in their work. As the Irish economy collapsed, both produced portraits of young women held back economically and socially. These novels, falling under the branch of chick lit known as 'underling lit' or 'assistant lit', provide social commentary in their presentation of the 'iniquities of disagreeable employers [...] and the lunacies of bureaucratic systems' (Ferriss & Young, 2006, p.103). In this new economic scenario, which one cannot help but note Ahern's own father did little to alleviate, the premise on which popular fiction for women had been traditionally based was disrupted. Now, part of the heroine's quest was not only to hunt down a man, but also to escape from office-based drudgery to a new dream career. In both of the texts examined in detail below, this desire mutates as the protagonists come to see writing as the ultimate escape from unfulfilling work. In Irish chick lit then, the medium is very clearly the message.

While even apparently scholarly definitions of chick lit find the urge to condescend to the 'usually single women who enjoy their romance spiced with shopping' (Bloom, 2008, p.306) irresistible, the economic impact of these books is incontestable. As Taylor points out, in terms of sales, chick lit 'has undoubtedly been one of the most significant generic developments in late twentieth century fiction (let alone women's writing in general)' (2011, p.73). If only in sheer numbers these books command attention. In 2005, Marian Keyes *The Other Side of the Story* (2004) took a top-five place in the *The Bookseller's* Top 100 list, having sold 488,508 copies within the year, taking third place again in 2007 with *Anybody Out There?* (2006) following sales of 585,026 copies (Montoro, 2012, p.4). Translated into real terms over subsequent years, and controlling for the frequency with which chick lit is shared among friends and resold second-hand, Keyes' readership is simply vast. A crucial aspect of this, as Keyes has observed, is that at total sales of over 23 million copies, her readers 'must, necessarily, be male as well as female' (Montoro, 2012, p.204). While the scale of interest in these books captures one aspect of the phenomenon, the more pressing aspect lies between the colourful covers. After all, it is one thing to suggest

that many people have read these books, quite another to propose why. What does seem clear is that chick lit is carefully attuned to readers' tastes and current trends. The inherent danger with this approach is that the longevity of the novels might be stunted. In their references to models of cars and brands of cosmetics, chick lit novelists risk alienating future readers for whom the implied value of these products is unknown. It is equally possible, of course, that the modish name-dropping will re-emerge to future generations as historical detail. Either way, those who would critique these elements of chick lit as simply materialistic miss their real purpose in the eyes of readers. For now at least, Keyes' use of brands in her novels, notably Clinique and Jo Malone, creates a shared shorthand for luxury. The products are carefully pitched, maintaining the crucial balance between the aspirational and the accessible; an important caveat, since chick lit protagonists need to be recognisable, even familiar to their readers. In fact, the novels depend upon this imagined intimacy connecting characters and readers by clothes, jobs and relationships. The chick lit novelist does not simply provide the reader with a 'mirror' for her life, in the way Taylor observes; these protagonists are, in fact, fully formed avatars.

The shared aspirations and consumer values which endear chick lit protagonists to their readers are effective because they perpetuate the idea of character as avatar. Both Keyes and Ahern write about young women who are simultaneously knowable and unique, balancing everyday problems with (eventually) the necessary self-awareness needed to overcome them. In these Irish examples, it is specifically the transformative element which drives popularity, as the authors consistently present 'a coming-of-age or "coming-of-consciousness" story where a woman's life is transformed' (Yardley, 2007, p.4). Typically, the transformation is from inadequate self into best self, a stripping back of the flaws to reveal the new improved version within. Central to this is the use of narrative form, carefully crafted to form 'the impression that the protagonist is speaking directly to readers' (Ferriss & Young, 2006, p.4). This sense of direct communication, traditionally achieved through the use of a familiar tone or a first-person narrator, has evolved in line with communication technology, responding in particular to women's use of email. As Shari Benstock has described, in chick lit, the use of email 'links it to the epistolary tradition and to the novel that emerged out of private modes of writing commonly associated with women' (Ferriss & Young, 2006, p.255). In this way, and many others, chick lit contributes to the broader tradition of women's writing by engaging with the evolving environment from which the texts emerge. Indeed, as

Benstock continues, linking chick lit authors with writers such as Woolf and Wharton:

> Just as the then cutting-edge technologies of the telephone, radio, telegraph, and cinema shaped modernist style, email and instant messaging function in chick lit to capture the rapid, clipped pace of contemporary life and conversation.
>
> (Ferriss &Young, 2006, p.256)

The use of communications technology in these novels is transformative in regard to both content and form. Just as Anne Enright's essay experiments with the new vocabulary of the digital age as she punctuates her prose with the 'Click. Wait. Wait. Error' (p.3) of online browsing, so too do these novels blur the borders between page and computer screen.

You've got mail

Both Marian Keyes' *The Other Side of the Story* and Cecelia Ahern's *Where Rainbows End* depend upon email for their plot and narrative form. Keyes' novel is shaped around Gemma Hogan's witty emails to a friend working in Seattle, recounting her father's affair and the dramas of her career and love life. Subsequently forwarded without her knowledge, the emails are transformed into a novel alongside the co-synchronous plots of estranged best friend Lily writing a surprise bestseller and Jojo, a glamorous literary agent. First published in 2004 and reissued as a Penguin Celebration edition in 2007, *The Other Side of the Story* is a self-aware commentary on the readers, writers and publishers of chick lit. In Ahern's *Where Rainbows End*, published as *Love, Rosie* in the USA, protagonist Rosie Dunne's life is narrated through emails, instant messenger (IM) and the odd letter as she overcomes the obstacles of teen pregnancy and failed relationships. While both Keyes and Ahern provide a traditional narrative perspective in these texts, they also include their characters' self-narration in the form of emails and transcripts from related forms of online communication. These elements appear in the novels as echoes of online texts, positioning the protagonists as both authoring and reading their own lives through their written exchanges. In one sense, the use of email is simply a direct reflection of the shift in communication habits which occurred during this period. More specifically, as highly successful examples of chick lit, the novels also reflect wider social change directed towards the demographic of professional single women in their 20s and 30s. Simply put, these

books needed to echo the working world as readers experienced it. As discussed above, publishers now recognised the potential value of these novels, not only in terms of readers' supposed susceptibility to homogenous aspirations (love, marriage and shoes, principally), but also through a pragmatic realisation of purchasing power. Disposable income and urban commuting ensured not only the means to buy books but also the time to read them. It is so obvious as to seem redundant, but the context in which a book is read, the time allocated, aural distractions and so on, are necessarily impactful to the reading experience. Unsurprisingly, the readability of chick lit is often cited as one of the most admirable features, with Keyes frequently credited for perfecting the direct, first-person narrative style now a characteristic of the genre. The format is so familiar to readers precisely because it combines regular speech habits with the informal written conversations which take place between women such as notes passed in class, personal letters and more recently, emails. In this sense, at least, chick lit might be seen as the antithesis to science fiction, making use instead of the most mundane of new technologies. The novels considered here, for example, engage with technologies already taken for granted; sending emails, typing documents, booking hotels. Yet it is exactly here where they are most innovative, providing the evidence that computers are undeniably embedded into Irish culture.

On a purely pragmatic level, it is inconceivable that the young Irish women of the generation written about by Ahern and Keyes would not use email. Yet the authors' use of email technology is not just historicising detail, in the sense that characters drive cars rather than take the horse-drawn omnibus, its very inclusion provides a guiding principle for the ways in which these women's lives are presented. Much like the name-dropping of a particular perfume or designer jacket acts as shorthand for an aspirational and recognisable lifestyle, the comfortable use of email technology brands these characters with a certain level of professionalism and career ambition. At the same time, email is flexible; it can be informal, even gossipy, unthreatening to any of the gendered expectations which these books uphold. The obvious precursor for this, as noted previously, is the epistolary novel and, to a degree, the use of email is simply an update to the most relevant form of communications technology. In point of fact, Ahern's characters communicate via a combination of letters, emails and IM technology, capturing this as a moment of transition rather than of retrospective transformation. Nevertheless, the prominence given to electronic communication allows both novels to bring together the on-screen world of an email exchange

with the on-page dimension of the novel. Their appearance on the page, including the email addresses of the sender and recipient and the subject line, strip the narrative of superfluous scene setting, bringing the virtual conversation to the fore. More than this, Ahern's *Where Rainbows End* depends upon the comparisons between analogue and digital communication, such that the whole plot is shaped around a printed wedding invitation and letter which are intercepted and inexplicably preserved for years. One cannot help but wonder that if email had been used for these messages, as it is for most of the narrative, the whole misunderstanding might have been fixed a good deal sooner. As it is, the novel is shaped by written communication in multiple formats, following best friends Rosie and Alex and the lifetime of inopportune circumstances which prevent them from recognising their mutual love. From childhood notes passed in class, their correspondence evolves in line with the technology around them, graduating to emails and instant messages as teenagers. Naturally, the characteristic formatting of these forms on the page relies upon the reader's ability to interpret the on-screen grammar and mini-narrative of the email form as below:

From: Rosie
To: Alex
Subject: Suspended

(Ahern, 2009, p.15)

As Ahern demonstrates, an email does not rely on content to convey meaning, as she captures the essence of the exchange simply by presenting the participants and the topic. Later, as they progress to using IM, Ahern comically presents the teenagers' initial naivety when passing electronic notes in computing class. When the teacher interrupts the IM conversation, suggesting that they might learn 'how to keep an instant message private' (p.20), the pair are initiated into the perils of online communication, foreshadowing events to follow. More significant for our purposes here, however, is the detailed representation of IM as a literary device. The communication tool established in the mid- to late 1990s is positioned here not only as a tool for social exchange, but also as a technology taught in Irish schools. With this, Ahern implicitly dates the novel, placing the protagonists in the same generation as their author. Learning how to 'IM', at the time a cutting-edge technology, now already defunct, places Alex and Rosie at the apex of the generational shift, taking computer technology from futuristic to mainstream.

For the most part in *Where Rainbows End*, online communication occurs within the recognisable scope of email and, as per Benstock's observations, with the use of email comes an implicit change of pace. The lexicon of email exchange is built into the dialogue via conversational imperatives; characters must 'email me back' or compose 'just a quick email' (p.22). While these terms are hardly visible to contemporary readers due to their ubiquity, they are significant within the wider scope of this study because they stand alongside an internet which is not yet fully domesticated. Characters here still frequent internet cafes, for instance, to send family emails and there is a novelty and semi-glamour in the whole thing. It is notable too that the internet is presented as a playful place; the idea of threat not fully established in the characters' perceptions of online life. When friend Ruby hacks Rosie's emails, for instance, the 'crime' functions as a convenient way of speeding up the plot, saving readers from the repetition of rereading relayed messages (although of course they might have more conveniently been forwarded). Ahern is also deft at placing email conversations side by side as an effective narrative device, showing the contradictory positions of characters, while also emphasising the privacy of the form and the potential to manipulate it. When Rosie plans to visit Alex in America, for instance, his wife's email vetoing the trip is followed directly by his own message, falsely claiming that 'Sally doesn't mind' (p.132). In this one exchange, Ahern captures the inbuilt flexibility of email, permitting Alex to split himself between the two conversations, portraying contradictory accounts of the same event. By contrast, IM, although a staple of communication in the text, retains an air of novelty which email has already lost. Much closer to conversational forms than email, IM allows participants to 'chat' in real time. The invisibility of the interlocutor is seen to encourage open and easy conversation, yet it is precisely this which also leads to mistaken identity and misplaced confessions. Rosie's outpouring of feelings to Alex is, in fact, actually read by his new partner Bethany. When her confessor's real identity is revealed, Rosie is shocked by Bethany's lack of online etiquette, sending the reply, 'What?? You think I just rant about my private life to all strangers on the computer???' (p.328). Although large sections of the novel are presented as IM conversations, the transcripts are not truly realistic, since characters communicate in full sentences, lacking the abbreviations or mistypings which actually characterise the form. If typing mistakes are removed for ease of reading, Ahern does take full advantage of the frequent occurrence of the misdirected message. Open to manipulation by users, the IM system is also revealed to be rife with farcical potential for novelists.

Rosie's boast that she is 'perfectly capable of carrying on two conversations at the same time' (p.108), for example, prefaces the inevitable mix up in which she sends a message *to* the person she means to write *about*. The inclusion of this common online faux pas acts as another familiar experience to bind readers and protagonists together. Similarly, the infiltration of the technical, but everyday grammar and vocabulary of the digital age reinforces the presence of cyberculture between the pages of the book as readers come across pseudo links such as 'Attachment: CV.doc' (p.117). Conversations are also shaped by this force, punctuated by updates from the computer screen such as 'Rosie has logged off' (p.48). By including language on the page which takes its meaning from the screen, Ahern demands a level of online literacy from her readers. This is further complicated if the book is read on a screen device such as an e-reader or tablet, creating the sense that these phrases such as 'Click on the icon to the left to print this page' (p.338) might actually have a function, that they might indeed be clicked. In whatever medium the novel is read, Rosie's computer screen remains at all times just beneath the surface of *Where Rainbows End*, shaping her actions and justifying the plot structure.

As the novel progresses and Rosie becomes increasingly absorbed by her life online, she moves beyond speaking to her real friends via email and IM and ventures into an internet chat room. Her encounters there form a crucial element of the novel, identifying the shift from actual to virtual communities which takes place online. As she logs into the 'Relieved Divorced Dubliners' internet chat room (p.330), Rosie seeks comfort in the people behind the words. Ahern takes on the conventions of the chat room, amusingly caricaturing the participants through their usernames 'Divorced_1' and 'LonelyLady', while 'Buttercup', that is, Rosie, is ignored by the other users until she adopts the tone of the group. As a 'chat-room virgin' she is asked to give her 'stats' – the list of identity markers such as age and gender by which the members of the group know one another. It is important to note here that the online group maintains a local identity. Although they meet online, they live in the same city (or at least claim to), bringing the physical location into cyberspace. Although the chat room environment is new to Rosie, the conversations and types of people are not and there is comfort in the familiar. This section of Ahern's novel captures the kinds of discussions (and arguments) which go on between semi-anonymous members of established online groups not in a global, but a specifically Irish context. Rather than seek the anonymity which the web purports to offer, the group create an intimacy via impersonal connections. These

are people who have never met but know the details of one another's relationship problems. The intimacy and camaraderie within the group offer a commentary on the kinds of human relationships formed online. When Rosie joins as a novice, for example, she is surprised by the ability of others to appraise her situation so quickly, 'hearing' her jealousy through her typing. Evidently then, the chat room represents a space on the internet in which the written word creates a forum for advice, as well as the presumption of expertise. Equally, as Ahern makes clear, chat rooms create a space in which ganging up and bullying can be cultivated; Ahern's portrait is a light but no less astute representation of the dynamics of online groupings. A key aspect of this is the construction of the online chat room as oracle and confessional, as the members reassure Rosie 'what goes on in this room, stays in this room' (p.525). The framing of the group's ethics is revealing since, on a practical level, there is no 'room'. Physically, the chat room participants operate in isolation, engaging with computers in their own rooms across Dublin. These physical rooms act as nodes on the network of 'Divorced Dubliners', allowing them to 'meet' in a virtual shared space in preference to face-to-face conversation. It is this anonymity provided by the screen and the expectation to speak openly which reimagines the computer as virtual confessional. Indeed, throughout Ahern's novel, characters pair off with online confessors; just as Ruby supports Rosie, Alex turns to brother Phil who multitasks 'Surfing the internet' (p.271) while offering support on the ongoing saga. Finally, when the novel draws towards its close, Phil finally advises the now 50-year-old Alex to 'Get off the internet [...] and pick up the phone. Or the pen' (p.552). Quite contrary to the insularity of the chat room, in times of crisis or romantic denouement, penance must still be paid through more traditional technology it seems.

Confessions of a webaholic

Rather than simply a mode of communication or information exchange, email between friends figures in these novels as a confessional act. In both novels, friendships bisected by the Atlantic are maintained through online contact with intimate revelations and day-to-day events similarly recounted in the characteristic self-deprecating humour of Irish chick lit. For protagonists in both Keyes and Ahern's novels, this new iteration of friendship has become normalised as an unremarkable aspect of contemporary life. Indeed, in both novels, events and people seem not to fully exist until they have been recounted and narrated

in a digital dispatch. This shift, in which meaning is attributed not to the experience, but to the retelling of it, is a reflection of the changing work environment in which these women operate. Simply put, the conceit by which Rosie and Gemma construct instantaneous narratives is only rendered possible by their working lives in which they are tethered daily to computers. In *The Other Side of the Story*, Keyes builds on this with her representation of an early smartphone, pre-empting the role of internet-enabled handheld devices in transforming working practices. A physically cumbersome 'huge brick of a thing', Gemma's 'Communicator Plus', already seems archaic, while remaining symbolic of the now commonplace idea of being anchored to cyberspace by a handheld device. As Gemma reflects, rather than providing freedom, the device 'just made me more of a slave than I already was', allowing her employers to contact her 'any way they wanted, whenever they wanted' (p.14). In this way, email is detached from the computer and figuratively embedded in the body via the palm of the hand. The subsequent expectation that email responses will be immediate is similarly experienced somatically. Later in the novel, when Jojo is frustrated by a colleague wasting her time, she experiences a quasi-allergic reaction to being offline as she 'itch[es] to get to her emails' (p.117). Through these characters, Keyes captures the learned dependence on email, presenting both women as equally reliant on electronic communication for professional and personal validation. Both Gemma and Jojo use email for administrative and logistical tasks as often as they do for flirting or joking. Indeed, the range of email usage as well as the frequency is crucial to a full understanding of these characters and of the generation of young Irish women they represent. Perpetually mid-conversation with multiple interlocutors, these characters write more and more about themselves while thinking less and less clearly. So, as the characters' lives become more complex, there is a clear sense that the constant self-narration to friends, lovers and colleagues leads to an outsourcing of independent thought. For these young women, unlimited online contact with others, both known and unknown, creates a world in which it is always possible to defer to someone else.

As Keyes' title suggests, any story is only one account of the innumerable versions possible. Further, in this novel, the rotation of narrative perspectives reinforces the sense that people inevitably interpret shared events in light of their own role. Yet here, as in Ahern's *Where Rainbows End*, otherwise intelligent women are slow to reach solutions for their own problems, be they romantic, financial or professional. This reliance on the 'rescue' motif is understandably critiqued by feminist

scholars, yet it is, I would suggest, possible to reconfigure this for the digital age. In these two novels at least, the protagonists of Irish chick lit are not reliant on rescuers per se, but reviewers. Certainly, they seek reassurance and approval, but it is as likely to be from strangers as potential husbands. When Lily's book becomes a bestseller, it is not as a result of the publisher's marketing campaign, but via online word of mouth; that is, 'what the readers are saying about her on Amazon' (p.162). Keyes demonstrates masterful self-awareness here, recreating the language of Amazon reader reviews, the kind often applied to her own work, as the chick lit within the chick lit is described as 'Enchanting...comforting...magical' (p.163). When Lily's publisher Jojo brokers a reprint in response to this demand, Keyes directly references the rising power of women readers via the online expression of opinions and evaluation. Furthermore, the fictional Amazon reviews reflect their real-world counterparts by reproducing the hyperbolic language and, more importantly, the reviewer's sense of authority. When Lily's first book is highly praised and rated with 'four or five stars', she imagines the 'lovely people' beyond the screen as new friends (p.278). When her second is eviscerated, the extreme (though not unrealistic) reader comments portray the book as at best a waste of money, at worst the cause of a relapse into clinical depression. What Amazon gives with one review, it takes away with another.

Keyes' use of fictional Amazon reviews of equally fictional novels provides a valuable reflection of an online culture in which readers conceive of themselves as reviewers by default. As her protagonists come to recognise, this cancerous multiplication of commentary and judgement is as likely to destroy as it is to promote. For Anne Enright, this cacophony of opinion creates the sense that the entire internet 'is about what someone else said', to the point that it collapses into nothing more than 'a gossip factory' (2000, p.7). Quite so, and it is within this 'gossip factory' that online narratives and chick lit converge. In a purely practical sense, to be online is to have one's opinion repeatedly solicited and unknowingly gathered. Websites with various purposes want to know what you like and how much you like it, inviting users to 'comment' and contribute. In simple terms, online readers are frequently invited to write their side of the story. Although many people are happy to bypass the role of 'produser', numerous others enthusiastically offer up their thoughts for the world to read. The attraction is clear; in the age of web 2.0 and beyond, those who once read the internet can now write it. For readers of chick lit, the fantasy of authorship has been embedded in the genre from the outset with online chat rooms and how-to books

providing guidance for would-be authors. There is evident irony here as fans of the genre reinforce the cynical attitudes of critics by perpetuating the idea that anyone might write a chick lit novel. In *The Other Side of the Story,* Keyes' takes up this idea by constructing Gemma as an accidental novelist. From the start, Gemma has a vague ambition to write, but no real intention. The only sense that she might, in fact, comes in the form of her jealous response to Lily's success as she explains, 'I was the one who was supposed to write a book; I'd talked about doing it often enough' (p.24). Gemma does not work hard to get her book published. She gets an agent through a friend's initiative and writes a book by merging her emails with her current fantasies. Her literary success, such as it is, does not stem from her ability as a writer but her experience as a reader.

Gemma's idle dream to write a book, and equally, the ease with which she later relinquishes it, speaks to an idea at the core of chick lit – the author fantasy. Just as the protagonists present attractive lifestyles for readers, so too do the authors who create them. The inevitable author website, cynically, if realistically viewed as an 'extra tool in an author's entrepreneurial effort to top the charts' (Bloom, 2008, p.17), perpetuates the idea of the author as the ultimate chick lit protagonist. Both Marian Keyes and Cecelia Ahern's websites sustain the conventions of the genre online, reproducing the colours and images found on the covers of their books. More powerfully, their online newsletters and profiles invite readers into their lives, replicating the informality of chick lit to extend the illusion of friendship. While these websites are, self-evidently, the 'tools' of publishers, these Irish authors have also stepped outside of this marketing model, adopting new technology to become increasingly accessible to their fans. Marian Keyes, for example, is particularly well known on Twitter for her close interactions with her readers and 'followers'. Approaching the social networking platform with much the same tone as she does her books, Keyes maintains her recognisable style, coining Irish slang hashtags, creating mini fantasy adventures and 'Live-Tweeting' popular television programmes. Through this unmediated online presence, Keyes establishes a tangible bond with readers, allowing her to embody the authority and glamour of authorship while retaining the sense that she is accessible and knowable. This combination of admiration and interaction is not to be underestimated in sustaining the popularity of the genre. Admittedly, following Cecelia Ahern or Marian Keyes on Twitter might be no more than an extension of the fantasy of knowing or being an author, but there is at least the chance that they might follow you back.

Blogtrotters

As one of the dominant forms of microblogging, Twitter has become synonymous with the contemporary appetite for personal narratives. Yet it is only one of many blogging, or web logging, formats which allow 'millions of individuals whose personal narrations were formerly considered marginal' to share their words with the world (Keren, 2010, p.111). For many, this reconsideration of 'marginal' lives represents a central achievement of online narratives, not least of all in relation to gender. Although the idealism is inspiring, the reality is rather less convincing. While studies demonstrate that blogger numbers are evenly distributed between men and women, their blogs do not receive equal critical attention in a landscape in which 'blogging is fraught with traditional ideas about gender' (Ratliff, 2009, p.128). As Taylor persuasively argues, just as the diary has been systematically devalued as historically 'gendered feminine, and taken up predominantly by women', so too has its online descendant, the blog (2011, p.184). When women blog about relationships, infertility, fashion, motherhood or depression, their narratives meet the same divided criticism as that aimed at chick lit. Although popular blogs achieve equivalent status to bestseller novels with an audience of loyal followers, they are as frequently denounced as 'self-indulgent, narcissistic, and confessional and are presumed to serve no purpose, other than to service the bloggers' egos' (Ratliff, 2009, p.142). By contrast, blogs gendered masculine, typically engaging with technology, business and politics, are increasingly absorbed into the mainstream media. By writing about topics which overlap with the apparatus of state and commerce, these bloggers move into a shared frame of reference with trusted forms of written information, whether or not they hold any individual authority or expertise. It was precisely this concern over the unlegislated nature of blogs which in 2007 led Michael Foley of the *Irish Times* to differentiate between those who can and those who perhaps shouldn't blog:

> Take blogs. So what if people want to publish their thoughts so strangers can read them? In most cases there is nothing wrong with it. But journalism it is not [...] The online world is full of unverified information, inaccurate information, made-up stories posing as fact.
>
> (Foley, 2007)

For all Foley's doubts, by 2012, the *Irish Times* blog section had effectively replaced the notion of opinion columnists. These online

narratives provide 24-hour availability, with embedded hyperlinks and related blogrolls; they can be accessed on the move, shared, retweeted and commented upon. It may or may not be journalism, but it's not strictly blogging either. What Foley crucially overlooks here is that, for many bloggers, the very point is to construct and share 'made-up stories'.

The Blog Awards Ireland are testament to the popularity and variety of Irish writing in this genre, with the annual long and short lists acting as an archive of social trends and cultural fashions in twenty-first-century Ireland. The categories including pop culture, the outdoors, health and wellbeing, news and current affairs and Irish language point to the breadth of Irish blogging, as well as reinforcing the sense of close online communities. Designed to highlight the best of Irish blogging, the awards also plug into the privileged status awarded to Irish narratives online. Sites such as the Irish Blog Directory reinforce this with a service that collates 'blogs of Irish content or Irish interest' in order to promote them globally. As they proudly point out:

> Our directory is not only for Irish people but for anyone all over the world who may have an Irish flavoured blog. You don't have to be Irish to blog about Ireland.
>
> (Directory, 2007)

Between the awards promoting the elite, and the directory measuring the scope, one might easily get the impression that the 'Irish flavoured blog' has become irrepressible. Undoubtedly, the narrative format has become markedly popular, in part due to the implicit equality of a genre 'theoretically available to all' and 'lauded for [its] ability to give voice to the formerly voiceless' (Taylor, 2011, p.182). One such example of this has been in the subgenre of patient blogging, in particular, by women with cancer. The flexibility of the format allows patients to break out from a passive relationship with their illness, charting their experiences for loved ones as well as supportive unknown readers. Very often, these are women writing publicly for the first time, sometimes painfully aware of the sense that time is limited. Nevertheless, although the topic is clearly exposing, it is also revealing that these bloggers frequently take their lead, not from medical journalism, but from the dark humour and hopefulness of chick lit. Just as Keyes and Ahern have written about women who are surprised to find a novel lurking within them, these bloggers take the rebellion of their cells as an inspiration to write out their lives.

Cancer chic(k)

Marie Ennis-O'Connor's 'Journeying Beyond Breast Cancer' (2013), a winner of Blog Awards Ireland 2012 and 2013, has been read by over 700,000 people. Shocked by a diagnosis in her early 30s, Ennis-O'Connor became a self-taught expert on her illness, using her blog to share a vision of informed and empowered patients. In the subsequent years, she has come to be seen as an advocate for patients, influencing health policy and public opinion via initiatives such as a monthly 'tweet chat' at EU level. Ennis-O'Connor's posts are short but media rich, written to both comfort and inspire her readers. Via large images and bold headlines such as 'Are you ashamed to be ill?' and 'Cancer has become a part of my journey but it's not the whole story', the blog creates a space for reflection and discussion. Indeed, the purpose of the blog is clearest in the comments section of each post in which readers reblog, comment or share on social networking sites, extending the conversation into further online spaces. While this contagion of online narratives is often seen as one of its strengths, it is also evidence of its insularity. When bloggers link their narratives to others, they do not share their stories with the world, but rather perpetuate a local network within a global template. This is particularly the case with topics perceived to be only relevant to women, so that 'although women's voices are being heard on the Internet, too often we are only talking to each other' (Collingwood, 2012, p.4).

While Ennis-O'Connor's blog reflects on life 'after' a major illness, Deirdre Featherstone's 'Kicking the Shite Out of Cancer' (2013) offers a real-time account of treatment and the lived experience. Outlined on the home page as a blog written with 'coarse language' and 'dodgy wit', Featherstone retains the handmade quality of an earlier generation of blogs. Her writing is not carefully edited or constructed but comes as an outpouring of news like a conversation between friends. The design is colourful and bright, featuring candid videos and photos so that the blog also acts as a scrapbook of family life. Featherstone is a woman embedded in an Ireland of the digital age. Having worked for large corporations, like Intel and Hewlett Packard and now running her own web design and development company, the internet provides an obvious outlet for her experiences as a patient. Whereas 'Journeying Beyond Breast Cancer' is written with the relative contentment of the survivor, Featherstone writes from within the disease. Shortlisted for the 2013 awards, the blog is notable for its direct conversational tone and a frank approach to cancer. When Featherstone describes (and photographs)

her breasts, 'Floppy Fiona' and 'Cancerous Chloe', she encapsulates the spirit of dark humour and insatiable positivity which characterises this form of writing. The blog is written from an autobiographical impulse certainly, but it is also a construction. Through the blog, 'Dee' creates herself an online persona alongside the friends, doctors and body parts who are the supporting characters. The blog is shaped around the ongoing plot of her treatment, but also the subplots of her family life, holidays and charity work. It is this narrative aspect which so clearly allies the blog and others like it to chick lit. The protagonist suffers, but she also succeeds and, in doing so, provides entertainment as well as support and advice for readers.

Both of the blogs referenced here are written by women attempting to regain control through writing. Just as Henrietta Lacks' narrative of cancer is one of disempowerment and unchecked multiplication, these blogs challenge the dominance of the illness, using the internet to gain knowledge and then to share it. Such a transformative narrative is only made possible by the specific context provided by the blog. Part diary, part fiction, the blog sits uncomfortably in traditional genre distinctions. This is not because the narrative is unrecognisable, but that the author is so paradoxically visible and masked at the same time. As Lindemann observes:

> The blogger is a slippery figure made out of words, links, and ongoing interactions with a changing set of readers. No matter what you call her, she is a character who changes with each new post and every single comment.
>
> (2010, p.212)

The writing cure

It is no coincidence that the phenomena of blogging and chick lit share a chronology, coming to prominence at the turn of the twenty-first century. The shared context for their emergence includes overlaps in audience and shared stylistic features, but more tellingly, a breakdown in the distinction between authors and readers. In both blogs and chick lit, authors make use of an 'among friends' tone, drawing readers in with familiarity, rejecting any superiority with an apparently self-deprecating attitude. The structures too are similarly sequential with casts of characters gradually revealed; just as both blogs and chick lit novels represent serious themes cushioned by humour. Perhaps one of the most revealing aspects, however, comes in the form of commercial exploitation.

After all, the rise of book clubs in front rooms and online grew out of 'new purchasing strategies in supermarkets' and the 'rapid proliferation of chick lit lists on the Amazon and other Internet bookseller sites' (Gill & Herdieckerhoff, 2006, p.490). This reconception of reading as a group activity for the twenty-first century led several readers to write online reviews of the books they read, or even, to write their own stories in the form of a blog.

In Irish chick lit, this fantasy of reader turned author is made possible as a direct result of cyberculture. In Keyes' novel, Gemma's emails really do become a book; in Ahern's, Rosie's emails *are* the book. Blogging provides a useful counterpoint to this type of popular fiction precisely because of the clear connection which can be drawn. Although bloggers often initially claim to be writing for themselves, the form only truly functions with an audience. After all, it is through an audience that a blogger might profit from their work financially, typically through advertising or securing a book contract. Less cynically, however, bloggers, such as those discussed above, seek an audience as a means of mutual support and community. Whatever the motivation, 'Bloggers want their readers to keep visiting the site, reading, and leaving comments' in order to keep the blog alive (Ratliff, 2009, p.130).

When Gemma jokes about her 'Communicator Plus' having the ability to 'read your thoughts' (p.14) in Keyes' *The Other Side of the Story*, she echoes the anxieties around the living machine discussed at the start of this chapter. It is a common image, one which inverts the Turing Test, placing the computer inside the mind rather than the mind inside the computer, blurring the physical and digital. Later in the same novel, Keyes latches onto a parallel idea, that of writing as a symptom of physical and emotional malfunction. In response to each traumatic event in her life, Lily suffers a relapse of writing in which computers offer the only cure. Sitting 'for fifteen hours a day' at her mother's computer, hands clattering at the keyboard, 'fingers unable to keep up with the flow of words from [her] brain' (p.610), Lily withdraws into semi-isolation. Parenting her book rather than her daughter, she feels compelled to transfer her story from her 'head to the computer' (p.610). The narrative grows inside of Lily but can only be brought into the open by her interaction with the computer. It is a symbiotic relationship, as her overloaded brain crashes the 'circuits in [her] head [...] moving at such speed, they could not contain the information' (p.524). Like HeLa cells, the narrative is out of control. Through the act of writing, however, the author can limit, edit and use the computer to curb the growth. It is a fact that the most successful bloggers understand all too well. The task

of blogging is not one of self-authorship so much as 'editing one's experience', one version of a life among millions of others (Friedman, 2010, p.202). Inevitably though, blogs, like their writers, eventually die. Sometimes these points are connected, sometimes the author simply loses interest in the topic or the readers move on. In their place, new stories emerge, multiplying unstoppably but never truly complete and so the genres diverge. Chick lit is a form built upon an ending; problems will be solved, conclusions drawn. Online lives, by contrast, can never be so satisfying; as Enright so aptly has it, online 'the meaning is so often in the gaps' (2000, p.6).

5
The Digital Divide

It was unimaginable, unconscionable, that the civilization to which Anna and Alex belonged could disappear. What could replace it? How could they imagine anything other than what there was now, planes and city breaks, computers, four-wheel drives, new books every week, concerts and operas and a constant stream of easy entertainment.

(Ní Dhuibhne, 2007, p.119)

In Élís Ní Dhuibhne's *Fox, Swallow, Scarecrow* (2007), protagonist Anna Kelly looks up at the architecture of the famous Mosque–Cathedral of Córdoba in Andalusia and reflects upon the nature of 'great civilisations'. As she walks through the 'forest' of pillars, Anna thinks about the Mosque's builders, oblivious to the eventual fate of their civilisation constructed out of faith and a 'sense of their own invulnerability, their permanence' (p.119). In spite of the lesson which surrounds her, Anna's own civilisation, or more properly the products and the privileges associated with it, seems immune to any equivalent threat. Anna's civilisation, twenty-first-century Ireland, manifest in affluent, middle-class Dublin suburbia, encloses her in what Susan Cahill calls the 'bubble of the Celtic Tiger' (2011, p.162). As Cahill so convincingly argues, it is precisely because Anna inhabits 'a perpetual present' (p.162), blind to the influence of past or future, that her life comes to symbolise the period's short-sightedness. Lauded as a standard-bearer for the 'Celtic Tiger novel', *Fox, Swallow, Scarecrow* engages with the epic themes of morality and betrayal, refined through specifically Irish concerns, such as the endemic flouting of road safety laws and the contradistinction between the quality of life in urban and rural settings. It is a novel shaped around frustration, dissatisfaction, awkwardness and disconnection, but most

116

of all, around the nature of self-awareness and self-centredness. When Anna looks up at the architecture of the Mezquita, she is quite unable to conceive of her own way of life becoming equally displaced from its current trajectory. Rather, the cavernous space (another bubble of civilisation) simply reflects back her own priorities, specifically 'that she needed to be working on that novel' (p.119).

Anna's distraction further emphasises *Fox, Swallow, Scarecrow* as a conspicuously literary novel, not least in terms of the meta-fictional relationship with Tolstoy's *Anna Karenina*. The cast of characters who are writers, poets and publishers, enact the novel's portrayal of the cultural boom by highlighting the emergence of Irish literature as an industry, including the displacement of the fabled 'standing army of a thousand poets' by an 'even bigger army of arts administrators' (p.65). Through Kate, for example, an administrator at 'Poetry Plus', Ní Dhuibhne relates the miraculous amounts of 'dosh sloshing around [...] in the coffers of the state' being directed towards 'The Arts' (p.65). During this period of unprecedented economic prosperity, political cachet became linked to literature as a proven example of Irish innovation, 'dramatically (and wonderfully) out of proportion to the size of the country' (Haahr, 2004, p.44). Between 1994 and 1998, Arts Council funding rose by 400 per cent, only to be dramatically reduced in the recession, with some organisations, including the Irish Writers Centre, losing their grant entirely (Slaby, 2011, p.77). For Anna, however, unable to foresee these years of drought, the Dublin literary scene provides a vibrant and irresistible counterbalance to her life as a wife and mother. As a consequence of their various roles in 'The Arts', Ní Dhuibhne's characters observe and narrate the politics of Irish literary production during this period, yet it is through Anna's writing in particular that we come to see a portrait of the writer during the Celtic Tiger.

Although it seems a tangential detail, it is crucially important to acknowledge the change in practice at this time which promoted computers to the centre of the writing process. In *Fox, Swallow, Scarecrow,* Anna Kelly is inspired by and distracted by the internet as she writes, just as email allows her to conduct the business of her literary career as well as her love affair. Anna's imagination is unashamedly backed up by 'research – on the net', although she is ultimately held back by the lack of websites containing 'Great ideas for *Harry Potter*-style novels':

> She had checked, and other similar sounding words as well. (There were plenty of other ideas, and even programmes you could buy with your credit card, which would give you a template for a novel. All you

had to do was fill in the names, the places, the descriptions [...] She had added some of those sites to her 'Favourites', for a rainy day.)

(p.39)

The internet is a source of amusement, productivity, distraction and fantasy for Anna, almost but not quite able to do the writing for her. Yet for all the computer appears here as the essential tool for contemporary writers, it is also represented as a drain on human energy. Looking at the pile of rejected manuscripts on her publisher's desk, Anna laments the hours wasted in front of the screen, regretting the time not spent 'doing whatever it is people who don't write do in those long hours when the others are at their PCs' (p.188). In this, Anna converts creativity into economic value. Having slaved at their machines, these would-be writers are not economically productive, using their computers only to make 'Home-made books' (p.188), perhaps simply for the pleasure of writing. They are in this sense craftspeople rather than manufacturers, operating outside of the established economic structures. The very idea that they might 'derive some satisfaction from that' (p.188) is impossible for Anna to understand in her bubble of 'city breaks, computers, four-wheel drives'. It is exactly this distinction which Ní Dhuibhne presents as the gradual fracturing of a civilisation and a life. As even Anna, heroine of Celtic Tiger Ireland, acknowledges, 'they all topple in the end. They never see it coming until it is too late' (p.119).

The extinction of the Tiger

From very early on, the appeal of the 'Celtic Tiger' as a name for the 'economic boom from 1994 to 2000' embedded the mythic creature in the public imagination (Kirby, 2005, p.41). An apparently miraculous transformation, the upsurge in the economy took Ireland from being 'the poor cousin of Europe to being one of the richest, and most recently to being one of the most indebted' (Bonner, 2011, p.51). A decade or so after the end of the boom period, historical and critical analyses now accompany official enquiries as the longer term economic and social implications become all too clear. Having emerged from 'a jungle of competitive capitalism' (Allen, 2000, p.2), the Celtic Tiger stood for 'the newfound dynamism' of the Irish economy (Coulter & Coleman, 2003, p.4). However, as the realities of offshore banking, social exclusion and tax evasion became increasingly apparent, the 'metaphor would slip its moorings and begin to move through a range of other debates on the nature of culture and politics' (Coulter & Coleman,

2003, p.4). In the aftermath, discussions have, understandably, clustered around the issue of blame, with critical consensus condemning the Irish government as 'corrupt, inept, or both' (White, 2010, p.38). Not only a matter of economic growth recorded in stock markets and financial audits, the Celtic Tiger also marked a wider change in experiences and expectations. As early as 2000, Kieran Allen could present the now conventional account of roads 'snarled with cars' and house prices at 'fantasy levels' (p.11) as a matter of historical scene-setting. More significant than these impediments to middle-class living standards, however, were the far more damaging effects on those entirely unable to benefit from the transformed economy, either during or since the economic boom. If the Celtic Tiger had been a rising tide to lift all ships, the recession which followed revealed the detritus left behind at low ebb. For Allen, these consequences were acts of 'social vandalism' (2000, p.100), undermining Irish housing, education and health care, as the failure to fund public infrastructure (as a consequence of corruption and mismanagement) became impossible to overlook.

The post-mortem of the Celtic Tiger can be divided into two stages. In the first instance, critics seek to understand the socio-economic conditions which made the boom possible; in the second, they hope to identify where it all went wrong. As Coulter argues, 'orthodox accounts' present a combination of fiscal prudence in the 1980s and the success of so-called social partnerships or at least of a more 'harmonious era in labour relations' (Coulter & Coleman, 2003, p.11) as laying the foundations for economic growth. Yet, as he goes on to argue, these standard narratives are ultimately unconvincing when probed. The rather more persuasive, if less appealing explanation, positions the Irish economy at the mercy of global capitalism. For Coulter then, the discussions and decisions which created the Celtic Tiger 'were taken not in the corridors of Leinster House but in the boardrooms of a handful of multinational corporations' (2003, p.18). While this account might usefully support the case against inept or naive politicians, it fails to recognise that the Irish government directly sought out multinational companies that would build an Irish economy on 'informational capitalism' (Haahr, 2004, p.41). Companies and sectors were targeted precisely because they were seen as conducive to economic growth and the provision of associated standards of living, and computer technology was at the top of the list. The strategy seemed to pay off: exports in this sector were recorded at €31 billion in 2002 with the industry as a whole worth 16 per cent of gross domestic product (GDP) (Lillington, 2004, p.67). By 2010, software was still at the heart of the economy, with five of the world's top-ten

ICT companies operating in Ireland, more than 220 companies employing more than 40,000 people and annual exports of over €50 billion (White, 2010, p.36). In these terms, Ireland's marked economic growth, far from being a reward for thoughtful budgetary foresight or internal union negotiations, seems instead an act of benevolence from a 'handful of principally US computer companies' (Coulter & Coleman, 2003, p.21). These computer companies, most notably Intel and Apple, absorbed the dual advantages of low corporation tax and 'a young, educated, English-speaking workforce' with wage expectations among the lowest in Europe (Allen, 2000, p.25). As Allen observes, the advantage of the English-speaking workforce was particularly evident in the computer industry, where it remains the 'dominant language' (p.25). More than this, the fact that the economic boom was financed by the very symbol of the new century added to the sense that Ireland was now irredeemably modern. As Haahr recalls, 'Irish politicians rarely missed an opportunity to stress that the country was one of the biggest exporters of software in the world' (2004, p.44), while conveniently overlooking the fact that the majority of Irish jobs in the sector were in roles such as telesales or customer support. The distinction is an important one. The oft-cited example of Intel's plant in Kildare and Dell's base in Limerick, established in the 1990s to create a highly technical Irish workforce, omits the detail that the majority of the software was still written abroad at that stage. Nevertheless, the real socio-economic significance of these companies goes beyond the remit of individual jobs. While physically located in Ireland and employing Irish workers, the legal status of these large companies typically allows for the diversion of profits (and tax) out of the country. Controversy in the media over these rerouted benefits is characterised as either a scandalous abuse of power or a necessary evil of the global economy. Similarly, the conceptual impact of 'multinational companies' is translated in some quarters to the more politically charged term 'American imperialism'. Although as White acknowledges, some specialist Irish software companies 'have found a niche to serve needs in a variety of fields' (2010, p.35), they remain in the minority to large corporations. It surely seems to go without saying then that the impact these companies could affect in leaving might be as monumental as that caused by their arrival.

The danger, as Coulter observed in 2003, was the creation of precarious relationships between the computer companies and the economy they bolstered. In Coulter's imagined scenario, the predicted implications of Intel closing operations in Kildare are seen as 'sufficiently grave to undermine conventional estimations of the vitality of the Celtic

Tiger' (2003, p.21). While Intel Ireland is currently celebrating its 25th anniversary, other companies such as Gateway, 'which came and went in Ireland over an eight-year span' having been 'wooed by the Irish government in an attempt to improve the country's economic performance and technological profile' (Salerno-O'Shea, 2002, p.131), contribute to a narrative of corporate withdrawal. Quite aside from the impact that the arrival and departure of these companies has on individual employees, their presence, for however long, undoubtedly contributed to the internal and external perception of Ireland as a natural habitat for computer technology. A key element of this is the significance attributed to the role of Irish locations in the development of consumer-grade computing. As Lillington puts it, 'Ireland has done very well out of this increasing prevalence of ICTs' particularly in the transitional period from 'hulking computers controlled by a trained engineering priesthood, to the nimble, egalitarian world of the desktop computer and laptop' (2004, p.68). While the research and development departments of Irish-based multinationals are now as advanced in Ireland as anywhere in the world, a more localised narrative reinforces the rhetoric that these are 'Irish companies' bringing technology into Irish homes. Intel Ireland is particularly proficient at this through the sponsorship of science fairs and a high-profile Transition Year programme. In other words, the embeddedness of these companies in the Irish economy, whatever their providence, has also resulted in an embeddedness in Irish society. The consequence, according to Haahr, can be viewed as a move towards Castell's idea of the 'network society'; observing in Ireland 'the pervasive presence of the network as opposed to the hierarchy' or 'society as a set of nodes' (2004, p.42). It is a pleasing notion, the idea that our increasing reliance on the network might inspire a more egalitarian social structure. In Haahr's construction, however, Irish society is increasingly connected, yet implicitly, further isolated as separate 'nodes'. It is surely revealing that this reimagining of Irish society, within and beyond the Celtic Tiger, takes up the imagery of the computers which have shaped it. Computers and economic growth have, in fact, become irrevocably linked. Even for those who are understandably cynical about the significance of the Celtic Tiger, the vocabulary of computers seems to provide the only suitable language for the debate. When Thomas McCarthy bemoans the replacement of the Irish drive towards nationhood with a striving towards prosperity, for example, he argues that the 'software of our past has been rebundled to suit the present task of Irishness', with the Celtic Tiger emerging as 'our great new invention' (1997, p.120). Perhaps even more so than his use of

cyberculture vocabulary, McCarthy's expression is fixed in the Celtic Tiger moment by his use of 'our', even if the intention is satirical. The very term 'network society', just like the concept of 'Irishness', is based on unachievable notions of collective identity. A strong economy, however it is established, patently does not equate to universally improved conditions for all citizens. The success of the Celtic Tiger depended upon the hard work of those who would never be proportionately rewarded. The use of collective nouns and the rhetoric of collective success portrayed the economic and social advantages as universal. This idea, that the benefits were to be fairly distributed, is 'perhaps, the most pernicious of the myths that have bloomed during the Celtic Tiger era' (Coulter & Coleman, 2003, p.21).

Beyond the pale

In *Fox, Swallow, Scarecrow*, Anna's lover Vincy claims that 'Ordinary Irish people were now aristocrats' and should, therefore, 'be learning to behave in kind' (p.277). In many ways, these 'ordinary Irish people' are the most visible consequence of the Celtic Tiger, 'affluent, secular, self-absorbed' and characterised by 'multinationally fueled materialism' (Gillespie, 2008, p.43). Yet it remains quite clear, both within the novel and beyond it, that their experience of these years is not wholly representative. As Cahill points out, in the novel, Anna 'literally throws money away' to the homeless, although perversely, even her act of charity simply 'fuels more consumption' (2011, p.163). While her motives are dubious at best, Anna's superstitious habit highlights the poverty which runs adjacent to her prosperous life. Furthermore, in a very literal way, her wealth prevents her from fully recognising the homeless. Even as she hands money to a man on the street, he defies her classification, becoming 'the hobo or the homeless man or the tramp or whatever he was' (p.93). Whatever the man is, it is clear that he is not at all like her, at least not in any way that she can articulate. In fact, the recurring figure of the homeless man is, by some measure, far easier to classify than Anna is. As Allen observes, while there are numerous studies of poverty, 'very few have appeared on exactly how the Irish rich operate' (2000, p.58). To the contrary, the newly formed Irish aristocracy seem determined to actively avoid publicising the details of their wealth or the exact source of its acquisition. All the more reason then that literature must step in to offer revealing or interrogative representations of lifestyles made possible by the specific circumstances of the age. In the aftermath which followed the Celtic Tiger, it is perhaps unsurprising that the extremely

wealthy would want to avoid discussing their part in what was at best misplaced faith, at worst wilful neglect of the most vulnerable. Even as it became apparent that whatever benefits the Celtic Tiger brought would not be equally distributed, large sectors of the population continued to believe the seductive 'rhetoric of economists' and their assertion that 'economic growth would create a good and just society' (Kirby, 2005, p.41). Although there had always been disparities in income caused by inequalities in education or through the structures of land ownership or inherited businesses, there was a prevailing perception that poverty was a matter of relative scale. With the sheer pace of cultural change brought about by the Celtic Tiger, in tandem with the move towards less censorious language, 'poverty' disappeared altogether, only to be replaced by its contemporary equivalent, 'social exclusion'. In this terminology, society as a whole is seen to have progressed, leaving behind, as Allen puts it, 'a residual category' unable to keep pace (2000, p.36). It is a highly revealing term, since, while we are accustomed to hearing of the socially excluded, we are rarely acquainted with the social excluders who are implicitly culpable. There is also a sinister neutrality in social exclusion; the exclusion might be institutional or structural, but it seems equally likely to mean failure at an individual or, at least, familial level. In *Fox, Swallow, Scarecrow*, Ní Dhuibhne's socially excluded clearly bear the marks of a society they no longer fully belong to: an Eastern European cleaner who was once a teacher; a homeless man reading *War and Peace* on the doorstep of the Heraldic Museum.

If Ní Dhuibhne's novel toys with reader expectations by presenting characters who are simultaneously excluded by and deeply embedded in Celtic Tiger Dublin, it is in contemporary Irish film where marginal lives have been most fully explored. Jenny Knell's account of the 'Celluloid Tiger', for example, traces a contemporary history of Irish working-class cinema, beginning with the popular adaptations of Roddy Doyle's Barrytown novels in the 1990s and their portrayal of 'urban decay and working-class suburbia' (2010, p.213). While these films provided a gently political, comic portrayal of working-class Dublin, more recent films such as Lenny Abrahamson's *Adam & Paul* (2004) offer 'searing, unsentimental portrayals of individuals who have been systematically ignored by society' (Gillespie, 2008, p.48). The urban decay which forms the backdrop in Abrahamson's film makes the Doyle adaptations seem as cartoons. Here, protagonists Adam and Paul seem to walk through a different city from the affluent Dublin barely visible in the background. The film follows the two men through their repeated 'failures', acting out a tragicomic reminder of the 'ugly economic consequences for the

working classes that counterbalance the middle class affluence of the Celtic Tiger' (Gillespie, 2008, p.48). For both Gillespie and Knell, *Adam & Paul* is notable precisely because of the revealing contrast it affords. As Knell puts it, the film renders 'its marginalized protagonists visible while highlighting problematic and exclusionary Celtic Tiger Dublin' (2010, p.229). The Celtic Tiger, in this formulation, is a phenomenon of extremes; two entirely distinct groups of people, operating within the same city but in different worlds.

The representation of Irish society in *Adam & Paul* offers cinematic evidence to the claim that 'Ireland has been, and is becoming more so, one of the most unequal societies in the developed world' (Keohane, 2008, p.121). The characters' lives, marred by addiction and chaos, are indeed the opposite to Anna Kelly's prioritisation of clothes, cars and computers. Nevertheless, in terms of cultural expression, there is more than a hint of Beckettian futility and Joycean wandering about these characters. So while they certainly represent an under-explored side to contemporary Irish life, they remain, in many ways, canonical. That said, the film makes multiple points specific to contemporary Irish society; one of the most noteworthy (and amusing) scenes in the film occurs when Adam and Paul speak to a Bulgarian man, thus raising the topic of immigration. During the encounter, Adam and Paul privilege Ireland as the promised land of the EU, apparently oblivious to the scene around them, not to mention their own appearance. Abrahamson's inclusion of this scene, and in particular the Bulgarian character's defence of his own country, provides a commentary on the misuse of immigrants and refugees as scapegoats. As the film indicates, the attempt to shift attention from the politicians' failures and corruption onto 'the refugees who were taking scarce resources' (Allen, 2000, p.173) ought to be a source of national shame. While the mistreatment of immigrants is clearly unacceptable, the pace of change in Ireland 'from a homogeneous to multicultural population in less than twenty years' has proven disorientating for some (Bonner, 2011, p.52). Certainly, both *Adam & Paul* and *Fox, Swallow, Scarecrow* present the Celtic Tiger and its fallout as rending further inequalities in this short space of time. Whether on the grounds of wealth, ethnicity or nationality, they suggest, contemporary Ireland is a divided society. Where both are less overt, however, is in the matter of gender. For women in particular, the category of social exclusion finds various expressions across socio-economic circumstances. While the well-off Anna risks the loss of her whole 'civilisation' through divorce, for example, the less fortunate permanently teeter on the edge of society through precarious work or gendered inequalities in pay and conditions.

In the decades which bridged the turn of the twenty-first century, cultural and economic shifts led to a huge rise in the proportion of women in paid employment in Ireland (O'Connor, 2007, p.65). The removal of the 'marriage bar' and the number of women studying at degree level led to a larger pool of qualified women, yet as Pat O'Connor observes, the figures are hardly indicative of gender equality. In 2007, the number of women in professional roles was still undermined by the fact that they were 'rarely at the top of such structures' (2007, p.66). It is particularly marked that during the Celtic Tiger, women were not always adequately rewarded for their contribution to the growth in the Irish economy; particularly for those in casual employment in the service industries. For the majority of women, the Celtic Tiger meant the 'creation of a large body of badly paid jobs' as well as the ongoing problem of long-term unemployment, so that the economic boom was 'accompanied by growing levels of poverty' (Coulter & Coleman, 2003, p.23). Work was often part time, poorly paid, non-unionised and lacking in standard benefits and entitlements (Drew, 1992, p.95). As Sinéad Kennedy demonstrates, the gender pay gap and continuance of low pay was especially prevalent in traditional 'female roles' such as cleaning, creating the 'double burden' for women trying to 'reconcile work and family life' (Kennedy, 2003, p.107). Yet at a professional level too, women were disadvantaged by the economic boom. As Kennedy explains:

> The majority of new female employment is in the service sector, many in jobs that used to be relatively well-paid, high status male jobs, such as in computers [...] which have been deskilled and demoted in the job hierarchy.
>
> (2003, p.96)

Even when women were provided with the opportunity to take on careers in technology, in other words, the roles themselves were often devalued by their very presence. Since, as shown above, computer technology was at the core of Ireland's most significant recent period of economic growth, exclusion from computer technology meant exclusion from the economy and society. The 'haves' and 'have-nots' in this sense are not categories of money but of technology, a scenario known as the digital divide. In the very simplest of definitions, the term 'digital divide' refers to 'the gap between those who have access to technology and those who do not; between those who have the expertise and training to utilize technology and those who do not' (Cooper & Weaver, 2003, p.3). Through social and educational biases, women are

particularly vulnerable to this, all the more so when excluded by means of poverty. With the supposed ubiquity of the internet and home computing in contemporary Ireland, it is easy to forget that until the early 1990s internet technology was almost exclusively restricted to those in university, research and military contexts. While middle-class access to computers and internet-enabled devices is at an all-time high in Ireland, there are still those who lack access to public services because they lack access to the internet. Government and industry policies have long proclaimed plans to roll out better facilities, notably in schools. However, such projects are rarely purely socially minded, but rather respond to concerns by businesses that the Irish infrastructure is 'struggling to keep up with demand' (Sowinski, 2006, p.68). Bridging the digital divide is, more often than not, a means of attracting foreign investment through a suitably efficient workforce, rather than necessarily opening up the benefits of the internet for its own sake. Nevertheless, the internet is a technology supposedly born out of equality. As Wertheim has it, 'If cyberspace is to become a truly equitable place then we are going to have to face the question of how to ensure *everyone* has equal access' (2000, p.291).

The flexible woman

While analyses of the Celtic Tiger phenomenon are, by their nature, informative of the Irish context, they can create a misleading impression that such events were unique to Ireland. While there were, undoubtedly, elements specific to the Irish case, the contemporary period has seen global shifts in constructions of the working class brought about by new technologies. On an international scale, for instance, theorist Manuel Castells has observed the economic necessity of 'flexible women', just as Donna Haraway has described the structural impact of the technologies which have made these modes of work possible. These influential approaches are summarised by David Bell, who outlines the 'underemployment, casualization, insecurity [and] lack of welfare' which can leave women vulnerable to being 'switched on or switched off, valued or discarded' (2001, p.105). As Bell continues, these transformations are not limited to the workplace but extend into the home, so that even leisure and intimacy are 'restructured by science and technology' (p.105). It is for precisely this reason, the public and private impact of cyberculture, that the novel is such an ideal form in which to explore Irish manifestations of global transformations. Through its representations of the protagonist's work and private life, Roddy Doyle's *Paula Spencer* (2006) provides the archetypal representation of the Irish

'flexible woman'. The sequel to the 1996 novel, *The Woman Who Walked into Doors*, *Paula Spencer* is an account of cleaner and recovering alcoholic Paula as she attempts to rebuild her life. The novel is representative of Doyle's oeuvre, featuring the familiar 'urban working-class realities, unemployment [...] dysfunctional families and spousal abuse' (Persson, 2006, p.63). Yet while the themes may have remained depressingly relevant, this novel takes place in an altogether different Dublin from those which provided the backdrop to Doyle's popular novels in the 1990s. Nine years have passed between the two texts featuring Paula, during which time the city has changed dramatically around her. Dublin has become a city of arrivals and the Eastern Europeans she cleans with and Nigerian checkout girls she buys her shopping from symbolise the personal and global imperative to move on. Similarly, Paula's alcoholism, the wrong kind of excessive consumption, marks her as out of step with the restrained and sophisticated newly developed taste for 'wine consumption' and 'eating out' (Bonner, 2011, p.61). Although working hard in a number of commercial and private cleaning jobs helps Paula to build domestic stability, she remains excluded from the lifestyle enjoyed by her sisters with their holiday homes in Bulgaria. In a very obvious sense then, this is a novel about displacement. The internationalisation which surrounds Paula, for example, serves only as further evidence of her stagnation, just as her striving for more shows how little she has. Through her work she exists on the periphery of society, cleaning offices once the workers have gone home, ironing other people's sheets in empty houses. But just as importantly, she is acknowledged as one of many in this state of transition: 'There's plenty like Paula. Although it's changing, the whole place' (p.12). Paula's experience, looking in on the Celtic Tiger, reflects the fact that although 'absolute poverty has clearly decreased over the last thirty years in Ireland, relative poverty has increased' (Foster, 2008, p.12). For Paula, this is made particularly apparent in her desire to save up enough money to buy her son a computer, epitomising the concept of the 'digital divide'. While web-based technologies may be increasingly sophisticated and user-friendly, access still depends on owning the necessary equipment and the ability to pay for data costs such as home broadband or network charges. For Paula, owning a computer represents a major step back towards the society from which she is excluded.

Domestic technology

In contrast to the gadget-filled houses she cleans, the technology in Paula's home (in parallel to her body) is worn out and overused. From

the outdated kitchen clock to the decrepit washing machine, the novel bears witness to the failure of domestic machinery and its gradual replacement with new technology brought in by (or at least, for) her children. From the new American fridge, television, mobile phones, stereo and finally a computer, the more devices that come into the house, the more successful Paula feels. But it is the purchase of a computer for her teenage son which finally signifies her belated acceptance into a cosmopolitan, cyberliterate Ireland. Taking the Dart home from her cleaning job, Paula proudly thinks of 'the brochures in her bag. Dell, Gateway, Intel [...] They all looked lovely' (p.44). Since the information technology sector was and remains 'the most visible portion of the new Irish economy' (Salerno-O'Shea, 2002, p.127), its influence naturally extends into the private lives of individuals. As the novel demonstrates, the rise of the technology sector in Ireland during the Celtic Tiger went beyond the concern of media commentators and economic analysts, shaping the products and lifestyles Irish people desired. In Paula's case, the new computer functions not only to strengthen her relationship with her son but also as a visible link to her community and society. The more she learns how to use the computer, the more included she becomes. Although the computer, as an object within the home, mirrors the other renewed domestic technology as a symbol of stability, its futuristic functions set it apart, literally ensuring that she remains part of the (virtual and actual) community. Paula's victory in saving for and buying the computer is a key marker of her recovery, but it is when she learns to use the computer herself, via her teenage son Jack, that she really begins to see it as truly restorative.

> He went on-line. She watched him. It looked easy enough. Then he typed something – she leaned closer to the screen – www.google.ie.
>
> It's a search engine, he said. – A bit like a library.
>
> (p.122)

Despite his embarrassment at 'his mother's attempts to keep up with pop music or use the internet' (Trilling, 2006, p.59), Jack explains the internet to his mother by translating it back into literary terms, as he says, Google is like a library. As the novel continues, it is her increasing confidence, in life and online, which measures the progress in their damaged relationship. Beyond the context of the novel, this event captures in fiction a moment of cultural transition with genuine literary-historical value. The very idea that Google needs explaining, or for that

matter, the presence of Paula's Polish neighbours who work for Google, are literary-historical touchstones in the timeline of Irish cyberculture. When Jack shows Paula how to Google her own name or to search websites on Thin Lizzy, we see the remarkable become ordinary as she adapts to the processes of the internet: 'He clicked again, at other pages [...] It was safe now; she knew what it was' (p.124).

After these initial supervised visits to cyberspace, Paula's greatest victory in the novel comes when her presumed lack of knowledge about computers works to her advantage. When Jack is suspended from school for writing comments about his teachers on the website 'ratemyteachers.ie', Paula hatches a plan to have him edit his words online to confound the teachers' printed evidence. Her pride at becoming a 'tactical genius' (p.210) grows not only out of impressing her son but in gaining unexpected power over the computer. These are moments which might be easily overlooked in Doyle's novel. As dictated by the narrative strategy, they are small examples of personal success against a backdrop of routine, recovery and domesticity. Indeed, the dramatic action in *Paula Spencer* is punctuated by mundane activities such as making soup and changing sheets (although the symbolic significance of these acts is much more than this); going online is simply another domestic task. This is not a novel about computers, far from it, but it is a novel about a particular person living in Ireland at a particular time, during which nothing else could so neatly symbolise personal and national progress as going online for the first time.

The other side

The concept of the digital divide draws a distinction between those with access to and knowledge of digital technologies, and those without. Understandably, these differences also have an impact on attitudes towards technology. While Paula overcomes her socio-economic disadvantage to bring a computer into her home, it retains an aura of enchantment – in the house but of the future. Just as earning the computer had been a marker of personal success, owning it remains a precarious privilege; she might lose it far more easily than she gained it. On the other side of the digital divide, however, are those for whom computer ownership is merely an expectation. Having the means to replace computers with the latest upgrades or supplement them with additional gadgets, shifts the perception of computers from desired object to necessity. Computers may be more affordable for this sector of Irish society but they are no less

troublesome. As Kieran Keohane explains, the 'accelerated modernization' and increased secularism which characterised Celtic Tiger life also brought with it the attendant problems of 'existential anxiety, inner loneliness and boundless egoism' (Keohane, 2008, p.119). In other words, far from creating a hyper-connected community of Irish cyber-enthusiasts, unrestrained access to web technology may have created a generation of isolated individuals, without a higher authority available to intercede.

The real difference between Paula Spencer's experience of cyberculture and that of her more affluent neighbours then, is the cultural value attributed to computers. What for Paula is a highly sought-after status symbol, is for those like Anna Kelly in *Fox, Swallow, Scarecrow,* simply a standard domestic technology. As I'll argue here, this casual incorporation of computer technology is perhaps the best indication of cyberculture's true integration into Irish literature. In Anne Enright's 2011 novel *The Forgotten Waltz,* for example, the internet is always present, in the background, significant mostly for its quiet omnipresence. The novel includes all of the day-to-day technology of our time, so taken for granted that it would seem odd or inaccurate without it. There are iPods, mobile phones, children playing Nintendo and a protagonist who works with 'European companies, mainly on the web' married to 'a happening geek' with a 'Masters in multimedia' (Enright, 2012, p.12). More significant still is the way in which the individual's particular engagements with technology are shown as reflections of their personality. Computer technology, in other words, provides metaphors as well as props here. While Claire Bracken's claim that Enright privileges twentieth-century technology over the 'digital and cyber technologies of the new millenium' (2011, p.185) in her writing was accurate when made, it must be revised in light of the *The Forgotten Waltz.* Here, for example, protagonist Gina Moynihan describes how the 'internet was made for Conor', her husband, in order to show that 'he was always interested but could never settle on one thing' (p.18). The comparison is clear, Conor is like the web, in constant flux, perennially unfinished. Observations of Gina's brother-in-law go even further, merging man and machine by noting how he 'opened a bottle of red, sat on the rug and shut down, massively and at speed' (p.25). Unlike Doyle's novel in which access to cyberspace must be earned, here it is expected and required. As a result, technology forms part of the novel's landscape, including the main narrative which is formed out of Gina's account of events leading up to and including an affair.

The plot of *The Forgotten Waltz* centres around a relationship which begins at a conference in Switzerland at which the protagonist is speaking on 'International Internet Strategy' (p.32). As this first infidelity becomes an established affair, back in Dublin the lovers prioritise taming the technology, keeping liaisons in hotels secret by ensuring 'No emails, no paper trail, just two, instantly deleted texts' (p.62). While the narrative is shaped as a reconstruction, recalling the spontaneity and instinctive attraction between the lovers, the computer acts as cyber spy, upholding 'the verifiable truth, reconstructible through emails here on my computer, calendar entries' (p.47). This is a novel very clearly couched in human interactions – love, lust, infidelity, guilt – but as a novel of the late 2000s in Ireland, these very concepts are only really explicable via the technology which surrounds and defines them. In the depths of the affair, for instance, Gina observes her husband:

> sitting in the armchair, his face blue in the light of the screen, and nothing moves except the sweep and play of his finger on the mouse pad and his thumb as it clicks.
>
> (p.70)

Conor's paralysis, at the screen as in life, shows him passive in response to his wife's adultery; he is illuminated by the light of the screen and blind to the events taking place before his eyes. Gradually reconstructing the stages of the affair and their ultimate culmination in the same stagnation, marriage 2.0, Gina implicates her husband Conor by blaming him for the encroachment of the virtual in their real lives. Reliving old frustrations, she bemoans the domestic drama of the flooded washing machine he incorrectly installs before going 'back to play Shattered Galaxy' (p.72) *Shattered Galaxy*, a real online multi-player game, set in a post-apocalyptic future (and so appropriately named for the destruction of a marriage), brings together the real conflict of the domestic dispute with online virtual warfare. Gina's frustration here is multilayered; Conor has neglected his responsibilities as a husband to engage in childlike games – he plays rather than provides. More importantly, by retreating into cyberspace he becomes necessarily absent from the real world. As Gina recalls:

> The whole internet thing maddened me, by then – I can't remember when it happened, when Conor at the cutting edge turned into Conor hanging out with a load of wasters online.
>
> (p.72)

Although apparently disconnected in Gina's recollection, Conor's withdrawal into cyberspace coincides with her affair. He seeks comfort and company in online gaming just as she later seeks comfort in the ritual of checking her emails when finding it 'hard to settle' (p.152). The verb 'to check' is revealing in this context, suggesting an anxious confirmation that the emails are still there, as well as an implicit threat posed by the messages which demand nurture and attention. While Gina looks to her emails for companionship, the presence of technology in the absence of human company is also shown as potentially disturbing. When exiled from her family and separated from her lover at Christmas, for instance, Gina's loneliness is underlined by the failure of technology, the sheer 'nothing on the internet' (p.158). On this most sociable of days, the internet fails to distract or comfort, rather it emphasises absence, empty for all its supposed capacity. The failure of cyberspace to soothe Gina is further reinforced as she imagines her lover Seán at home with his family, marking his daughter's technological coming of age as she unwraps 'her first laptop' (p.152). Alone, Gina thinks about her lover 'all day: his daughter sitting at his feet, writing her first email, *Hello Daddy!*' (p.181). The email, sent at redundant proximity, is in the most narrow sense pointless, since father and daughter are within touching distance. At the same time, the child's first email captures the wider theme of frustrated communication on which the whole novel stands.

This contemporary Irish Christmas, shaped by interactions with computers, confirms *The Forgotten Waltz* as a novel tied to a precise time and place. As Hermione Lee puts it, the novel takes place at:

> the end-point of the snow-bound winter of 2009, when Dublin has ground to a halt and the streets are empty and blanketed, as if in a faint tribute to the end of Joyce's great story of love, loss, family and nation, 'The Dead' [...] This Ireland of the 2000s is dead, too: the bubble has burst, the boom is over, all the buying has stopped.
>
> (Lee, 2011)

Indeed, it is precisely this lack of buying which holds Gina in stasis. Back in her childhood home, unable to sell her late mother's property, the internet provides a ghost archive of memory. She sits alone, aware that the house surrounding her is simultaneously available 'on the internet for anyone to click on and dismiss' (p.181). By placing the property details online, Gina opens up the private spaces of her childhood to a public gaze, tuning into the 'shifts in the cultural imaginary and

the relationship between past and present, remembering and forgetting' (Bracken & Cahill, 2011, p.5). In this way, the connection with Joyce's 'The Dead', as highlighted in Lee's review, is revealed further, not least in the way both narratives convey the isolation of individuals within a relationship. The bubble has indeed burst and not just in terms of the property market. The regression and stagnation which accompany Gina's failure to sell the house also taint her new relationship. Indeed, the supposed upgrade from Conor to Seán soon reverts to a reconstruction of the same patterns, with her new lover acting as if programmed: 'He comes home late, he goes out to the gym, he gets stuck on the internet' (p.179). Just as Conor had retreated into his *Shattered Galaxy*, Seán is ensnared online, his connection with the computer creating a barrier from his lover. All of this, in the 'snow-bound winter of 2009', binds technology to coldness; the absence of human touch in the guise of communication. By the late 2000s, it seems, the internet was general all over Ireland.

Digital convergence

The concept of the digital divide draws attention to the inequalities caused by discrepancies in access to technology. Yet as the novels discussed above demonstrate, once access to cyberculture is established, the consequence is multiple forms of connectivity. Whether between parents and children, lovers or strangers, *Fox, Swallow, Scarecrow, Paula Spencer* and *The Forgotten Waltz* portray the various links computers forge between people. While these person-to-person bonds are clearly significant in any discussion of Irish cyberculture, the more revealing relationship is surely that between person and machine. As these Irish novels demonstrate, this relationship, like any other, is formed out of an emotional response. As Sherry Turkle has it, computers have become 'culturally powerful objects' precisely because people are 'falling in love with their machines and the ideas that the machines carry' (1996, p.49). This 'love' for computers grows out of a dependence on the predictability and reliability they represent. In some cases, this may emerge as a direct rejection of human relationships, in others, it reads as self-absorbed narcissism. After all, the computer allows the user to project their own needs and desires onto it. In some cases, this blurs the distinction, as in Enright's preference for the 'body-machine compound' (Bracken, 2011, p.186). In this way, the computer can both replace another human body and become an extension of one's own. This convergence between the body and the computer is, predictably,

most apparent in those two most bodily of human experiences: illness and sex.

As several critics have acknowledged, one of the most significant lost opportunities of the Celtic Tiger era was the failure to develop public services, particularly health care. Instead, dilapidated hospitals and increased private costs have contributed in no small way to the contemporary preference for turning to the internet for free health advice. In Roddy Doyle's short story 'The Photograph', the protagonist follows his doctor's advice to research his new diagnosis online:

> He googled it when he got home, and for a few stupid minutes, he wished he had cancer. It was fuckin' disgusting. *Diverticula are pockets that develop in the colon wall* [...] His finger was on the screen, under each word.
>
> (2011, p.20)

The story reveals the way in which access to information about the body has changed. No longer the result of a doctor looking inside the body, the patient now looks out to cyberspace through the screen. Importantly, this online information is visual as well as textual, making the unseen all too visible. Viewing intestines on the computer screen, even when not his own, causes the protagonist to experience a symbolic disembowelling, making him disgusted by his own body. The prevalence of medical websites and the associated hypochondria is a well-established aspect of contemporary cyberculture. At best providing patients with increased knowledge in diagnosis and treatment, at worst instigating further confusion and anxiety. Doyle had explored the use of such websites a few years previously in *Paula Spencer*. When her sister Carmel is diagnosed with breast cancer, Paula goes online to search the term 'Mastectomy' and is overwhelmed by the number of 'clicky words' and cold, technical information she finds there (2007, p.233). Here too, the information on the screen causes Paula to revert back to her own body, instinctively touching her nipple as she scrolls through the numerous websites. Similarly, in *The Forgotten Waltz*, Evie's ambiguous illness, a form of childhood epilepsy, leads her parents to turn to the internet as a twenty-first-century replacement for prayer. Without alternatives, the internet becomes the medical oracle, a source of comfort and empowering knowledge. Yet it is also in direct response to the 'many late nights on various websites' that Evie's mother convinces herself that there is 'something seriously wrong' (p.192). Evie's general presence, and more importantly, the fact that her illness is at the core of the novel, constructs an additional layer of guilt behind the affair. The fact that

the full implications of the illness and successful treatments remain out of reach, in spite of 'many hundreds of hours on the internet' (p.197), makes it even more so. Across these examples of contemporary Irish writing, the malevolent presence of serious illness is better understood, but also further amplified by recourse to the internet. Towards the end of *The Forgotten Waltz*, when the now-teenage Evie starts to become ill again, her mother Aileen is drawn back into old habits, 'on the internet every night, googling "absences", "lesions", "puberty"; inviting it all in' (p.215). As Gina's narration makes clear, the knowledge offered by the internet does not always equate to more power.

Online intimacy

These fictional accounts of medical internet searches are a reminder of the ultimate divide between the body and the machine. However far the computer may reach into the bowels, brain or breast, it comes no closer to understanding the person. Yet even with this rational knowledge, the allure of the computer is such that, at its most convincing, it seems to be alive. In an interview with Claire Bracken and Susan Cahill, Anne Enright acknowledges her tendency to put 'the organic against the inorganic' as part of a broader fascination with machines (2011, p.26). In *The Forgotten Waltz*, Enright returns to this idea by presenting the computer as a potential site for sexual infidelity. When Gina searches through husband Conor's 'browsing history', she is disappointed to find it 'completely unremarkable [...] at that stage I would have been happy to find porn' (p.72). While Gina's affair is so traditional as to border on cliché – an irresistible physical attraction to a colleague – Conor's is virtual, rejecting the real world for the (apparently unsexual) embrace of the cyber. She searches him for incriminating evidence, not by rifling through his pockets or reading secret letters, but by reviewing his browsing history, following his tracks in cyberspace. And yet, still the computer fails to reveal anything about Conor's body. Conor's addiction to *Shattered Galaxy*, however, does sketch a very particular form of intimacy with the computer. Time on the computer equates to absence from his marriage, leaving Gina a gaming 'widow' (King & Borland, 2003, p.222). Certainly, the very fact that Conor is able to withdraw from life in this way dates the novel to the age of sophisticated online gaming. Equally, Gina's expectation, or even anticipation, of finding pornography on her husband's computer is symptomatic of the era. For both partners, the computer is presumed to offer a physical interaction, whether the adrenaline of virtual warfare or the arousal of sexual images. The real impertinence of Gina's spying is, of course, the

fact that she is actually having an affair. Her search through Conor's browsing history and her criticism of his online gaming are, by this measure, misplaced if hopeful attempts to construct the computer as a genuine rival.

Whether as romantic rival or misleading medical oracle, the computer's power in these novels is emphasised by its familiarity. Even for Paula, for whom the computer is hard-earned, the machine soon becomes a domestic technology, albeit one with more 'brain-power'. In Doyle's novel, the computer marks Jack's bedroom as the hub of the household's external information. As the youngest member of the family, Jack is also, by default, the family's internet expert. By contrast, the more up-to-date technology in *The Forgotten Waltz* disrupts this standard domestic geography by displacing the home computer from its fixed location. Here Conor can move around the conspicuously stylish flat, 'sitting at his laptop like a demented organist, cursing the internet connection' (p.15) or even going online at a funeral via his smartphone. The relative newness of the internet as mobile shifts the location of the 'computer' from the home and onto the body. While cyberspace may be considered an imaginative endeavour made tangible, it remains the case (at least for now) that physical objects are needed to access it. The laptops, tablets and mobile devices, whether pocket-sized or desk-bound, are the physical things we touch in order to get access to virtual worlds and must not be overlooked. The swiping of fingers and rotating of screens, the increasingly intuitive 'natural' interactions, all place the body in contact with the portal to the imagination. It is, after all, the relationship we develop with these devices which constructs the forms of intimacy described above. For Bell, one of the reasons computers have been so readily accepted into our domestic spaces is their essential familiarity; the fact that 'the computer still looks like a television and a typewriter' he argues, reveals how technologies 'bear the impress of previous genres' (2001, p.43).

Gadgets

In one sense, Bell's comparison already feels out of date, since tablet computers such as Apple's iPad or Google's Nexus have recreated our expectations of screens and keyboards. Yet while tablet computers may be the next generation of devices to bring cyberspace into Irish homes, they remain, as Bell has it, visibly related to 'previous genres'. Where they differ, perhaps, is in their explicit claim on an intimate relationship with their owners. As Simeone explains:

the 'i' of the iPod, iMac, iPhone, iPad, and numerous Apple software applications is merely a lower-case prefix to a self-descriptive title beginning with an upper-case letter.

(2011, p.354)

In short, these are devices with their own identity, albeit one that is barely distinguishable from the 'I' who operates them. At the core of this is the well-established notion that computers have infiltrated the very ways in which we think and feel. The idea has become all the more convincing with transportable devices since the computer has ceased to be an adjunct to the home and can be viewed instead as an extension of the most computer-like organ, the brain. Computers then are not simply machines which think for us, but have become 'the postmodern era's primary objects-to-think-with' (Turkle, 1996, p.48). While the comparison of brain and computer is understandably tempting, the 'brain-as-computer metaphor is patently unstable' (Simeone, 2011, p.337). Turkle's concept of the computer as an object we think 'with' might, therefore, be more effectively nuanced into an object we think *through*. In contemporary Irish literature this is revealed in the language and imagery of computers as indistinguishable from the function of the human brain. When Gina obsesses over a potential future with Seán, for instance, her mind, as if programmed, 'wipe[s] the thought, fifty, sixty, a hundred times a day' (p.55). Just as a computer allows the erasure of 'history', Gina tries to programme her thoughts away from an imagined future. Her attempt at self-control is destined to fail precisely because it falsely associates computer-like functionality with idiosyncrasies of the mind. As the novel attests, far from being unable to erase the idea of an imagined future, Gina, brain and body, makes it happen. Gina's inability to 'wipe' her imagination as a computer wipes memory files is no more than a recognition of her humanity. What it also does, however, is act as a reminder that our engagement with computers is as much about our eyes and hands as our brains.

When Seán first arrives at Gina's workplace, after their initial sexual encounter, it is the shock of the absence of technology which marks him out as unusual:

I couldn't think what was wrong with him. He was using a fountain pen – but that was all right, wasn't it? – his BlackBerry was neatly displayed on the table beside him.

(p.50)

Seán is flanked by gadgets, one from the last century, one very much of this. Carried on the body, both the 'fountain pen' and the 'BlackBerry' are technological prostheses by which others, in this case a prospective lover, can read him. For Simeone, 'the gadget is a technology of the imagination' (2011, p.356), but it is surely also a technology of faith. Seán's BlackBerry, obediently awaiting his instructions, sits 'beside him' as a faithful companion. Yet the dependence is only one-way. Seán's relationship with his BlackBerry is built upon a foundational expectation that it will work. As in religion, the object becomes the tangible means through which to enact a relationship with the unseen. Extending this, there is something more than reminiscent of the rosary in the fidgeting, half-conscious clicking movements of those who constantly caress their smartphones. Paula's mobile phone, by contrast, is just a basic model, but it is still through this device that she rebuilds the network with her children and sisters by learning to send text messages. Unlike affluent businessman Seán, surrounded by laptops and smartphones, Paula is awkward as well as enthusiastic with her mobile phone. The gadget creates a network of contacts, while at the same time revealing her vulnerability. In a recent Eircom survey, the Irish obsession, or perhaps addiction, with mobile phones and internet-enabled gadgets emerged in full (Eircom, 2013). Perhaps the most revealing finding was the 46 per cent of people claiming to sleep better with their phone next to the bed. The gadget is perhaps less about reaching out to others than we might assume. As the survey suggests, gadgets bind person and machine, acting as a digital comfort blanket.

Consumption and exclusion

If individuals feel vulnerable without their gadgets at their bedside, it is as nothing to the impact the large-scale reliance on the technology sector has had on the Irish economy. Current and future risks have been reinforced by a series of closures, including Gateway's 2001 withdrawal from Ireland, evoking 'a national discussion on the inevitable risks of an economy driven by foreign investment' (Salerno-O'Shea, 2002, p.126). One thing that remains stable in the face of economic uncertainty, however, is the fact that 'the technology has not gone away' but rather, heralds the 'beginning of a massive, technology-driven transformation of daily life' in Ireland (Lillington, 2004, p.69). As this chapter has shown, the presence of hugely significant multinational technology companies, as well as global progress in the domestication of computer technology, has already led to a marked change in cultural attitudes

reflected in literature. Yet this brave new world of new technology is contentious, forming part of a more general concern that contemporary Ireland has seen the 'replacement of Irish national identity with nothing in particular' (Haahr, 2004, p.42). With the advent of affordable home computing and internet access, the criticism goes, came an Irish society morally, socially and culturally preoccupied. Certainly, Peadar Kirby's condemnation of the Celtic Tiger as an 'orgy of conspicuous consumption' (2005, p.42) has obvious resonance with this point, since nothing is quite so conspicuous as the gadgets contemporary Irish people carry about their person or place within their homes. Nevertheless, it is important to recognise that these relationships with gadgets, and computers more generally, are sensual as well as intellectual. This is all the more so with handheld gadgets which, sitting in the palm of the hand, seem to bring the internet in direct connection with the body. It is perhaps on this basis that Simeone can view gadgets as a truly 'influential metaphor for how people imagine their relationships to digital technologies' (2011, p.355). These are ideas which have been taken to further extremes by digital theorists, not least of all Donna Haraway's groundbreaking work on cyborgs. Haraway famously defines the cyborg as 'a cybernetic organism, a hybrid of machine and organism, a creature of social reality as well as a creature of fiction' (1991, p.149). In the contemporary Irish novels discussed above, the characters, through their various relationships with computers, might be seen to edge ever closer to a merging of human and technology. Yet this theory, however tempting, falls down in the Irish examples considered here at the revelation of human fallibility. It would be more accurate, in the case of these novels, to think in terms of the levels of intimacy people create with machines. The characters here might not become machines in any meaningful way but they do indeed begin to think through, and in some cases, as them. At the end of *Fox, Swallow, Scarecrow*, Anna Kelly wakes in hospital, finding her thoughts muddled and memories obscured. Here, it is not so much a case of human as machine, but the invocation of the internet as simile which demonstrates the character's submersion into cyberculture. The image, once rarefied, now presumed to be universally understood, brings together the human brain and its analogue, the computer.

> Anna was trying to remember a name, but it would not come to her. It was very frustrating, like trying to get your Internet connection to work when the link was broken.
>
> (p.349)

While the divisions which separate people and technologies are evident in contemporary Irish literature, connections are equally prevalent. It is, after all, through connections that individuals form networks of various kinds. What these texts demonstrate, of course, is that being outside any network, whether in society or simply one's own memory, is to truly experience exclusion.

6
Game Over

> Three times Cuchulain stepped upon the bridge, and three
> times he was flung backwards [until] the laughter roused such
> anger in him that, with a run and leap, he sprang clean on to
> the middle of the bridge; then, as the other end shot up, he
> dropped from it, and landed safe.
>
> (Squire, 1907, p.74)

Embraced at the turn of the twentieth century as the archetype of Gaelic
masculinity, Cúchulainn, in any spelling of his name, is a superhero
avant la lettre. Unfeasibly strong, athletically gifted and a skilled fighter,
the child warrior provided Patrick Pearse with an unparalleled exam-
ple to inspire the boys at St Enda's. As Elaine Sisson recounts, Pearse's
cult of Cúchulainn became a central feature of school life with images
of the young hero dominating the entrance hall, echoed on the cov-
ers of exercise books and performed in daily assemblies and annual
pageants (2004, p.79). In fact, Pearse's promotion of (and devotion to)
Cúchulainn formed part of a wider fashion for the idea of the war-
rior as 'the boys' especial hero' (Squire, 1907, p.vii), since so many
of his greatest successes occurred when only a boy himself. Publica-
tions such as Charles Squire's account of *The Boy Hero of Erin: The
Story of Cuchulain and the Champions of the Red Branch of Ulster* (1907),
Lady Gregory's *Cuchulain of Muirthemne: The Story of the Men of the
Red Branch of Ulster* (1902) and Eleanor Hull's *Cuchulain: The Hound
of Ulster* (1909) were among a slew of books targeted at young male
readers during the period. While Pearse, unsurprisingly, read a specifi-
cally Irish version of admirable boyhood in the stories, the books were,
in fact, at least as popular among British schoolboys. As with each
retelling, before or since, these new representations of Cúchulainn's

bravery and abilities reflected the age in which they were narrated. Thus, as Declan Kiberd has observed, Lady Gregory's account had morphed Cúchulainn into 'a sort of public schoolboy in the disguise of a Gaelic hero', reflecting both revivalist imperatives and the gendered expectations of honour and restraint as enacted in popular British school fiction of the early 1900s (O'Connor, 2005, p.x). By the mid-twentieth century, the increased influence of American popular culture similarly shaped representations and interpretations of Cúchulainn, whose effortlessly skilful use of weapons and freakish strength were equal to anything movies and comic books had to offer. But it is in our own time that Cúchulainn seems finally to have found the medium to adequately represent him. Look again at Charles Squire's account of the hero provided above, bounding and leaping over obstacles and enemies. Triply resistant, with superhuman capacity, Squire's 1907 Cúchulainn has all the attributes of a twenty-first-century videogame avatar.

In a very general sense, of course, this is far from surprising. Both Squire's book and many contemporary digital games (still) share at least an implicit target audience of boys in their late childhood and early teens. Since the proposed audience is similar, stereotypical representations of adventure and violence, seen as particularly attractive to this demographic, are repeated, even when produced a century apart. While these overlaps indicate a rather disappointing lack of progress in regards to socio-cultural attitudes to boys, the more detailed examples of cross reference reveal surprising connections. Take, for example, Squire's representation of the hero's unique 'moves', an inventory familiar to any gamer; the 'cat-feat' the 'champions whirl' and the threat to his enemies of 'sudden death' (p.77). More than this, Cúchulainn's special powers, or 'gifts', are not purely physical since, as Squire notes, he is also to be admired for his 'eloquence', 'prudent deliberation' and 'rapid calculation' (p.64). For all of these abilities, Squire's Cúchulainn, like any well-rounded videogame character, also has flaws which can be exploited. This is a Cúchulainn not always fully in control of his super-strength, accidentally punching holes in rock or knocking people's heads off with his hurl. Most importantly, however, this early twentieth-century version of the hero seems so uncannily predictive of gaming culture, precisely because he has 'the gift of games' himself (Squire, 1907, p.64). Squire presents the boy Cúchulainn as invincible, not only in the extremes of the battlefield, but also during the rather tamer contests of 'chess, backgammon, or draughts' (p.64).

Game on

In his autobiography *An Only Child* (1961), writer Frank O'Connor describes himself as a boy, rather less successful in games, but nonetheless bewitched by the thrilling accounts of Cúchulainn's childhood adventures as recounted in Eleanor Hull's bestselling book. The young O'Connor marvels at the hero's physicality, not least of all at the boy's famed ability to throw his spear, hurley and sliotar far ahead of him before running to catch them before they land. As O'Connor wryly laments, 'No one who has not tried that simple feat can imagine how difficult it is' (2005, p.113). Turning 13 in 1916, O'Connor inevitably grew out of imitating the Hound of Ulster, but his failed efforts to do so form a crucial aspect in the case for reading Cúchulainn as a proto-videogame avatar. Whether the medium is Celtic mythology, graphic novels or digital games, the heroic protagonist must be a figure the reader (or player) *wants* to mimic but ultimately cannot. Self-evidently, Cúchulainn's displays of strength and skill are astonishing precisely because they cannot be emulated. At the same time, his youth and character flaws make him recognisable to his readers, so that it is at least possible to *imagine* being him. This type of role-playing is a requisite of adventure-based game play in which one takes on the role of a character, split between the human who manipulates the controls and the figure moving on screen. In an adventure game setting, the on-screen figure, although controlled by human hands, is manifestly more powerful and able to go beyond human limitations; running faster, jumping higher, recovering from injury or even death. Just as these superhuman capacities are accepted by readers in the premodern framework of mythology, so too are they understood as unremarkable in the postmodern sphere of digital games. In this way, the avatars of contemporary videogames are an, admittedly blunt, representation of the post-human. Able to go beyond the physical limitations of the human body, not least of all in having multiple lives, they nevertheless remain dependent upon humans for their existence and manipulation. This sense of connectivity with the avatar is particularly the case for characters drawn as explicitly human forms by games designers. Such figures are recognisably human, even if not realistically so, but in their capacity to overcome basic physical weaknesses and limitations they emulate the type of ultra-human versions of ourselves previous generations have made into gods, mythic warriors and folk heroes.

With his ability to 'power up' from the already fantastical strength of his childhood to a tragi-heroic warrior adulthood, Cúchulainn maps

as neatly onto the template for the contemporary videogame avatar as he did for earlier readers of mythology, fantasy and schoolboy adventure. Yet perhaps the most telling overlap between the forms is in the broadly held concern (or paranoid belief) that such a figure would prove simply too irresistible for young and malleable minds. It was, of course, precisely Pearse's hope that the boys in his school would seek to emulate Cúchulainn, although undoubtedly in a more symbolic sense than the unfortunately pragmatic Frank O'Connor. Certainly, Eleanor Hull was all too aware of the potentially ominous impact Cúchulainn's use of violence might have on her young readers, effectively censoring the text 'in order to make it suitable reading for any children into whose hands the book might chance to fall' (1909, p.13). These were stories seen to have transformative, even incendiary properties. While Pearse could go as far as to present them as a barely sublimated call to arms, to Yeats, they stood, at the very least, as a powerful act of rebranding Irishness on an international stage. In his somewhat hyperbolic preface, Yeats describes Lady Gregory's account of the Cúchulainn myth as not only 'the best book that has ever come out of Ireland' but also designates the stories 'a chief part of Ireland's gift to the imagination of the world' (Gregory, 1902, p.vii). Yet even Yeats' endorsement of the stories on the grounds of artistic expression and cultural heritage was not enough to detract from the overarching narrative of Cúchulainn, 'the great doomed hero' as the ultimate emblem of Irish machismo (Tracy, 2008, p.204). That this version was preserved and promoted by nationalist discourse for the remainder of the century and beyond is hardly surprising, but it should also remind us of that altogether more direct relationship between cultural outputs and the contexts which produced them. In the first decades of the twenty-first century, as Kücklich explains, we similarly need to remember that videogames are 'cultural products with deep roots in the culture they stem from' (Rutter & Bryce, 2006, p.104). Just as novels, plays, films or statues before them, videogames are revelatory about the world they have emerged from and exist in. No longer niche, they are now established as both a mainstream aspect of contemporary culture and significantly, 'part of a general *storytelling ecology*' (Juul, 2005, p.17). It is perhaps small wonder then, that as soon as computers emerged with sufficient capacity to make it possible, the stories of Cúchulainn were reimagined once more for another generation.

Land of eternal youth

Whether played on multifunctional home computers, specifically designed consoles or, increasingly, mobile phones and tablets, digital

games have become a conventional aspect of contemporary life. As with any medium, videogames can be divided into a series of genres; some test a player's reactions such as sports games and first-person shooters, others are a test of strategy, including text-based role-playing, sandbox and simulation games. The thematic content of videogames, as they will be referred to here for purposes of clarity, is equally varied, although trends for war, fantasy-adventure, civilisation building and crime simulation are observable. As with literature and film, games are projections and reflections of their age and have been lauded by theorists in the field as the most sophisticated form of conveying meaning 'that the culture has yet seen' (Poole, 2004, p.189). As a subject for academic research and study, 'games studies' remains in the pioneering stage, yet the origins of the field can very easily be said to predate many of the more 'traditional' disciplines. While videogames are, evidently, *new* in terms of the technology required to play them, as *games* they are, of course, as old as civilisation. Videogames as we might now recognise them originated in the 1960s with the earliest arcade games, becoming fully embedded as a significant aspect of popular culture approximately 30 years later. As John Kirriemuir recounts, the explosion in low-cost home computers in the early 1980s saw machines ostensibly purchased for education or work, becoming in fact, among the first 'home video game machines' (Rutter & Bryce, 2006, p.25). Specifically, as Andreas Lange notes, the Sinclair ZX Spectrum, released in 1982, became a 'smash hit because of its suitability for games' (King, 2002, p.50), including two featuring the eponymous Cúchulainn as protagonist.

Tír Na Nòg (1984) and its prequel *Dun Darach* (1985) were designed by Greg Follis and Roy Carter of Gargoyle Games in the UK for the leading computer platforms of the decade. While *Tír Na Nòg's* grasp of the finer points of Celtic mythology is somewhat generalist by the standards Yeats had admired in Lady Gregory's work around 80 years earlier, it is nonetheless a resonant characterisation of the hero and was seen by contemporary reviewer Richard Price as a 'classic of Spectrum programming' (1985, p.48). In technological terms, the game represented a sea change in character animation through the use of multiple 'camera' angles. The narrative was similarly sophisticated, placing Cúchulainn in the afterworld as the player engaged in a combination of arcade game features, avoiding (or fighting) the enemy sídhe, while solving puzzles and collecting objects in the manner more typical of earlier text-based games. Just like the schoolboy readers at the start of the century, games reviewers were drawn to Cúchulainn's physical presence, his 'clear and purposeful' strides (Price, 1985, p.48) and 'epic height of 56 pixels' (Anon, 1985, p.17). To the game reviewers of the 1980s, Cúchulainn

clearly cut an intimidating figure, with Paul Bond joking in *Your Computer*, 'Britain's biggest-selling home computer magazine', that he would hope to placate the hero with 'at least three pints of Guinness' before daring to approach him in real life (1985, p.37). With his shoulder-length dark hair and muscular frame, dominating the screen in a way no videogame character had before, this Cúchulainn was far from a schoolboy in disguise. This was an Irishman, violent and silent, and the stereotypes and fears prevalent in the British media of the 1980s fed into perceptions of his on-screen persona. The multiple readings of this Cúchulainn as menacing are particularly difficult to countenance with contemporary eyes. Seen now, in light of intervening developments in graphics technology, the protagonist of *Tír Na Nòg* is just a line drawing, transparent, almost frail in his movements (See Fig 6.1). Visually, at least, only a grainy imitation of the famed hero of the Red Branch of Ulster written about at the start of the century.

This withstanding, for gamers in the 1980s, *Tír Na Nòg* represented the pinnacle of videogame design. Reviews in the popular computer magazines of the period provide some sense of this, particularly the degree to

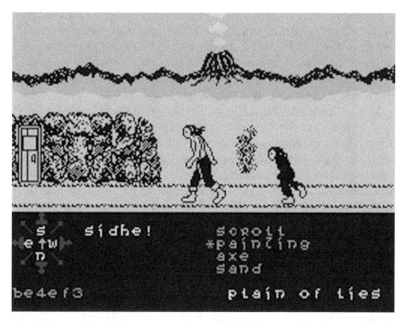

Figure 6.1 Screen shot from *Tír Na Nòg*, permission provided by Greg Follis and Roy Carter of Gargoyle Games.

which gamers engaged with the narrative aspect of Cúchulainn's story as well as his playability as a character. Peter Connor in *Personal Computer Games*, for example, explained the subtext of the game to his readers by portraying Cúchulainn's quest as an act of redemption for killing his own son (1985, p.78). Others, such as the double-page spread in the zine style *ZZap64*, focussed on how addictive the game was, providing readers with screenshots and stylised graphic drawings of the young reviewers, albeit specifying that it was also 'a delightful delve into mythology' (Wade et al., 1985, p.81). Rather than merely a token theme around which to shape a game, it was precisely the grounding in Celtic mythology which spoke to those already immersed in the genres of fantasy and science fiction. The anonymous reviewer in the January 1985 issue of *Sinclair Programs*, for instance, took up the concept as a stylistic framework, solemnly noting: 'Great were the heroes of Celtic lore, and greatest of all was the hero, Cuchulainn' (Anon, 1985, p.17). Acknowledging the in-game technologies which make *Tír Na Nòg* attractive to play, this reviewer sustained his pseudo-Gaelic construction to outline the prophesies of druids and mysteries of standing stones which form the game's backdrop before praising the programmers for the animation 'they have wrought' (p.17). As stylised as the game itself, the review refers to players as 'mortals', presumably to distinguish them more clearly from the hero they play as. The reviews explain the relationship between the player and his or her avatar by highlighting the level of commitment and immersion required. A common feature across the reviews, for example, is the exhortation for players to 'map' the game. This engagement on an imaginative and practical level is a custom extending from text-based games when players needed to draw a physical map of a game to chart their movements through the programme. In fact, the makers of *Tír Na Nòg* anticipated this by including a full colour map as a special feature within the game's box (See Fig 6.2).

The map and the associated printed manual serve as important paratexts, not least by presenting a backstory explaining the broader premise of the quest for those less familiar with the original mythology. Yet they also emphasise the significance of the source material for those seeking a full understanding of the game. The manual for *Dun Darach*, for example, includes a bibliography of further reading, while the back cover of *Tír Na Nòg's* cassette advises players that they will need not only lateral thinking, but possibly 'some library research' if they are to solve the game (Gargoyle, 1984). Far from being idle play, these are games which require genuine intellectual work. Similarly, the game manuals and the images they contain express the vast gap between the artwork

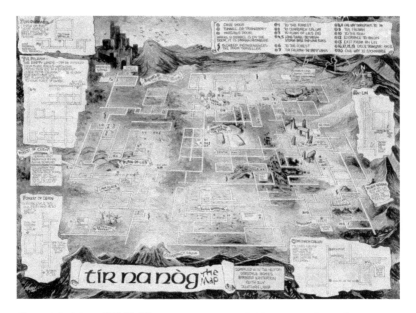

Figure 6.2 Map of *Tír Na Nòg*, permission provided by Greg Follis and Roy Carter of Gargoyle Games

used to market games on packaging and in advertisements and the actual graphics players experienced on screen. Indeed, the Cúchulainn as sketched in reviews and marketing material is almost unrecognisable from the cartoonish figure on screen, speaking to the genuine use of imagination among early gamers. Similarly, the objects Cúchulainn collects, a spear, bones, a feather and so on, are not recognisable on screen without the on-screen subtitles in lurid pixelated Gaelic font. Although the game is ostensibly directed towards a goal, the real pleasure is in the discoveries revealed by the endless walking back and forth across the screen. Using keyboard controls, players must navigate the avatar across a vast landscape. Bold yellow, pink and green wastelands, black and blue underground caves – the *Tír Na Nòg* Cúchulainn wanders just as he always has 'alone across that terrible stony trackless waste, for he knew not whither to turn, or how to go' (Hull, 1909, p.60).

Animation and characterisation

Admittedly unlikely bookends to the twentieth-century's portrayal of the hero, the echoes between Eleanor Hull's Cúchulainn and his

pixelated counterpart in *Tír Na Nòg* and *Dun Darach* are clear. Though employing different modes of representation and cultural narration, both identified the mythology surrounding Cúchulainn as apt source material, just as other poets, playwrights and politicians had before them. In the twenty-first century, where videogames have emerged as the latest significant forum for narrative exploration, literary-historical and mythological narratives remain highly valued. These intertextual relationships between videogames and other modes of representation have a crucial role in defining the status of games as conveyors of cultural meaning. Just as Hull's book was in 1909, the cultural artefact that is Carter and Follis' 1984 videogame is simultaneously old and new. Although both share the established narrative of Cúchulainn, the connection between them is easily overlooked by focussing on the 'newness' of the videogame format. We are, as Barry Atkins warns, at risk of being so 'blinded by the sheen reflecting off our consoles and computers' (2003, p.145) that we fail to notice that the typical narrative frameworks used in videogames are actually largely traditional.

Nevertheless, for all of these important overlaps there remains a crucial difference which distinguishes videogames from written narratives: the player–character relationship. It is through this unique interaction, Mark J. P. Wolf explains, that players can 'participate in and alter events in the game's diegetic world' (2003, p.93). In the simplest of terms, if the player chooses not to manipulate the character, he or she simply won't move; passivity is not permissible. Games such as *Tír Na Nòg* expressly connect the videogame narrative to the written one which inspired it, often in overt ways such as referring players back to reading material. Yet this is not to say that the game or the character are meaningless without reference to the mythology from which they stem. Players of *Tír Na Nòg* are no less able to play the game for encountering Cúchulainn for the first time on the ZX Spectrum rather than in Lady Gregory's book. While the character of Cúchulainn is recognisable across these different forms, he is not the *same* in each because his purpose and function are not the same. With the establishment of large gaming corporations such as Sega and Nintendo in the late twentieth century, characterisation became an increasingly lucrative element of gaming in the form of merchandising and product placement. While the aim of a particular videogame quest, or the context in which it occurs, might be generic to the point of obscure, it was imperative that the character design captured the player's imagination. So while blue hedgehogs and mushroom-guzzling Italian plumbers appear disconnected from legend or mythology, their function as memorable characters is uncontested. Large Japanese gaming

corporations moved away from traditional narrative structures to commercially successful and universally appealing characters, becoming globally successful as a result. Nonetheless, within this context, the attractiveness and suitability of Cúchulainn as a videogame character has been sustained. Re-emerging in unlikely forms in Japanese franchises *Final Fantasy* and *Megami Tensei,* albeit as an obese and poisonous monster and as a svelte androgynous manga figure, respectively, the name Cúchulainn remains shorthand for an exceptional warrior in the gaming world. Perhaps unsurprisingly though, it took an Irish games design company to redraw the hero in more recognisable terms.

In 2013, Dublin-based company bitSmith released *Kú*, a game inspired by the Táin epic and reimagined in the style of 'Celtic-punk'. Described by the game's makers as 'a fusion of Celtic and steampunk aesthetics', *Kú* is stylistically bold with a backstory that presents an apocalyptic vision of Ireland 'devastated by technomagical war' and, wittily, suffering from the effects of 'economic collapse' (bitSmith, 2013). As the game's developers acknowledge, *Kú* was designed to demonstrate Cúchulainn's suitability as a videogame character on contemporary platforms. His adventurous persona and, as importantly, his deadly weaponry, provided a convenient template for this contemporary rebranding of the hero. Indeed, one of the key strengths of the game stems from the designers' acknowledgment that, as Andreas Lange puts it, 'games are bearers of cultural values and traditions' (King, 2002, p.53). Although available via universal platforms, bitSmith market *Kú* as an expressly Irish game, most notably through the feature which allows the game to be played in the Irish language. While the distinctive hand-drawn images and original soundtrack add to the game's ingenuity, the content, a series of puzzles and battles, places it within the familiar terms of other indie games of a similar scope. *Kú* is clearly an ambitious game, inspired as much by the grammar of classic games such as Nintendo's *Zelda* as the traditions of Irish mythology. The real highlight of *Kú* is Kú himself, the red-headed boy warrior with his sword and steam-powered hurley used to stun his enemies (See Fig 6.3).

Kú is distinct from the manly hero of the earlier ZX Spectrum games, returning instead to the earlier literary depictions of Cúchulainn as a boy. As a result, Kú joins the multiple representations of the heroic boy as both subject and object of videogaming and, of course, Irish literature. The customary association between boys and gaming, however myopic, has often been cited as an excuse to critically disregard gaming as a 'near-onanistic engagement of an individual with a machine' (Atkins, 2003, p.5). This contradiction between the evident physicality

Figure 6.3 Kú 'The Journey Begins', artwork by Basil Lim on behalf of bitSmith Games

of the on-screen boy and his sedentary putative double continues to be cited as a cause for social panic over gaming behaviour, just as the introduction of joysticks and handheld controllers further distanced videogame consoles from their computer origins, emphasising the suspicion that gaming was merely something (else) for adolescent boys to do with their hands. Kú can only be successful if the player enables his physicality by making him run, roll and fight. By swiping and tapping the screen, the player physically engages 'with bits of plastic and metal, silicon and glass' (Atkins, 2003, p.11), small-scale hand gestures which translate into Kú's full-body actions. As Atkins goes on, this human engagement with computers is plainly physical, straining backs and eyes, as the 'game takes its toll on the body even as it promises a disembodied and virtual experience' (p.11). Most obviously it affects the hands, causing the repetitive-strain conditions in the hand and wrist nicknamed 'Nintendonitis' (Kent, 2001, p.279). Kú, by contrast, wields an all-powerful hand using his Árgatlamh gravity glove to solve puzzles and overcome enemies. He becomes, in this way, part boy, part machine, with technology drawn to the palm of his hand by an overwhelming force.

Kú invites players to make these kinds of interpretive critical readings, in part due to its alliance with mythology, but also through the implied commentary on contemporary Irish society. *Kú* takes place, after all, in a once-prosperous land, now dogged by 'tricksters, deceivers and mindless predators' (bitSmith, 2013). While there are techniques and approaches from literary studies which might prove useful in this task, *Kú* is a game,

not a novel, and must be understood as such. Julian Kücklich provides a useful warning of the dangers of 'theoretical imperialism' to those who would import terminology loosely or risk simplifying or distorting readings of games through the use of literary modes (Rutter & Bryce, 2006, p.95). Instead, scholarship must acknowledge 'indigenous' games theorists such as Celia Pearce, who convincingly defends the value of comparisons, but on the clear understanding that games have 'unique and distinctive properties that differentiate them from other expressive forms' (King, 2002, p.113). The discussion here refers to games which are directly drawn from literary and mythological precedents, but that does not mean that they serve a derivative function. They are not, as Atkins reminds us, 'just pale reflections of novels, plays, film or television programmes' but rather engage directly 'with both other textual forms and the "real world" that it (and other forms of "realist" fiction) claim to represent' (2003, p.6). There is, as argued here, a pressing need to understand more about the relationship between videogames and the written narratives that inspire them, not least of all because it will help us to understand the reverse.

Death of the gamer

Paul Murray's novel, *Skippy Dies* (2010), bears out the spoiler of the title in the opening pages when schoolboy Daniel Juster, nicknamed Skippy by his friends, appears to choke to death. This event, around which the novel is crafted, presents the reader with a puzzle to solve; the meaning of Skippy's last words, written in raspberry syrup on the floor of Ed's Doughnut House. It is a novel of multiple battlefields including classrooms, virtual worlds and the Somme and a meditation on the overconsumption of gadgets, doughnuts and prescription drugs. *Skippy Dies* is set in the fictional Seabrook College, following the boys and their preoccupations, bravado about contrived sexual encounters, parochial rivalries and the gradual 'grim de-dreamification' (Murray, 2011, p.25) of their lives, as they come to sense that the opportunities promised by a privileged childhood are not guaranteed in adulthood. It is, in short, a novel about growing up in early twenty-first-century Ireland.

From de Valera's infamous fantasy idyll, through to recent revelations about systematic institutional abuse, Irish childhood is a popular topic for academic scrutiny. In the first decades of the twenty-first century, however, debates have begun to gather around the influence of global cultures via the media and the related move away from traditionally authoritarian parenting. One of the consequences of this, as

Inglis argues, is a culture of 'new individualism' in which 'Irish children live locally but have adopted lifestyles, tastes, and practices that are increasingly similar to those in the rest of the West' (2011, p.64). Within this context, exposure to international media and internet-enabled technology has become an expectation rather than a privilege for many Irish children and young people. The fictional pupils of Seabrook College embody this idea, offering a literary representation of Inglis' claim that Irish teenagers now grow up in 'a world in which there is a constant flow of new and better machines' (2011, p.70). Murray captures the implication of this change even on the soundscape of daily life, with the moment the 'air tintinnabulates with bleeps, chimes and trebly shards' of mobile phones at the end of the school day (p.12). The presence of cyberculture is further emphasised in the echoes in ordinary language, describing the priests who have traditionally run the school as 'outmoded technology' (p.94). It is clear that the boys in the novel view computers as part of their natural habitat, with Skippy's best friend Ruprecht most notable for his use of the machines to perform 'mysterious operations' (p.22) or for sending emails into space. Other uses are more mundane as the boys use the internet to research homework or watch pornography. Adult characters are equally absorbed by the machines, such as American gadget reviewer, Halley, who makes her living from the fact that 'Irish people are crazy for technology' (p.82). If not quite an account of a collective loss of Irish sanity, some doubt is cast by this novel on the widespread veneration of gadgets in Ireland. Certainly the young characters are dependent on their devices and the messages they receive through them to a damaging degree, apparently conforming to Inglis' sense that, increasingly, 'Irish children see and understand themselves in terms of stories, reports, media personalities, media celebrities, and sports stars' (2011, p.71). A cognate source of such stories is brought together in the novel by the much-admired new technology in the form of videogames.

The structure of *Skippy Dies*, like many novels, reflects the essential aspects of a game as identified by Celia Pearce. There is a goal to achieve, obstacles which get in the way, resources which help characters to overcome them and rewards and penalties as progress is made (King, 2002, p.113). Over the course of the novel, as in any successful videogame, various forms of information and knowledge are revealed to shape progress towards the goals. While this structural overlap is telling, the more relevant factor is the gaming within *Skippy Dies* as a day-to-day activity in the boys' lives, shown through their habitual huddling 'around the Nintendo' (p.25). Since the novel is set in the present day, this is little

more than accurate historical detail, verifying the contemporary normality of gaming as Bernadette Flynn (2003) has described it in her account of the videogame console as a digital hearth. As Flynn contends, the presence of games consoles has restructured the domestic space as well as producing a discernible change in the functionality and symbolism of technology within the home. As she goes on to explain, the etymological root of hearth, the Latin for 'focus', is especially apt in describing the technologies which have traditionally trained the domestic gaze before being superseded, from the original fireplace, to the radio, then the television and latterly, the games console (Flynn, 2003, p.561). Flynn's work describes a process of domestication from the public spectacle of the arcade into the heart of the home and Skippy's experience as a boarder brings this full circle. For Skippy, the console is a symbol of home at school, just as it is subsequently brought home during the holidays to bring the home that is school with him. In the digital age, the warmth and comfort from the digital hearth is portable. Similarly, the boarding-school setting also facilitates a return to the arcade dynamic as games are played, if not with, then in front of friends, typically to a chorus of asking when 'someone else could have a go?' (p.19). This semi-public game play conforms to Flynn's point that, although the console is in the home, it is not *of* it, with advertisements particularly keen to emphasise the idea of the console as a 'futuristic dream machine in opposition to the place of its location' (2003, p.557). For the young people in Murray's novel who perceive the home as a symbol of the endless limitations constructed by adults, the machine acts as a 'portal device', transporting them away from both the chaos and mundanity of their daily lives (Flynn, 2003, p.558). Yet if it is the console which conveys Skippy and his peers to another world, it is the game itself which provides the alternate, and preferable reality.

Land of hope

> Once upon a time, the Realm was ruled by a beautiful princess. You'll see her on the title screen, *Hopeland* written above her in medieval-type writing: blue eyes, hair the colour of honey, frost making her sparkle like a far-off star. In her frozen hands she holds a little harp.
>
> (Murray, 2011, p.108)

Videogames, both *as* fiction and *in* fiction, contribute to our understanding of narrative forms. Indeed, it is the imaginative capacity of games which players are typically drawn to. For all of the attention on

videogames as (dangerously) realistic, they are played precisely because they are 'highly subjective, optional, ambiguous, and generally evocative' (Juul, 2005, p.121). Murray's inclusion of gameplay in *Skippy Dies* supports this, providing not just a representation of the character as player, but also an insight into Skippy's cultural influences and the sounds and images acting on his imagination. At the same time, the presence of the game within the novel highlights the implicit textuality of videogames. Murray's use of the second-person singular and present tense, for instance, echoes the grammar of the early text-based adventure games, as he places both Skippy and the reader jointly in the player's point of view (POV) with the construction, 'You look at the map' (p.19). This first appearance of the game in the novel shifts the narrative not only through a change in tense, but also the vacillation between the fictional room where the game is being played and the virtual room in which the game is set. Further, Murray linguistically amalgamates the avatar of the game and the protagonist of the novel, portraying the moment 'zombies pursue him up a rickety staircase' (p.19). From the outset then, the content of the game is analogous with the wider narrative of the novel. Having already witnessed the character's death, the reader now observes Skippy's fate merging with that of his on-screen other, as the 'little spinning light that is his soul whirls up to the ceiling' (p.20).

Skippy plays the fictional *Hopeland* game throughout the course of the novel, incrementally overcoming parts of the quest in a traditional rescue plot, moving towards the final salvation of the princess. In his off-screen life, his quest for the beautiful but troubled Lori stands in obvious parallel, albeit concluding in subversive rejection of the norm when this 'princess' becomes partially complicit in the hero's demise, ultimately coming to recognise the need to rescue herself. Although fictionalised, the game bears many recognisable features typical of the gaming tradition. Beyond the gendered construction of the hero and victim, the enemy 'Mindelore' and the 'three ancient demons' pursued by protagonist Djed, an 'ordinary elf' chosen by the elders (p.108), are familiar tropes. In order to overcome the interim challenges, Djed makes use of his magical weapons, the 'Sword of Songs', 'Arrows of Light' and 'Cloak of Invisibility'. These elements of *Hopeland* place it within the fantasy-adventure tradition of gaming, a genre which traces its lineage back to pen, paper and dice-based role-playing games such as Dungeons and Dragons (King & Borland, 2003; Taylor, 2009). These popular games relied upon players' abilities to imagine fantasy landscapes, scenarios and characters, moving across an imagined not digitised terrain.

Indeed, as Henry Jenkins and Kurt Squire put it, it is because role-playing games are shaped by the notion of 'contested spaces' that the videogames inspired by them construct a site of exploration in which 'players complete quests, solve challenges or collect treasures' (King, 2002, p.66). While these games established much of the basic grammar now found in videogames, *Hopeland* also appears to have more specific antecedents. Played on a Nintendo console, *Hopeland* resembles *The Legend of Zelda* in which players 'help a young elf boy named Link explore a huge territory', fighting monsters, collecting treasure and exploring dungeons before defeating a monster to 'rescue Zelda, the princess of Hyrule' (Kent, 2001, p.353). *The Legend of Zelda* marks a watershed in games history and is seen by many as Shigeru Miyamoto's masterpiece. Unlike previous scrolling games such as *Super Mario Bros*, *The Legend of Zelda* was free-roaming, allowing players to discover puzzles as they wandered. On release, the game's complexity was reflected in the accompanying documentation. As with the earlier games *Tír Na Nòg* and *Dun Darach*, the game's makers included 'a thick instruction booklet that identified most of the monsters and weapons in the game and a large fold-out map of the fantasy land of Hyrule' (Kent, 2001, p.354). Subsequent manifestations such as *The Legend of Zelda: The Wind Waker* were similarly important with the game 'praised for its expressive graphics, lavish world, and detailed storyline' (Juul, 2005, p.1). In aesthetics, characterisation and gameplay, the *Zelda* games have remained influential, not least of all on the designers of *Kú*, who also hoped to recapture the Japanese game's 'magic' in their own design (bitSmith, 2013).

Djed or alive

Just as Kú's Celtic-punk 'gravity glove' draws technology to the palm of his hand, Lucien King has described videogame controls as 'electronic extensions of our physical and mental selves' (King, 2002, p.13). Gripping tightly to the controller of his Nintendo, Skippy is able to enact the kind of heroism not possible in his real life. Physically connected to the game through his hands on the controller's buttons and his eyes on the screen, he becomes cut off from the real world as 'the circuit of affection and logic that passes from computer to player and back closes onto itself', dedicating his 'whole being just to this world of play' (Evens, 2011, p.266). While Skippy's game play is clearly an act of escapism of the kind Evens describes, it might more accurately be thought of as role play since Skippy 'becomes' Djed in response to the game. Djed is of course simply an avatar, an actor Skippy directs against the backdrop of the game. Djed stands in for Skippy within the

world of the game, going where he cannot go, beyond the screen. Far more significant, however, is when Djed stands in for Skippy outside of the game. This merging is most notable at the Halloween Hop when Skippy's 'impressively elvish' costume, complete with the replica home-made weapons from the game, masks Skippy as a real-life Djed. At the same party, Lori, although actually dressed as pop star Bethany, appears to him as both the white goddess of the classroom and the princess from the game. When the two of them go on a real-life adventure, albeit high on a mixture of Ritalin and asthma inhaler, it seems to Skippy (or is it Djed?) that he is experiencing the best night of his life. Typically, character descriptions in novels require the reader to form the details of physical appearance in their own imagination. By contrast, as Steven Poole points out, a 'videogame character must be determinedly individ-uated and given a complete, solid visual form' (King, 2002, p.77). While Murray describes the landscape and aesthetic of *Hopeland* in some detail, we only really see Djed when Skippy adopts his form, wearing 'his run-ners, fitted out with tiny wings' and 'crepe-paper hunting hat' (p.164). Skippy's embodiment of his videogame avatar speaks to the comfort he finds hiding behind and within him; a concept echoed in the name *Djed*, the Egyptian symbol for stability and backbone. Although Djed is, by his nature, unreal, he provides Skippy with an understandably attractive model for overcoming danger. As Poole puts it, designing a videogame character is really 'the art of designing people, or at least beings, into whose shoes we enjoy stepping' (King, 2002, p.85). Skippy does this in a literal sense at the Halloween Hop, but more so by step-ping into the role of hero. Djed, like Cúchulainn, Kú and Link before him, are all 'chosen'. Chosen for their bravery and capacity to fight, these boy heroes are the antithesis to Skippy, who is singled out for his vulnerability. Indeed, Skippy uses *Hopeland* in much the same way he abuses prescription drugs; as an escape from the painful realities of his life. Rather than becoming 'lost' inside the game, however, this behaviour only serves to emphasise the game's fictionality. As Atkins argues, videogames might be seen as at least as escapist as any fiction where 'the utility of that escape demands our recognition of an impera-tive for return' (2003, p.142). As the novel all too tragically reminds us, the game cannot last forever.

Who's for the game?

Videogames ultimately differ from other forms of fiction in the critical matter of winning or losing. Whereas in life Skippy is repeatedly made aware of his physical vulnerability, in the game he can defeat the

demons using his weapons, strength and skill. Djed, like Cúchulainn, is disproportionately strong for his size and age, but it remains his skilled application of violence which brings him victory. In his discussion of the perennial conflict between the games industry and the media condemnation of violence in videogames, Clive Thompson outlines the paradoxical argument 'that games either brainwash us into violence or are harmless fantasies' (King, 2002, p.24). This 'violence debate' has, as Jo Bryce and Jason Rutter put it, been voiced from positions of adult authority by 'academics, parents and governments for almost the entire history of the medium' (Rutter & Bryce, 2006, p.205). Yet as many critics have argued, violence in videogames is not *ipso facto* an instigator of violence in the real world, but rather a reminder that videogames are fantasy or fiction. After all, videogames often place the player in a position of law enforcement or responsibility; Djed's mission to reclaim the Realm and the princess, for example, is clearly rooted within the philosophy of justified violence. Yet unlike the game in which Djed's enemies are clearly defined, violence in Skippy's real world is random and deregulated, allowing for the exception of the sanctioned violence of a 'rousing game of rugby' (p.412). So it is that in his fight with bullying sociopath Carl, Skippy imagines enacting Djed's moves. Although Skippy's inner voice reminds him that 'every Demon has a weak spot' (p.358) as he tries frantically to remember 'the forward roll and jab, the spinning kick, the tiger throw' (p.359), it is brave fluke rather than fighting skill that leads to his victory. So, just as Skippy's Halloween costume transports Djed's capacity for adventure from the computer screen to the school hall, during the fight, his movements echo the 'embodied experience of fighting in computer games' and the 'duality of presence' of the self in and out of the game (Taylor, 2009, p.109). As Taylor points out, there is a need to acknowledge that the pleasure gained from fighting in a game might easily be seen in light of the satisfaction of 'competently embodying a character' (p.109) which can be most fully demonstrated (in many games) through acts of violence. It is not, in other words, that *Hopeland* makes Skippy a better fighter, simply that it makes him a better Djed.

Although concentrated on *Hopeland* during the course of the novel, Skippy's world view is informed more generally by the grammar of videogames. When visiting Lori's bedroom for the first time, he surveys the objects, the posters on the wall, her photographs, just as in a game a player must look over the available clues, deciding what is useful for now and taking note of things that might become useful later on. The dynamic form of videogames is also invoked as Skippy attempts to 'pause' troubling aspects of his life, keeping home and school on distinct

'levels'. Most telling, however, is the way Skippy conceives of his relationship with his father as 'the game', the object of which appears to be a denial of reality:

> You and Dad are playing a game [. . .] The most important rule though is that you never ever talk about the game: you act like there is no game, even though you both know the other person is playing.
>
> (p.105)

While his mother lies upstairs in bed with cancer, Skippy and his father imitate normality, or rather, the hyperreal, as they role-play 'TV Dad and TV Son' (p.105). Home for the holidays, Skippy plays the two games side by side, one moment fighting the fire demon in *Hopeland*, then interrupted by his Dad, talking in a code in which they both 'replace almost all words with the word *great*' (p.239). Taking refuge in banal conversation provides a preferable alternative to talking about the upsetting reality of his mother's illness, or the suppressed truth about 'coach'. For Skippy, this real-world game is equally seen as an adventure, 'a very precious, very fragile cargo' to be carried through a jungle (p.239); but it is, ultimately, a malfunctioning game. While offering some perceived protection, the 'game' creates increased isolation and confusion since it is a game he cannot win. The parallel games are revealing, highlighting the fact that videogames are rarely admired for their emotional literacy. For the most part, the margin of success or failure is clearly measured in the collection or destruction of objects or people. While these dynamics are sometimes explained as a consequence of the limitations of the gaming environment or a risk-adverse industry, it is also an artistic and technical reality that it 'is *hard* to create a game about emotions because emotions are hard to implement in rules' (Juul, 2005, p.20). It is a point made particularly clear in the 'game' Skippy plays with his father in which the repression and avoidance of emotions are paired with superficial communication and role play. This game is, of course, a kind of playing at adulthood and is no more appealing for that. Even when embodying Djed on the magical night out with Lori, for example, reality cannot be wholly avoided, as she asks him about his parents and 'Out of nowhere the Game shrieks up' (p.214).

Irish games industry

Skippy's immersion in the structures and symbolism of gaming extends to his imagined future as he describes his ambitions to 'design video

games' when he grows up (p.368). The character's articulation of this dream and adult reactions to it reinforce the sense that working in the digital games industry has become a potential reality for young Irish people of his generation. Far from being an unrealistic fantasy, Skippy's desire to turn his teenage hobby into his adult career places him within a key area of growth within the Irish economy. Games which might be thematically, if loosely, labelled as 'Irish', already extend beyond those inspired by Celtic mythology, as described above, to sports games such as GAA football and hurling for the PlayStation as well as 'novelty games' for smartphones and tablets featuring cartoonish and stereotypical characterisation. *Lep's World* (nerByte, 2014), for example, is a hugely popular platform game in which a red-bearded leprechaun collects pots of gold against a backdrop of green fields and rainbows. Over the last decade or so, the number of indigenous companies has multiplied at the same time as Ireland has become an established base for international publishers and manufacturers. In fact, as early as 1989, Proinnias Breathnach was able to point to Ireland's disproportionate share of Japan's games-related manufacturing investment in Europe, seen by the Industrial Development Agency (IDA) as a direct result of their campaign to develop the electronics sector in Ireland. The consequence was marked growth in the production of personal computers and electronic components, notably Atari games and consoles from 1986 (Breathnach, 1989, p.29). As already discussed, the history of electronics manufacture in Ireland is equally a narrative of withdrawal and evasion; far more work is needed on the implications of the aftermath of failed or limited international investment. Certainly, the switch from hardware manufacturing to software development is now established. In more recent years, videogames have led the charge with what leading expert Aphra Kerr describes as 'the rapid growth of micro Irish companies' drawing increased political attention to the cultural and economic value of the games industry (McCormick, 2012, p.3). In the 2012 report *The Games Industry in Ireland,* James McCormick recounts current successes while emphasising the need for investment and acknowledgment in order to create a sustainable Irish industry. The survey estimates the current size and scale of the Irish games industry via a census, pointing to the economic imperatives of creating Irish jobs and generating tax revenue. Similarly, the report captures the increased political prioritisation of digital games, referring to the various grants such as the Internet and Games Competitive Start Fund and the Internet Growth Acceleration Programme (iGAP) which have supported new projects, as well as identifying the number of third-level institutions now offering games

development courses (McCormick, 2012, p.8). McCormick's report is a contribution to a much wider field in which academics and practitioners are currently working hard to establish Irish gaming as both a creative industry and an area for scholarly research and study. Evidence of this growth can be identified in sites such as GameDevelopers.ie, established in 2003 by Kerr. Hosting news, resources and an advice forum, the site acts as an information hub for those working in, or aspiring to work in, the Irish games industry. Similarly, GetIrishGames.ie and IrishGamesIndustry.ie collate resources as a means to boost the industry both in terms of economic impact and cultural profile. Face-to-face events are equally important with the long-established Games Fleadh or conferences such as 'The State of Play' held in November 2012 at the Dublin Institute of Technology bringing the professional and academic cohorts together to showcase work and discuss future priorities (State, 2013). One of the strengths of videogames as cultural artefacts is their inherent transnationalism with multi-language modes allowing for different iterations of the same product and characters and scenarios designed to have cross-cultural appeal. Large international investment in the technology industry may well prove economically advantageous but it remains a political, social and cultural imperative that games reflect a diversity of narrative and artistic traditions. The apparent buoyancy of the Irish indie games industry promises positive educational and economic outcomes. It also reinforces the need to take gaming seriously and to acknowledge the reverberations occurring in other forms, including the novel.

They shall not grow old

Paul Murray's *Skippy Dies* forms part of the first generation of Irish novels to capture what Lynne Hershman-Leeson refers to as the 'dynamic revision' digital technology has brought to 'every aspect of life as we knew it' (1996, p.vii). Writing about videogames is simply writing about contemporary Irish life to the point that exclusion of them ought to be more remarkable than inclusion. Yet as this chapter has argued, the creation, play and analysis of videogames necessitates an expansion of the critical vocabulary previously applied to textual forms. According to Poole, videogames are 'rewiring our minds'; the way we write and talk about them, and their representative value, therefore, needs to keep pace (2004, p.240). Similarly, the transformational effect of videogames contains as much potential as it does risk. As shown above, Skippy's thinking is clearly moulded by his game play, including the

acquisition of highly valued skills such as strategy and stamina. Most obviously, *Hopeland* instils in Skippy an appetite for adventure and self-sacrifice, precisely the same characteristics Pearse had hoped to convey to Irish schoolboys a century earlier. Indeed, contemporary videogames, of the kind *Hopeland* is modelled on, express an altogether more ancient narrative of the explorer within unmapped territory. All of the games referenced above, both real and fictional, are driven by the imperative to master unknown space, just as Murray's division of *Skippy Dies* into 'Hopeland', 'Heartland', 'Ghostland' and 'Afterland' echoes the sense of a player progressing through levels and locations. While these structural interactions between videogames and the novel are clearly illuminating, even more is promised by the potential of the videogame to provide models for figurative language. In the final section of *Skippy Dies*, Lori, institutionalised for an eating disorder and breakdown, finds herself suddenly aware of the complexity of adult life and 'feels herself grow older, like she's finished a level in a videogame and moved on invisibly to the next stage' (p.513). If life is a videogame for the teenage characters in *Skippy Dies* in which the next level is to grow up, the demons standing in the way are, very clearly, the adults.

In his portrayal of contemporary Irish teenagers, Murray depicts this stage of life as both their tragedy and superpower. Placing them on the verge of comprehending the adult world while, at least initially, too naive to recognise it as their own future, they are 'machines for seeing through the apparatus' of adulthood (p.27). Like the online 'walk-throughs' Skippy seeks out to help solve the mysteries of *Hopeland*, adults are supposed to model a successful future. But if *Skippy Dies* is a novel of teenage vulnerability, it is equally populated by flawed adults, in some cases literally scarred by the mistakes of their youth. While Skippy might conceive of his transition from boy to man as a graduation from amateur to professional gamer, the illustrious Seabrook College prefers more acceptably manly futures: rugby player, banker, businessman. It is within this context that Skippy is isolated amid an abundance of father figures, all of whom arguably contribute to his death. Whether by action, inaction, abuse or oversight, these figures of masculine protection in the form of father, teacher, priest and coach are complicit in this contemporary narrative of sacrificed Irish boyhood. As Gerardine Meaney reminds us, portrayals of Cúchulainn as the epitome of Irish boyhood must be read alongside his representation as 'murderous father and failed patriarch, one who seeks to take up the role of paternal authority and finds that in doing so he destroys it' (2006, p.245). Cúchulainn's filicide represents a failure to transition

between generations; the death of the son before (and by) the father, itself a failure of the future.

Attitudes towards and familiarity with new technology are often seen as divided along generational lines. Certainly the Seabrook boys', albeit misplaced, confidence that they can adapt their computers to access a parallel universe, indicates an erroneous but complete faith in technology. Yet at the same time, they find cyberculture disorientating and overwhelming. The availability of online information opens the boys up to string theory and poetry, but also, as Murray makes clear, violence and pornography. As becomes all too apparent in the novel's darkest moments, the blurring between fiction and reality constructs the computer screen as a site of danger as much as refuge. It is perhaps for this reason that Skippy rarely seems to stray from the controlled environment of the game. Within the frame of *Hopeland* Skippy acts, as Kücklich puts it, within an 'aesthetics of control' (Rutter & Bryce, 2006, p.108), interacting with the fictional world through and as Djed. Equally, of course, the game also controls the player; Skippy can only make 'choices' dictated by the game's design. Rather than the image of videogames as lawless and unrestrained, for Kücklich, the real pleasure of gameplay comes from the 'equilibrium between the player's control over the game and the game's control over the player' (Rutter & Bryce, 2006, p.108). Small wonder then that Skippy is so drawn to an experience paradoxically characterised by escapism and boundaries. As the game, and his life, draws to a close, Skippy must hunt down the final demon. The parallel between the demon on screen and the demon in his mind now made explicit, the division between the game world and real life finally breaks down. In principle, videogames are bounded by the internal logic and the pre-designated properties of objects; as Evens observes, 'everything that happens in a game happens by design' (2011, p.262). Although the player controls the avatar's actions, he or she can only do so within the possible options programmed into the game. Yet in Skippy's case, the influence of drugs and trauma take the game beyond its programmed limits and turn it into a hallucinogen, as he wonders, 'Is this supposed to be happening? Is this still the game?' (p.452). Just as any work of fiction is necessarily incomplete and must be supplemented by the imagination, Skippy projects his own nightmares and memories onto the landscape of the game. As Poole explains, books too have 'always been highly interactive' if the reader's imagination makes them so, but the 'videogame changes dynamically in response to the player's input' (2004, p.105). *Hopeland*, in other words, transforms in response to Skippy's deteriorating state of mind. As explored above,

videogames provide players with an opportunity to construct an alternate identity, using an avatar as a shield from reality. For Skippy, this is amplified by his use of pills which convert him into 'Danielbot' (p.421), a kind of semi-conscious cyborg wandering unchecked towards his fate.

From the earliest arcade machines onwards, videogames have always been about immortality, even if only in the form of earning the right to be named on the leader board. In videogames, as in Celtic mythology, the short but memorialised life is the life well lived, as Cúchulainn was only too keen to proclaim. Indeed, whether on the page or the console, the very concept of Tír Na Nòg underlines the sense of invincibility which defines the young. This idea is captured by Richard Price in his review of the ZX Spectrum game in which he reminds potential players that, since Cúchulainn is already dead, 'you cannot be killed, merely returned to the beginning' (1985, p.48). Death is just a part of the game. Murray's narrative also returns to its beginning, which is also an end. It is here that Skippy's friends try to break the unbreakable rule. Based on a discussion in Irish class on Samhain and the same sinister sídhe found in the *Tír Na Nòg* videogame, the boys plan to contact Skippy in The Otherworld. Merging technology and mythology, Skippy's gang are inspired by post-World War I experiments to contact dead soldiers in 'Summerland' by broadcasting music, a process they attempt to replicate with waves of sonic energy and Lori's voice. Inevitably, and tragically, their playing is unsuccessful and the reality of death, and with it adulthood, must be accepted. *Skippy Dies* is a novel shaped around the fact that youth is far from everlasting. These Irish teenagers are as cruel and self-destructive as they are innovative and hopeful; the fragility of their personalities is a side effect of their age. It is the adults, however, specifically those in positions of power, who have lost all sense of moral focus. When the school board constructs a plan to cover up the real details of Skippy's case, passing it off as a result of his mother's terminal illness, the head callously sums up the boy's death as 'game over' (p.488). In a real videogame, of course, 'game over' is not the end at all, but rather a bridge to a new start, a transition between attempts. A player might feel disappointment or frustration, but the on-screen declaration is also an invitation to try again. As Juul puts it, a 'game is a frame in which we see things differently' (2005, p.201). Murray's use of *Hopeland* throughout *Skippy Dies does* just that, providing a model for how the forms and conventions of videogames enrich Irish literature.

Bibliography

@11ysses. *How 'Ulysses' Met Twitter 2011*, Available at: http://11ysses.wordpress. com, date accessed 14 September 2011.

@Ireland. (2014) *Ireland Twitter Feed*, Available at: http://www.irishcentral.com, date accessed 2 January 2014.

AbairLeat. (2014) *An Teanglann Arline – Online Language Lab*, Available at: http:// abairleat.kontain.com, date accessed 12 December 2013.

Abbey. (2014) *Abbey Theatre Archives*, Available at: http://www.abbeytheatre.ie/ archives/, date accessed 2 January 2014.

Aciman, A. & Rensin, E. (2009) *Twitterature: The World's Greatest Books in Twenty Tweets or Less*, 1st edn. (London: Penguin).

Ahern, C. (2009) *Where Rainbows End* (London: HarperCollins).

Allen, K. (2000) *The Celtic Tiger: The Myth of Social Partnership in Ireland* (Manchester: Manchester University Press).

Anon. (1985) 'Tir Na Nog', *Sinclair Programs*, (8501) 17, Available at: http://www. worldofspectrum.org/, date accessed 20 November 2013.

Armand, L. (2004) *JoyceMedia: James Joyce, Hypermedia and Textual Genetics* (Prague: Litteraria Pragensia).

Armintor, D. N. (2007) 'The Sexual Politics of Microscopy in Brobdingnag', *SEL Studies in English Literature 1500–1900*, 47(3), 619–640.

Atkins, B. (2003) *More Than a Game: The Computer Game as Fictional Form* (Manchester: Manchester University Press).

Attridge, D. (ed.) (2004) *The Cambridge Companion to James Joyce* (Cambridge: Cambridge University Press).

Barry, S. (2008) *The Secret Scripture* (London: Penguin).

Baum, T., Hearns, N. & Devine, F. (2008) 'Place Branding and the Representation of People at Work: Exploring Issues of Tourism Imagery and Migrant Labour in the Republic of Ireland', *Place Branding and Public Diplomacy*, 4(1), 45–60.

Bell, D. (2001) *An Introduction to Cybercultures*, 1st edn. (London: Routledge).

Bell, D. (2007) *Cyberculture Theorists: Manuel Castells and Donna Haraway* (Abingdon: Routledge).

Bell, L. & Trueman, R. B. (eds.) (2008) *Virtual Worlds, Real Libraries: Librarians and Educators in Second Life and Other Multi-User Virtual Environments* (Medford, NJ: Information Today).

Berlant, L. (1998) 'Collegiality, Crisis, and Cultural Studies', *Profession*, 105–116.

Berry, R., Barsanti, M., Levitas, J., Rutowski, C. A. & Utell, J. (2012) *About Ulysses 'Seen'*, Available at: http://ulyssesseen.com/landing/about-2/, date accessed 2 May 2012.

Birke, D. & Christ, B. (2013) 'Paratext and Digitised Narrative: Mapping the Field', *Narrative*, 21(1), 65–87.

bitSmith (2013) *Kú: Shroud of the Morrigan, bitSmith Games*, Available at: http:// kuthegame.com/about/, date accessed 2 January 2014.

Bloom, C. (2008) *Bestsellers* (Basingstoke: Palgrave Macmillan).

Boland, E. (2001) 'Code', *The Threepenny Review*, (85), 13.

Bolan, P., Crossan, M. & O'Conner, N. (2007) 'Film and Television Induced Tourism in Ireland: A Comparative Impact Study of *Ryan's Daughter* and *Ballykissangel*' in *Proceedings of the 5th DeHaan Tourism Management Conference* (Nottingham University Business School), 226–252.

Bolger, D. (1995) *A Second Life* (London: Penguin).

Bolter, J. D. (1991) *Writing Space* (Aarhus: Lawrence Erlbaum).

Bond, P. (1985) 'Tir Na Nog', *Your Computer*, (8502), 37.

Bonner, K. (2011) 'Exciting, Intoxicating and Dangerous: Some Tiger Effects on Ireland and the Culture of Dublin', *Canadian Journal of Irish Studies*, 37(1/2), 50–75.

Boon, S. & Sinclair, C. (2009) 'A World I Don't Inhabit: Disquiet and Identity in Second Life and Facebook', *Educational Media International*, 46(2), 99–110.

Boruch, M. (2013) 'Boredom', *The Yale Review*, 101(1), 116–121.

Bracken, C., 2011. 'Anne Enright's Machines: Modernity, Technology and Irish Culture' in C. Bracken & Cahill, S. (eds.) *Anne Enright* (Dublin: Irish Academic Press), 185–204.

Bracken, C. & Cahill, S. (eds.) (2011) *Anne Enright* (Dublin: Irish Academic Press).

Breathnach, P. (1989) 'Japanese Manufacturing Investment in the Republic of Ireland', *Area*, 21(1), 27–33.

Buchanan, J. (2009) 'Living at the End of the Irish Century: Globalisation and Identity in Declan Hughes's *Shiver*', *Modern Drama*, 52(3), 300–324.

Burks, A. W. (1973) 'Logic, Computers, and Men', *Proceedings and Addresses of the American Philosophical Association*, (46), 39–57.

Burns, Fergus. (2006) 'Getting to Know You', *Virtual Ireland* supplement *The Irish Times*, Monday 4 December 2006.

Byrne. (2012) 'Actor Gabriel Byrne Labels the Gathering a "Scam"', *RTE News*, Available at: http://www.rte.ie/news/2012/1106/344428-the-gathering-gabriel-byrne/, date accessed 10 December 2012.

Cahill, S. (2011) *Irish Literature in the Celtic Tiger Years 1990 to 2008: Gender, Bodies, Memory* (London: Continuum).

Castells, M. (2001) *The Internet Galaxy: Reflections on the Internet, Business, and Society* (Oxford: Oxford University Press).

Castells, M. & Ince, M. (2003) *Conversations with Manuel Castells* (Cambridge: Polity).

Cawley, M. (2003) 'The Rural Idyll' in J. Hourihane (ed.) *Engaging Spaces: People, Place and Space from an Irish Perspective* (Dublin: The Lilliput Press), 61–74.

CHTM. (2013) 'Come Here to Me!', *Dublin Life & Culture*, Available at: http://comeheretome.com, date accessed 24 April 2013.

Clements, Aedín Ní Bhróithe. (2012) 'Irish Studies and the World of Online, Digital, and Born Digital Documents', *American Conference of Irish Studies* (New Orleans).

Collingwood, S. L. (2012) *Feminist Cyberspaces* (Newcastle: Cambridge Scholars).

Connor, Peter. (1985) 'Tir Na Nog', *Personal Computer Games*, (14), 37.

Cooper, J. & Weaver, K. D. (2003) *Gender and Computers: Understanding the Digital Divide* (London: Lawrence Erlbaum).

Corral, W. H. (2012) 'Dublinesque', *World Literature Today*, 86(6), 70–71.

Coulter, C. & Coleman, S. (eds.) (2003) *The End of Irish History? Critical Reflections on the Celtic Tiger* (Manchester: Manchester University Press).

Crouch, D. (2000) 'Places Around Us: Embodied Lay Geographies in Leisure and Tourism', *Leisure Studies*, 19(2), 63–76.

Derrida, J. (1984) 'Two Words for Joyce' in D. Attridge & D. Ferrer (eds.) *Post-Structuralist Joyce: Essays from the French* (Cambridge: Cambridge University Press), 145–159.

Directory. (2007) *Irish Blog Directory*, Available at: http://www.irishblogdirectory.com, date accessed June 2007.

Donoghue, D. (1986) *We Irish: The Selected Essays of Denis Donoghue* (Brighton: Harvester).

Doyle, R. (2007) *Paula Spencer* (London: Vintage).

Doyle, R. (2011) *Bull Fighting* (London: Jonathan Cape).

Doyle, R. (2012) *Two Pints* (London: Vintage Digital).

Drew, E. (1992) 'Part-time Working in Ireland: Meeting the Flexibility Needs of Women Workers or of Employers?', *The Canadian Journal of Irish Studies*, 18(1), 95–109.

Dublin City. (2013) *Dublin Free Wifi*, Available at: http://www.dublincity.ie/main-menu-services-business/dublin-free-wifi, date accessed 20 December 2013.

Dublin VL (2009) *Dublin Virtually Live*, Available at: http://dublin.readyhosting.com/index.php, date accessed 2 April 2009.

Eagleton, T. (2012) 'Irishness is for Other People', *London Review of Books*, 34(14), 27–28.

Eircom. (2013) *Household Sentiment Survey*, Available at: http://www.banda.ie, date accessed 1 January 2014.

eISB. (2014) *The Irish Statute Book app* © The Office of the Attorney General, Available at: https://itunes.apple.com/ie/app/eisb-the-irish-statute-book/id438450060, date accessed 12 February 2014.

Ennis-O'Connor, M. (2013) *Journeying Beyond Breast Cancer*, Available at: http://journeyingbeyondbreastcancer.com, date accessed 3 December 2013.

Enright, A. (2012) *The Forgotten Waltz* (London: Vintage).

Enright, A. (2000) 'What's Left of Henrietta Lacks?', *London Review of Books*, 22(8), 1–9.

Epstein, M. & Klyukanov, I. (2009) 'The Interesting', *Qui Parle: Critical Humanities and Social Sciences*, 18(1), 75–88.

Evens, A. (2011) 'The Logic of Digital Gaming', *Mechademia*, 6(1), 260–269.

Fáilte Ireland. (2005) *A Human Resource Development Strategy for Irish Tourism: Competing Through People, 2005–2012* (Dublin: Fáilte Ireland).

Fáilte Ireland. (2012a) *Discover Ireland*, Available at: http://www.discoverireland.ie, date accessed 25 October 2012.

Fáilte Ireland. (2012b) *Report and Financial Statements for the Year Ended 31st December 2012* (Dublin: Fáilte Ireland), 1–51.

Fáilte Ireland. (2013) *The Gathering Ireland 2013: Final Report* (Dublin: Fáilte Ireland), 1–64.

Farrell, S., Meehan, C., Murphy, G. & Rafter, K. (2011) 'Assessing the Irish General Election of 2011: A Roundtable', *New Hibernia Review*, 15(3), 36–53.

Featherstone, D. (2013) *Kicking the Shite Out of Cancer*, Available at: http://kickingtheshiteoutofcancer.com, date accessed 1 December 2013.

Ferriss, S. & Young, M. (eds.) (2006) *Chick Lit: The New Woman's Fiction* (London: Routledge).

Flynn, B. (2003) 'Geography of the Digital Hearth', *Information, Communication & Society*, 6(4), 551–576.

Foley, M. (2007) 'Blogging: A Great Leap Forward: Virtual Ireland', *Irish Times*, Previously Available at: http://www.ireland.com/timeseye/virtualireland/articles/article7a.html, date accessed 1 February 2007.

Foster, R. F. (2001) *The Irish Story, Telling Tales and Making It up in Ireland* (London: Penguin).

Foster, R. F. (2008) *Luck and the Irish: A Brief History of Change, 1970–2000* (London: Penguin).

Friedman, M. (2010) 'On Mommyblogging: Notes to a Future Feminist Historian', *Journal of Women's History*, 22(4), 197–208.

Gargoyle. (1984) *Tír Na Nòg Cover Art* (Dudley: Gargoyle Games).

Gathering. (2013) *The Gathering Magazine*, Available at: http://www.thegathering-ireland.com, date accessed 3 January 2014.

Gibbons, L. (1996) *Transformations in Irish Culture* (Chicago: University of Notre Dame Press).

Gill, R. & Herdieckerhoff, E. (2006) 'Rewriting The Romance', *Feminist Media Studies*, 6(4), 487–504.

Gillespie, M. P. (2008) 'The Odyssey of *Adam and Paul*: A Twenty-First-Century Irish Film', *New Hibernia Review*, 12(1), 41–53.

Glynn, I., Kelly, T. & MacEinri, P. (2013) 'Irish Emigration in an Age of Austerity', *Department of Geography and the Institute for the Social Sciences in the 21st Century* (Cork: University College Cork), 1–140.

Gregory, A. (1902) *Cuchulain of Muirtheme: The Story of the Men of the Red Branch of Ulster* (London: John Murray).

Grene, N., Lonergan, P. & Chambers, L. (eds.) (2008) *Interactions: Dublin Theatre Festival 1957–2007* (Dublin: Carysfort Press).

Groden, M. (2001) 'Introduction to James Joyce's "*Ulysses* in Hypermedia"', *Journal of Modern Literature*, (3–4), 359–362.

Groden, M. (2004) 'Problems of Annotation in a Digital *Ulysses*' in L. Armand (ed.) *JoyceMedia: James Joyce, Hypermedia and Textual Genetics* (Prague: Litteraria Pragensia).

Guardian. (2012) 'Kindle Ebook Sales Have Overtaken Amazon Print Sales, Says Book Seller', *The Guardian*, Monday 6 August 2012, Available at: http://www.guardian.com, date accessed 3 November 2012.

Guest, T. (2007) *Second Lives: A Journey Through Virtual Worlds* (London: Hutchinson).

Haahr, M. (2004) 'The Art/Technology Interface: Innovation and Identity in Information-Age Ireland', *The Irish Review*, (31), 40–50.

Haraway, D. (1991) 'A Cyborg Manifesto: Science, Technology, and Socialist-Feminism in the Late Twentieth Century' in *Simians, Cyborgs and Women: The Reinvention of Nature* (New York: Routledge), pp. 149–181.

Harzewski, S. (2011) *Chick Lit and Postfeminism* (London: University of Virginia Press).

Heaney, Seamus. (1998) *Opened Ground – Poems 1966–1996* (London: Faber & Faber).

Henry, M. & Johnston, S. (2009) *Interview: Second Life and Tourism Ireland*.

Hershman-Leeson, L. (1996) *Clicking In: Hot Links to Digital Culture* (Seattle: Bay Press).

Hickman, M. J. (2012) 'Diaspora Space and National (Re)Formations', *Éire-Ireland*, 47(1–2), 19–44.

Hubbard, P. (2006) *City* (Oxford: Routledge).

Hughes, D. (2003) *Shiver* (Dublin: Methausen).

Hull, E. (1909) *Cuchulain: The Hound of Ulster* (London: George G. Harrap and Co.).

IB. (2011) *How Irish Are You? Census Campaign 2011*, Available at: http://www.irishinbritain.org/campaigns/how-irish-are-you-census-2011, date accessed 25 January 2012.

Inglis, T. (2011) 'The Global and the Local: Mapping Changes in Irish Childhood', *Éire-Ireland*, 46(3–4), 63–83.

IRO. (2013) *Ireland Reaching Out*, Available at: http://www.irelandxo.com, date accessed 14 November 2013.

Joyce, J. (2000) *Finnegan's Wake* (London: Penguin Classics).

Joyce, J. (1998) *Ulysses* (Oxford: Oxford University Press).

JoyceWays. (2012) *JoyceWays: Ulysses for You app* © Joe Nugent.

Juul, J. (2005) *Half-Real: Video Games Between Real Rules and Fictional Worlds* (London: The MIT Press).

Kelleher, M. (2013) 'Finding New Partners: Irish Studies and Its International Futures', *The Irish Review*, (46), 60–70.

Kennedy, Sinéad. (2003) 'Irish Women and the Celtic Tiger Economy' in Allen (ed.) *The End of History? Critical Reflections on the Celtic Tiger* (Manchester: Manchester University Press), 95–109.

Kent, S. L. (2001) *The Ultimate History of Videogames: From Pong to Pokemon and Beyond – The Story Behind the Craze That Touched Our Lives and Changed the World* (Roseville, CA: Prima Publishing).

Keohane, K. (2008) 'Best of Times and Worst of Times', *The Irish Review*, (38), 118–122.

Keren, M. (2010) 'Blogging and Mass Politics', *Biography*, 33(1), 110–126.

Keyes, M. (2007) *The Other Side of the Story* (London: Penguin).

Kiberd, D. (1995) *Inventing Ireland* (London: Random House).

Kincaid, A. (2005) 'Memory and the City: Urban Renewal and Literary Memoirs in Contemporary Dublin', *College Literature*, 32(2), 16–42.

King, B. & Borland, J. (2003) *Dungeons and Dreamers: The Rise of Computer Game Culture from Geek to Chic* (New York: McCraw-Hill/Osbourne).

King, L. (ed.) (2002) *Game On: The History and Culture of Videogames* (London: Laurence King Publishing).

Kirby, P. (2005) 'In the Wake of the Tiger: Mapping Anew the Social Terrain', *The Irish Review*, (33), 40–50.

Kirby, P., Gibbons, L. & Cronin, M. (2002) *Reinventing Ireland* (London: Pluto Press).

Knell, J. (2010) 'North and South of the River: Demythologising Dublin in Contemporary Irish Film', *Éire-Ireland*, 45(1), 213–241.

Koch, R. & Lockwood, G. (2010) *Superconnect: The Power of Networks and the Strength of Weak Links* (London: Little, Brown).

Krzywinska, T. & Atkins, B. (eds.) (2007) *Videogame, Player, Text* (Manchester: Manchester University Press).

KZero. (2009) *Consumer Virtual Reality*, Available at: http://www.kzero.co.uk/virtual-reality/, date accessed 3 May 2009.

Landow, G. P. (1992) *Hypertext* (Baltimore: The Johns Hopkins University Press).

Landow, G. P. (2006) *Hypertext 3.0: Critical Theory and New Media in an Era of Globalisation* (Baltimore: The Johns Hopkins University Press).

Lee, H. (2011) *The Forgotten Waltz* by Anne Enright – review. *The Guardian*. Available at: http://www.theguardian.com/books/2011/may/01/forgotten-waltz-anne-enright-review.

Lennon, J. (2012) ' "A Country of the Elsewheres": An Interview With Colum McCann', *New Hibernia Review*, 16(2), 98–111.

Lillington, K. (2004) 'Ireland, Technology and the Language of the Future', *The Irish Review*, (31), 66–73.

Lindemann, M. (2010) 'The Madwoman With a Laptop: Notes Toward a Literary Prehistory of Academic Fem Blogging', *Journal of Women's History*, 22(4), 209–219.

Linden Lab, (2008) SecondLife.com date, accessed 10 June 2008.

Liu, L. H. (2006) 'iSpace: Printed English After Joyce, Shannon, and Derrida', *Critical Inquiry*, 32(3), 516–550.

Lohr, S. (1995) 'The Meaning of Digital Life', *New York Times*, 24 April.

Luddy, M. & Meaney, G. (2007) *A Database of Irish Women's Writing, 1800–2005*, Available at: http://www2.warwick.ac.uk/fac/arts/history/irishwomenwriters/, date accessed 18 June 2011.

Mac Éinrí, P. & O'Toole, T. (2012) 'Editors' Introduction: New Approaches to Irish Migration', *Éire-Ireland*, 47(1–2), 5–18.

Mansfield, R. (2008) *How to do Everything with Second Life* (London: McGraw Hill).

Marino, M. C. (2008) '*Ulysses* on Web 2.0: Towards a Hypermedia Parallax Engine', *James Joyce Quarterly*, 44(3), 475–498.

Mazza, C., DeShell, J. & Sheffield, E. (1995) *Chick Lit: Postfeminist Fiction* (Tuscaloosa: Fc2/Black Ice Books).

McAleese, M. (1997) *Inauguration Speech* Online Copy Accessible at *Gifts of Speech: Women's Speeches from Around the World*, Available at: http://gos.sbc.edu/m/mcaleese.html, date accessed 4 May 2012.

McCann, C. (2010) *Let the Great World Spin* (London: Bloomsbury).

McCarthy, T. (1997) 'Celtic Tiger, Irish Climate', *New Hibernia Review*, 1(3), 115–120.

McCormack, M. (2006) *Notes from a Coma* (London: Vintage).

McCormick, J. (2012) *The Games Industry in Ireland*, (Dublin: Digital Skills Academy, The Digital Hub) Available at: www.GameDevelopers.ie, date accessed 28 December 2013, 1–30.

Meadows, M. S. (2008) *I, Avatar: The Culture and Consequences of Having a Second Life* (Berkeley: New Riders).

Meadowsong, Z. (2010) 'Joyce's Utopian Machine: The Anti-Tyrannical Mechanics of *Ulysses*', *James Joyce Quarterly*, 48(1), 55–74.

Meaney, G. (2006) 'The Sons of Cuchulainn: Violence, the Family, and the Irish Canon', *Éire-Ireland*, 41(1), 242–261.

Meaney, G. (2014) *James Joyce-'The Dead' app*, © UCD Humanities Institute.

Miall, D. S. (2012) 'Confounding the Literary: Temporal Problems in Hypertext' in A. Lang (ed.) *From Codex to Hypertext: Reading at the Turn of the Twenty-First Century* (Amherst and Boston: University of Massachusetts Press).

Montoro, R. (2012) *Chick Lit: Stylistics of Cappuccino Fiction* (London: Bloomsbury Academic).

Mulhall, A. (2013) 'Introduction: Queering the Issue', *Irish University Review*, 43(1), 1–11.

Murray, P. (2011) *Skippy Dies* (London: Penguin).

nerByte. (2014) *Lep's World* 2, Available at: https://lepsworld2.com, date accessed 4 January 2014.

Ní Dhuibhne, É. (2007) *Fox, Swallow, Scarecrow* (Belfast: Blackstaff Press).

Nunes, M. (1999) 'Virtual Topographies: Smooth and Striated Cyberspace' in M. L. Ryan (ed.) *Cyberspace Textuality: Computer Technology and Literary Theory* (Bloomington: Indiana University Press).

O'Connor, F. (2005) *An Only Child and My Father's Son* (London: Penguin).

O'Connor, P. (2007) 'Still Changing Places: Women's Paid Employment and Gender Roles', *The Irish Review*, (35), 64–78.

O'Dowd, C. (2010) 'Adapt or Die, Known Text or Non-Text: Irish Theater in 2009', *New Hibernia Review*, 14(3), 143–151.

O'Leary, S. & Deegan, J. (2003) 'People, Pace, Place: Qualitative and Quantitative Images of Ireland as a Tourism Destination in France', *Journal of Vacation Marketing*, 9(3), 213–226.

O'Toole, F. (2013) *A History of Ireland in 100 Objects* (Dublin: Royal Irish Academy, National Museum of Ireland and Irish Times).

Pastore, J. (2008) 'The Future without a Past: The Humanities in a Technological Society (Review)', *IEEE Technology and Society Magazine*, 27(2), 10–61.

Persson, A. (2006) 'Between Displacement and Renewal: The Third Space in Roddy Doyle's Novels', *Nordic Irish Studies*, (5), 59–71.

Poetry. (2013) *The Poetry Project*, Available at: http://thepoetryproject.ie/poems/, date accessed 2 February 2013.

Poole, S. (2004) *Trigger Happy* (New York: Arcade).

Price, R. (1985) 'Celtic Quest of Cuchulainn' *Sinclair User*, (34), 48.

Quinn, G, dir. (2009) The Crumb Trail, by Gina Moxley, Ulster Bank Dublin Theatre Festival, Ireland.

Rambler, H. (2009) *Interview: Dublin Virtually Live*.

Ratliff, C. (2009) 'Policing Miscarriage: Infertility Blogging, Rhetorical Enclaves, and the Case of House Bill 1677', *WSQ: Women's Studies Quarterly*, 37(1–2), 125–145.

Rutter, J. & Bryce, J. (eds.) (2006) *Understanding Digital Games* (London: Sage).

Ryan, M. L. (ed.) (1999) *Cyberspace Textuality: Computer Technology and Literary Theory* (Bloomington: Indiana University Press).

Rymaszewski, M., Au, W. J., Wallace, M., Winters, C., Ondrejka, C., Batstone-Cunningham, B. & Rosedale, P. (2007) *Second Life the Official Guide* (Hoboken, NJ: Wiley).

Salerno-O'Shea, P. (2002) 'Diversity and the Irish Workplace: Myths and Reflections from the Gateway Logo', *New Hibernia Review*, 6(3), 125–137.

Simeone, M. (2011) 'Why We Will Not Be Posthuman: Gadgets as a Techno-cultural Form', *Configurations*, 19(3), 333–356.

Sisson, E. (2004) *Pearse's Patriots: St Enda's and the Cult of Boyhood* (Cork: Cork University Press).

Slaby, A. (2011) 'Whither Cultural Policy in Post Celtic Tiger Ireland?', *Canadian Journal of Irish Studies*, 37(1/2), 76–97.

Smyth, G. (2007) 'Tiger, Theory, Technology', *Irish Studies Review*, 15(2), 123–136.

Sowinski, L. L. (2006) 'Ireland's Growing Digital Divide', *World Trade*, 19(4), 68–69.

Spiller, N. (ed.) (2002) *Cyber_Reader: Critical Writings for the Digital Era* (London: Phaidon).

Squire, C. (1907) *The Boy Hero of Erin: The Story of Cuchulain and the Champions of the Red Branch of Ulster* (London: Blackie and Son Ltd).

State. (2013) *State of Play*, Available at: http://stateofplay.ie, date accessed 23 December 2013.

Stoddard, E. W. (2012) 'Home and Belonging Among Irish Migrants: Transnational versus Placed Identities in *The Light of Evening* and *Brooklyn: A Novel*', *Éire-Ireland*, 47(1–2), 147–171.

Swearingen, J. E. (1982) 'Time and Technique in Gulliver's Third Voyage', *Philosophy and Literature*, 6(1–2), 45–61.

Swift, J. (2012) *Gulliver's Travels* (London: Penguin).

Tamaki, S. (2013) *Hikikomori: Adolescence without End*, J. Angles (trans.) (London: University of Minnesota Press).

Tapley, R. (2008) *Designing Your Second Life* (Berkeley: New Riders).

Taylor, A. (2011) *Single Women in Popular Culture* (Basingstoke: Palgrave Macmillan).

Taylor, T. L. (2009) *Play Between Worlds: Exploring Online Game Culture* (London: The MIT Press).

Theall, D. F. (2004) 'Transformations of the Book in Joyce's Dream Vision of Digiculture' in L. Armand (ed.) *JoyceMedia: James Joyce, Hypermedia and Textual Genetics* (Prague: Litteraria Pragensia).

Tobin, R. B. (2004) 'A Hitchhiker's Guide to Cyberspirituality', *The Furrow*, 55(11), 591–597.

Tovey, H. & Share, P. (2000) *A Sociology of Ireland* (Dublin: Gill & MacMillan).

Tracy, R. (2008) ' "A Statue's There to Mark the Place": Cú Chulainn in the GPO', *Field Day Review*, (4), 202–215.

Trevor, W. (1978) *Lovers of Their Time and Other Stories* (London: The Bodley Head).

Trilling, D. (2006) 'The Celtic Tiger'. *New Statesman*, 135, 59.

Turkle, S. (1996) *Life on the Screen: Identity in the Age of the Internet* (London: Phoenix).

Turkle, S. (1997) 'Computational Technologies and Images of the Self' in A. Mack (ed.) *Technology and the Rest of Culture* (Columbus: Ohio State University Press).

Vila-Matas, E. (2012) *Dublinesque* (New York: New Directions Publishing).

Wade, B., Penn, G. & Rignall, J. (1985) *Zzap!64*, (1), 80–81.

Walter, B. (2006) 'English/Irish Hybridity: Second-Generation Diasporic Identities', *International Journal of Diversity in Organisations, Communities and Nations*, 5(7), 17–24.

Watson, J. (1996) 'Ordering the Family: Genealogy as Autobiographical Pedigree' in J. Watson & S. Smith (eds.) *Getting a Life: Everyday Uses of Autobiography* (Minneapolis: University of Minnesota Press), 297–323.

Wenzell, T. (2009) 'Ecocriticism, Early Irish Nature Writing, and the Irish Landscape Today', *New Hibernia Review/Iris Éireannach Nua*, 13(1), Earrach/Spring, 125–139.

Wertheim, M. (2000) *The Pearly Gates of Cyberspace: A History of Space from Dante to the Internet* (London: Virago).

White, T. J. (2010) 'Celtic Collapse, or Celtic Correction?: Ireland's Recession in Historical Perspective', *New Hibernia Review*, 14(4), 27–43.

Wolf, M. J. P. (ed.) (2003) *The Medium of the Video Game* (Austin: University of Texas Press).

Wulff, H. (2007) 'Longing for the Land: Emotions, Memory, and Nature in Irish Travel Advertisements', *Identities*, 14(4), 527–544.

Yardley, C. (2007) *Will Write for Shoes: How to Write a Chick Lit Novel* (New York: Thomas Dunne).

Žižek, S. (2001) 'From Virtual Reality to the Virtualisation of Reality' in David Trend (ed.) *Reading Digital Culture* (Oxford: Blackwell), 17–23.

Index

GPSR Compliance
The European Union's (EU) General Product Safety Regulation (GPSR) is a set
of rules that requires consumer products to be safe and our obligations to
ensure this.

If you have any concerns about our products, you can contact us on

ProductSafety@springernature.com

In case Publisher is established outside the EU, the EU authorized
representative is:

Springer Nature Customer Service Center GmbH
Europaplatz 3
69115 Heidelberg, Germany

.